CLASSICAL DRAWING ATELIER

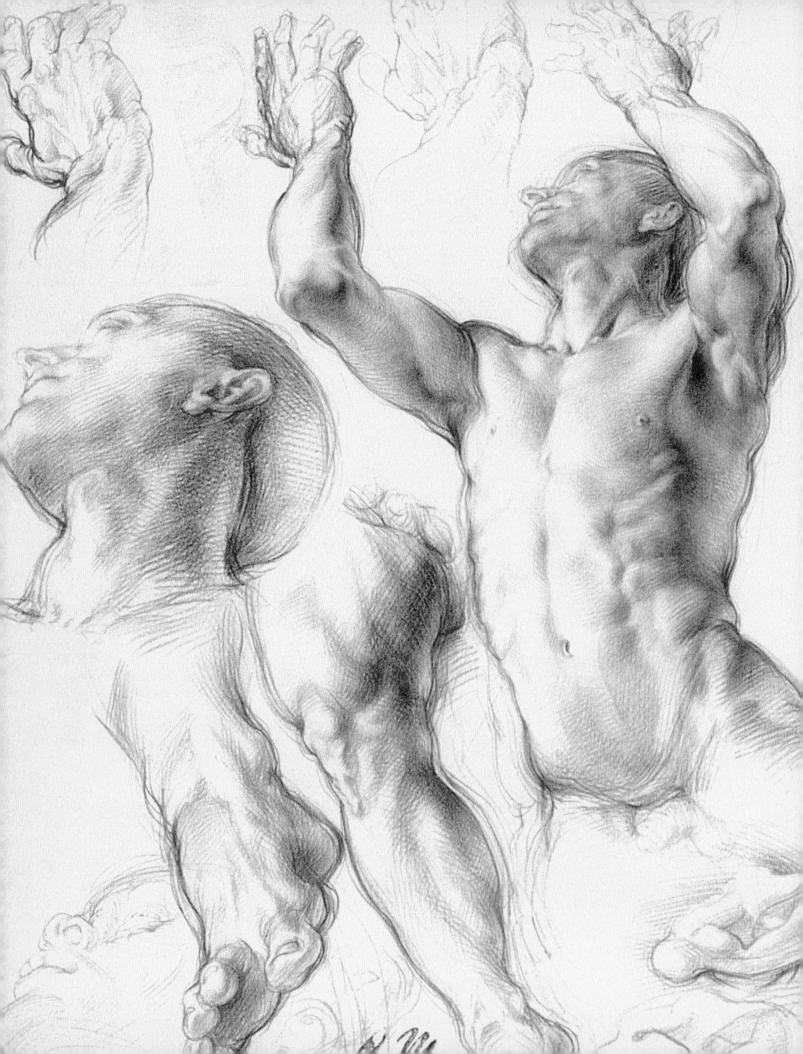

CLASSICAL DRAWING ATELIER

A Contemporary Guide to Traditional Studio Practice

JULIETTE ARISTIDES

WATSON-GUPTILL PUBLICATIONS / NEW YORK

Previous spread: Randolph Melick, *Study for*
Headless Man on Topless Bar, 2001, green
wax-based pencil on paper, 11 1/2 x 8 3/8 inches,
courtesy of Hirschl & Adler Gallery

Copyright © 2006 by Juliette Aristides

First published in 2006 by
Watson-Guptill Publications,
Nielsen Business Media, a division of The Nielsen Company
770 Broadway, New York, NY 10003
www.watsonguptill.com

Library of Congress Cataloging-in-Publication Data

Aristides, Juliette.
 The classical drawing atelier : a contemporary guide to traditional studio practice / by Juliette
Aristides.
 p. cm.
 Includes bibliographical references and index.
 ISBN-13: 978-0-8230-0657-1 (alk. paper)
 ISBN-10: 0-8230-0657-3 (alk. paper)
 1. Drawing—Technique. 1. Title.
 NC730.A68 2006
 741.2—dc22
 2006006985

Executive Editor: Candace Raney
Editor: Alison Hagge
Editorial Assistant: Maureen Lo
Designer: Christopher Cannon and Eric Baker, Eric Baker Design Associates
Production Manager: Ellen Greene

Every effort has been made to trace the ownership of and to obtain permission to reproduce the
material in this book. The author, editors, and publisher sincerely apologize for any inadvertent
errors and will be happy to correct them in future editions.

Printed in China
First Printing, 2006

2 3 4 5 6 7 8 / 13 12 11 10 09 08 07

To Constantine Aristides

Acknowledgments

I would like to express my gratitude to all the people who helped make this book possible: thanks to Candace Raney for believing in the merits of this book before there was anything to see; and to Pamela Belyea and Gary Faigin, Director and Artistic Director respectively of the Gage Academy of Art, without whom this project would never have been started. I appreciate the amazing generosity of those who contributed work from private collections, especially Fred and Sherry Ross from Art Renewal Center, and Allan Kollar from A. J. Kollar Fine Paintings. Special thanks to Dino Aristides for your mathematical expertise applied in chapter two. Much gratitude goes to Al and Kathy Lopus for being the patron saints of art, in word and deed. I greatly appreciate gallery contributors: Ramon Frey from Frey Norris Gallery; Dr. Gregory Hedberg, Director of the Department of European Art at Hirschl & Adler Galleries; Steven Diamant, Director of Arcadia Gallery; and Nicola Lorenz from Forum Gallery. Thank you to all the models who spent many long hours posing and to the students, photographers, and professional artists who contributed such beautiful work to this book. Special thanks to D. Jeffrey Mims, who provided so much encouragement. Much appreciation goes to Mark D. Mitchell, Assistant Curator of Nineteenth-Century Art at the National Academy Museum. This project could not have been completed without the help of my editors. Many thanks to Sarah Campbell, Sarah Jardine, and Alison Hagge for your valuable insights. I am very grateful to design diva Susan Bari Price for your labor of love in providing tireless assistance on many aspects of this project. Thanks to Carol Hendricks, the Gage Academy resident art historian and friend, for your help with art historical references. Also many thanks to Roy Zuniga for all the Saturdays you spent designing the diagrams, done only for the love of art. Finally, deepest thanks to my teachers to whom I am forever grateful, especially Myron Barnstone, Carlos Madrid, Jacob Collins, and Steven Assael.

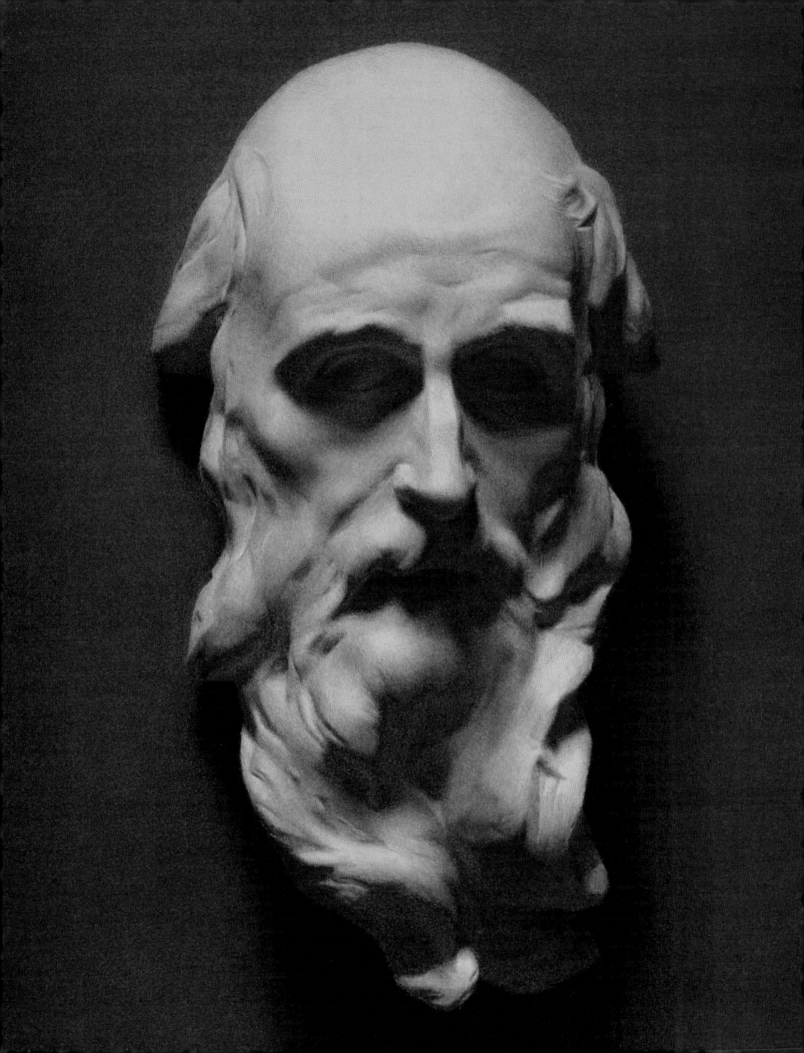

CONTENTS

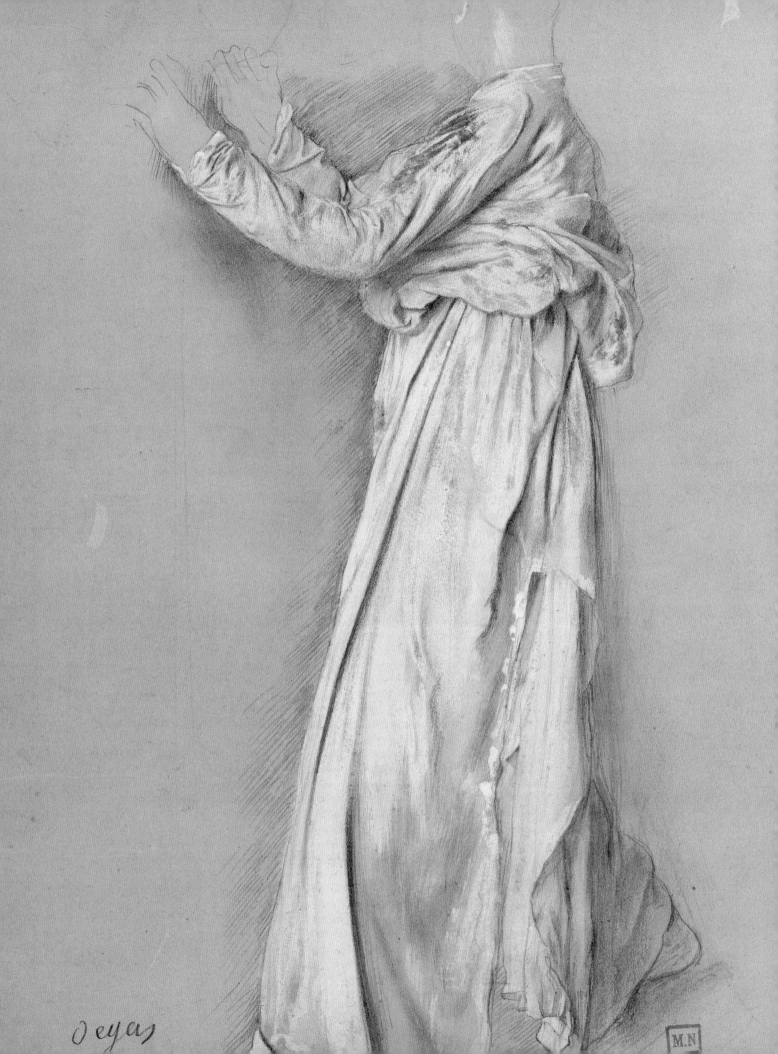

PREFACE

Drawing is an act of the will. Anyone can learn to draw. It is a matter of acquiring a series of finite skills that then have infinite applications. Once these skills have been mastered they can then be applied in any way the artist envisions. The difficulty often lies not in learning the skills themselves, but in actually applying them. A certain level of competence in drawing can be acquired by those diligent enough to pursue it. Anyone can learn to draw, but it takes both skill and talent to do it well.

Daniel Parkhurst, author and student of the academic painter William Bouguereau, wrote that "talent is just another name for the love of a thing." This love gives a person the desire to pursue an objective in spite of obstacles that arise and provides him or her with the stamina necessary for extended study. Just as not every piano student will become a professional pianist, most students of drawing will not become professional artists. However, art affords pleasure to all who study it and increases each student's ability to appreciate the art created by others.

The world, both physical and emotional, provides an infinite resource for the artist to reference. In addition, each person born is distinctive in personality and circumstance. These factors combine to create a unique internal landscape, allowing each artist to bring his own singular vantage point to the work. The work of all good artists reveals some aspect of the world that was closed to us before or creates a meeting place where we can identify a kindred spirit. The artist's vision shows us a different world by allowing us to see through their eyes for a brief moment as their distinctive and particular vantage point reflects their view of the whole.

The principles discussed in this book form the building blocks of art that, through the artist's vision, can be applied with unlimited variety. The face has just a few essential features—eyes, nose, mouth, and ears—that are applied in the human physiognomy with so much variety that we never see the same face twice. So too in art, there are principles that form the foundation of every successful work of art that have been applied and will continue to be applied with a breadth of variety to rival that found in the human race. Mastering the basic principles of art does not limit expression, distinctiveness, or personal freedom in our work. Rather, it strengthens these qualities by giving them structure.

Opposite: Edgar Degas, *Study for the Semiramis,* late nineteenth century, gouache on blue paper, with watercolor highlights, 11 3/8 x 8 5/8 inches, Louvre, Paris, France

Photo Credit: Réunion des Musées Nationaux / Art Resource, NY

Previous Spread: Matthew Grabelsky, cast drawing of Orfeo Boselli's *San Benedetto,* 2004, charcoal on paper, 24 x 14 inches, courtesy of the Angel Academy of Art

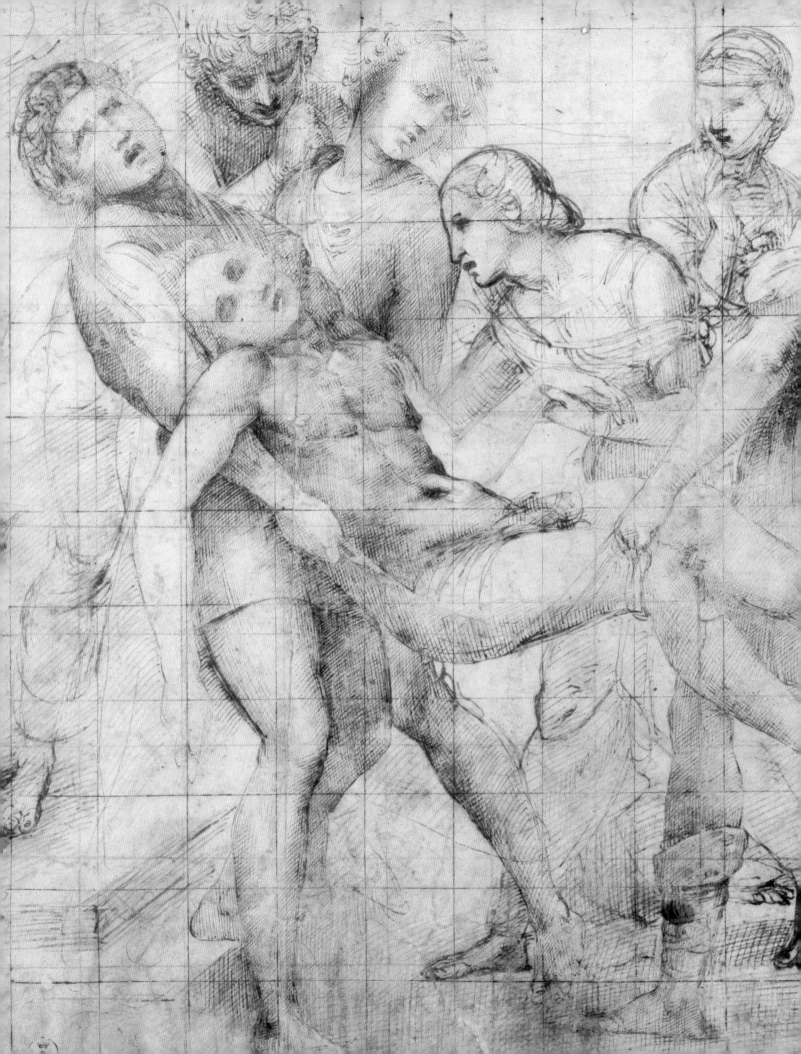

INTRODUCTION

"As has been said, you begin with drawing." — CENNINO CENNINI (from *Il Libro dell' Arte*)

The artistic masterpieces of every age have consistent underlying principles that emerge regardless of stylistic differences. By studying these artistic principles and their applications, we can appreciate the unique qualities embodied in the masterpieces of the ages. This in turn can help us recognize historical innovations in drawing and painting, and suggest to us ways in which these innovations can be used in contemporary art.

New art movements based upon artistic reactions to prior traditions have been responsible for much of the innovation in the art world. However, in the cultural climate that exists today this pattern of receiving an artistic heritage and either building on it or reacting against it has been broken. Many contemporary artists acknowledge no relationship at all to the art of the past. This failure to acknowledge what is in fact our common art heritage is, in my opinion, a major weakness of much current art.

In our arts climate, historical education and art training are often considered antithetical to genius. Rising artists are frequently expected to tap their knowledge directly from the ether, disconnected from history and labor. However, when the instincts of the individual are elevated above education, the artist can become stuck in a perpetual adolescence where his passion outstrips his ability to perform. A far more powerful art form is created when artists seek to first master the craft of art and then use it to express their individuality. As the British painter Sir Joshua Reynolds said in 1767, "Rules are not the fetters of genius, they are the fetters of men with no genius."

Only by rebuilding our knowledge base can art once again become the combination of brilliant technical achievement and unique self-expression that defined

the great art of the past. I was first introduced to this concept when studying with Myron Barnstone at Barnstone Studios. I was astonished to find that art had a language and a continuity of ideas that flowed throughout art history. Throughout high school and art school I was expected to create original work before ever learning the basic skills. After several frustrating years of trying to express myself without the proper tools, I decided to learn directly from artists. I found atelier training to be the most challenging and rewarding approach to education. This is why I choose to train my students in this method.

The atelier movement attempts to rebuild the links between masterpieces of the past and our artistic future. As such, it sets a different course than the one prescribed by the arts establishment of the modern era. By reinvigorating arts education we can give the next generation of artists the tools that have been lost or discarded over the last one hundred and fifty years. This book was written with the aim of reintroducing basic or fundamental principles of art. The principles laid out in this book, when studied in both successful works of art and through exploratory exercises, will hone one's powers of observation, cultivate awareness of visual subtleties, foster discipline of both eye and hand, and build the skill and technique required to create strong, successful artwork of any style or genre.

This book lays out the genesis of the contemporary atelier movement, the principles upon which atelier training is founded, and a few exercises for beginning to master those principles. I have also included a number of sidebars with words of wisdom from contemporary artists who are exemplary draftsmen. My goal is for students to gain confidence in their drawing skills and to be able to apply them in creating new work for our times. Once a student knows how to draw, lack of skill will not hinder the development of a personal vision. We can learn from the past not by blindly adopting historical methodology but by interpreting it and adapting it for our own needs.

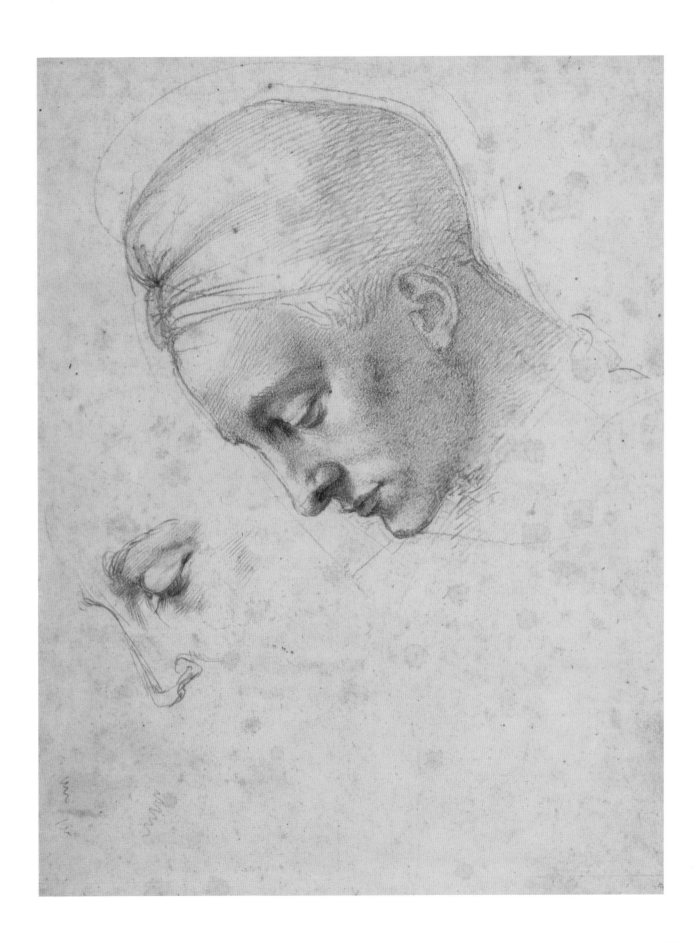

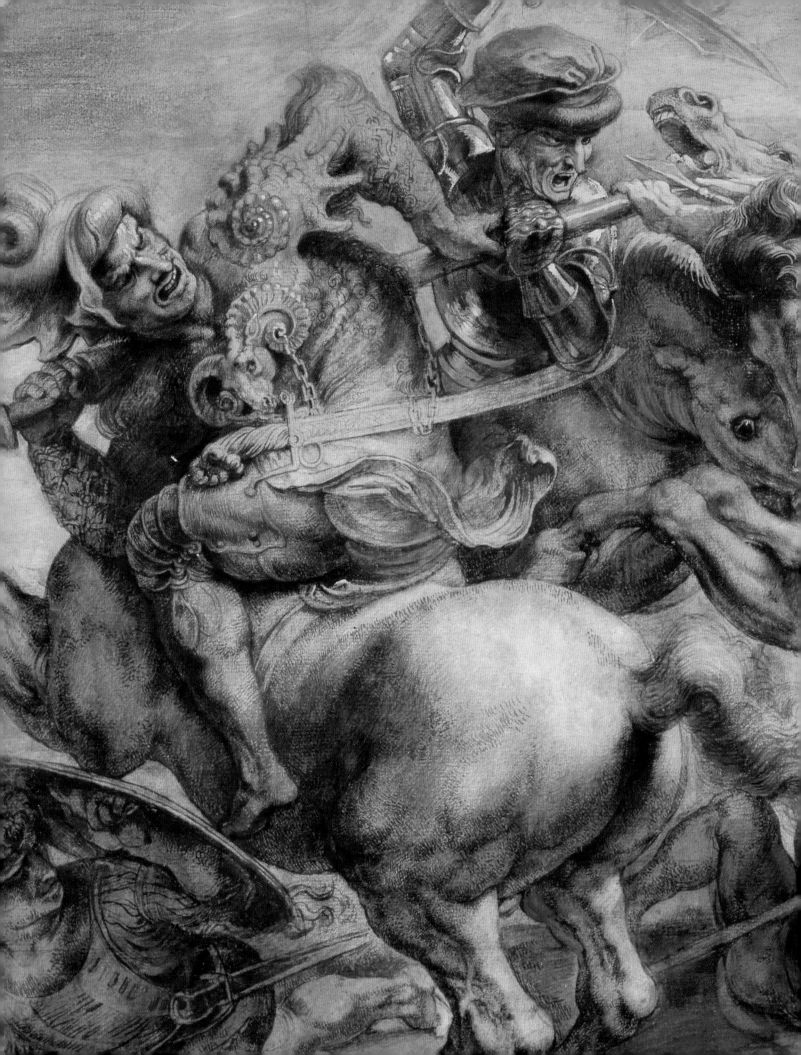

Welcome to the Atelier

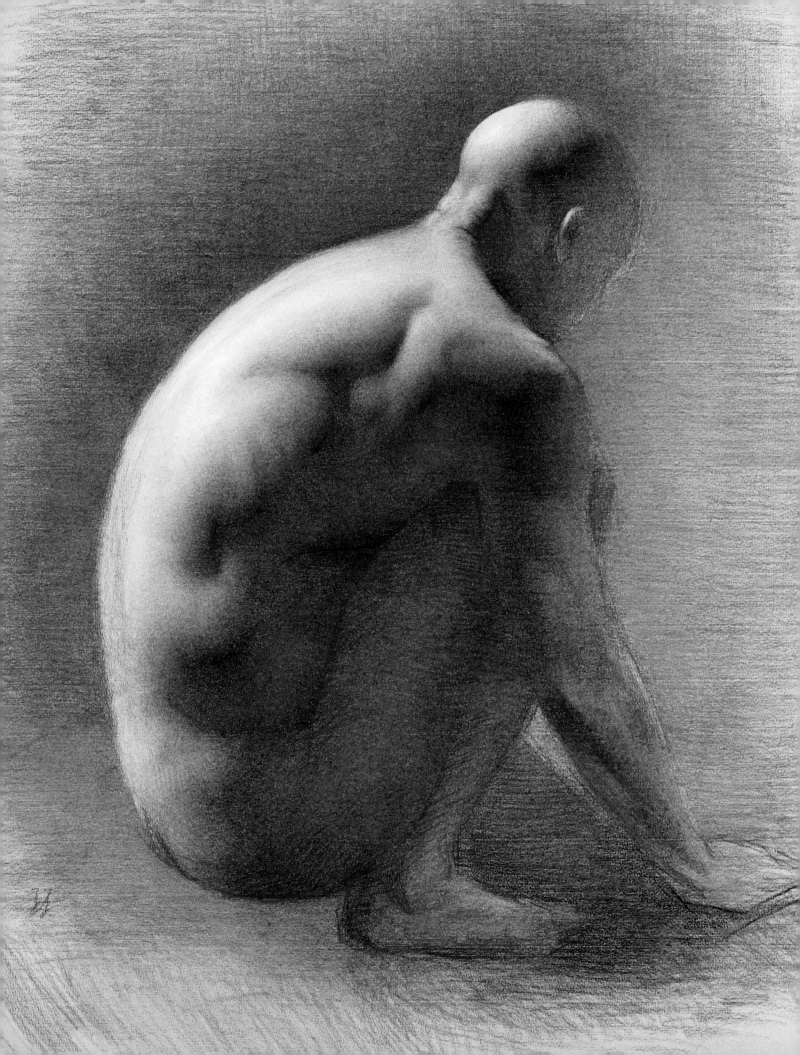

A HISTORICAL PERSPECTIVE

Artistic Training in the Twenty-First Century

"Nature alone can lead to the understanding of art, just as art brings us back to nature with greater awareness. It is the source of all beauty, since it is the source of all life." — EUGÈNE CARRIÈRE
(from *Eugène Carrière: Portrait Intimiste 1849–1906* by Valerie Bajou)

Oftentimes in order to advance one must look back. Like technology, art is built upon what happened before and influenced by what happened around the time of its creation. Each new technical discovery and stylistic invention paves the way for the next—generating either an affirmation of what has come before or a reaction against it. By looking back at the art that was created during previous eras we can connect with past masters, learn from their accomplishments, and create a new art for our times without reinventing the proverbial wheel.

With this in mind, in this chapter we are going to set the stage for our studies by briefly tracing the history of art produced in the classical style, dating back to the ancient Greeks. We will follow the role of artists in western societies and the changes in their training. Lastly, we will outline the role of ateliers and how they fit into the history of western arts education. This overview can help provide a context for our contemporary studies and can help ensure that our artistic choices are deliberate rather than happenstance.

The Origin and Perseverance of the Classical Aesthetic

The art produced in ancient Greece celebrated harmonious proportion, reason, beauty, and order. This period, which roughly spanned from 480 to 320 B.C.E., is often referred to as the Golden Age of Art. It is considered to be the starting point for the classical tradition—and indeed has influenced many aspects of western culture ever since.

The ancient Greek culture was built on a foundation of knowledge established by earlier ancient civilizations, including Egyptian, Near Eastern, and Aegean cultures. The Greeks invigorated existing artistic ideas and techniques by accepting knowledge from their forebears and combining it with their new

Opposite: Juliette Aristides, *Sutherland 3: Crouching*, 2005, charcoal on paper, 19 1/2 x 16 inches

Previous Spread: Peter Paul Rubens, copy after Leonardo da Vinci's *Battle of Anghiari* (detail), circa 1600, black chalk, pen, and brown ink on paper, heightened with gray-white chalk, 17 3/4 x 25 inches, Louvre, Paris, France

Photo Credit: Réunion des Musées Nationaux / Art Resource, NY

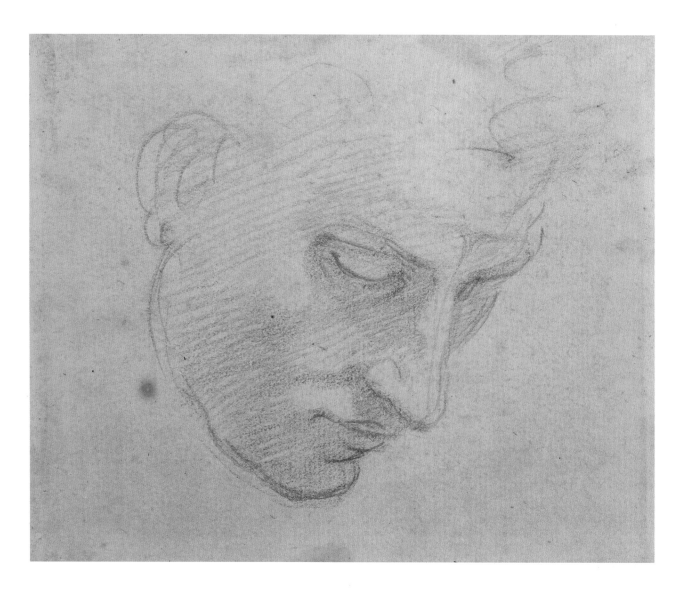

Michelangelo, *Man's Face*, early sixteenth century, red chalk on paper

Photo Credit: Scala / Art Resource, NY

scientific discoveries, thereby increasing the accuracy with which they represented nature. In so doing they turned from a canon of rigid artistic schemas and achieved a heightened realism in their art that was influenced by observation from life. The Greeks did not simply abandon artistic conventions; they added to them.

Early Greek sculpture embodied the idealism, formalism, and rigidity found in the art of the surrounding cultures. Imagine a frontal nude male figure staring straight ahead, with static and symmetrical features, no foreshortening, both feet firmly planted on the ground, and arms by his side. Such was the style that was common in Greece around 580 B.C.E. However, one hundred years later *Kritios Boy* was created. This famous sculpture is noted for being the first work to use contrapposto, a natural way to stand that captured a sense of movement and observed reality. Later Greek work becomes incredibly graceful—with figures modeled after athletes in dynamic poses, women with flowing draperies, and powerful, beautiful gods.

The ancient Romans borrowed many artistic elements from the Greeks, mimicking their accomplishments and standing on the shoulders of the masters before them. They tailored the artistic triumphs of Greece to their own needs, copying what they could and adding where necessary. The Romans introduced naturalism to the more idealized forms of the Greeks. Rather than echo the idealized heads common in Greek art, the Romans wanted to honor specific individuals by capturing their likenesses. Portrait busts were an important part of Roman culture and were created to honor relatives in funeral altars, tombs, and shrines. They were also used to honor emperors, high-ranking political officials, and notable military leaders. One particular sculpture, generically titled *Roman Portrait Bust of a Man,* that was created in the first century B.C.E. shows a bald man with a wrinkled and furrowed brow, loose jowls, baggy eyelids, and a light asymmetry to his face. This record of a human life with all its idiosyncrasies is a unique development of Roman art.

For six hundred years the classical tradition flourished throughout the Mediterranean and beyond. However, this artistic chapter was laid aside during the early Christian era and the Middle Ages. The early Christians rejected the foundation of classical art because of its perceived association with the idolatry of pagan religions. The classical veneration of the nude was found worldly and profane by the earliest Christians. Religious art was based on the mind's eye, searching for the eternal, rather than observing nature, which is temporal. The early Christians weren't interested in the illusionistic qualities of art. Their work was two-dimensional, always clothed, and based on canons and conventions that reflected their worldview. Consequently, the Greek interest in the study of nature was replaced by religious iconography and lay dormant for centuries.

The spirit and aesthetic of classical Greece was rediscovered during the fourteenth century, during the period called the Italian Renaissance, which literally means "rebirth." Philosophers, architects, and artists were all captivated by the humanistic perspective of the ancient Greeks, believing man is the measure of all things. Along with this interest came a turning back to the study of nature and classical canons. For visual artists, such as Leonardo da Vinci, this meant studying anatomy from cadavers and botany from actual plants. Perhaps the sculpture that most clearly embodies the Renaissance fascination with Greek art is Michelangelo's *David* (1501–1504). The heroism, realism, and beauty of the Golden Age of Greek art was revived; in this larger-than-life, idealized male nude sculpture, the pagan *Kritios Boy* was transformed into the biblical character of David.

The Artist as Craftsman

Many factors contributed to the excellence of the art created during the Italian Renaissance. One of these was that artists were venerated by society in a way that had never previously occurred. To fully appreciate the shift, it is helpful to review the role of artists in society prior to the Renaissance. The creation of

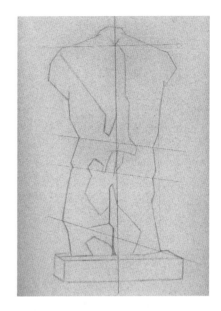

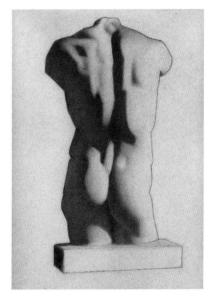

Ginette Chalifoux, copy after Charles Barque's *Male Torso, Back View,* 2002, graphite and pencil on paper, 9 x 12 inches. This is a student copy of one of the many lithographic plates created to train artists in a nineteenth century. The first drawing shows how the student is to begin by simplifying the shapes and the second shows how to bring the drawing to a finish.

Above: Photograph of the entrance to the Aristides Classical Atelier

Right: Artist Unknown, cast drawing of *Mercury,* mid-nineteenth century, charcoal with white chalk on paper, 23 7/16 X 17 7/8 inches, National Academy of Design Museum, gift of Daniel Huntington

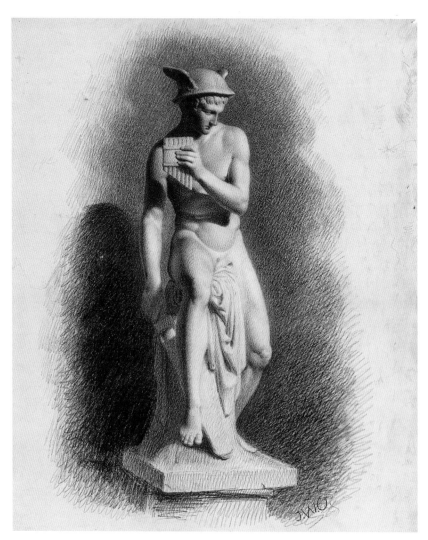

artwork had been seen as a craft and painters and sculptors were categorized among stonemasons, glaziers, and weavers as manual laborers. Artistic creativity per se was not valued, nor were artists encouraged to produce unique or original work. Paintings and sculptures were most often created for political or religious reasons rather than intellectual or aesthetic purposes. Moreover, art was often considered the creation of the person who commissioned it rather than of the artist. In fact, most works of art were not attributed to individual artists or even signed.

Art was produced by a team of people in a workshop environment. The master of the workshop was himself a successful working artist and was responsible for training and supervising the students and all the work that they produced. Each artist passed his knowledge on to the next generation through teaching by example. Because the art produced in the workshop was viewed similarly to the items (such as furniture or tapestries) produced by other workshops of the day, master and apprentice would often collaborate on the same work, painting side by side on a range of commissions such as altarpieces and frescos. Thus,

the art of the apprentice had to be indistinguishable from that of the master. Working closely in this manner with an experienced professional, the apprentice learned all aspects of the craft—from a practical knowledge of tools and materials to the theoretical complexities of composition and color.

The Rise of the Artist

This notion that artists were mere craftsmen began to change during the Italian Renaissance. However, it happened slowly over the course of many years. Early Renaissance artists such as Giotto commanded respect from their peers and patrons, but the idea of the artist as a valued creative individual was still in its infancy. When Michelangelo Buonarroti (1475–1564) entered into his painting apprenticeship at age thirteen, his father was displeased that his son would be interested in so humble an occupation.

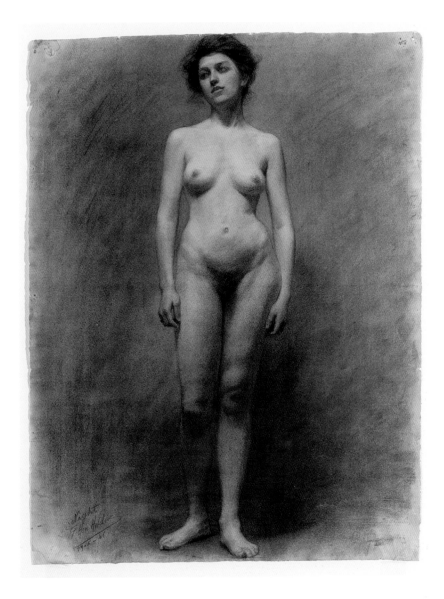

Above: Photograph of an atelier student drawing a cast of a bust of Julius Caesar

Left: George Howard Hilder, *Drawing of a Female Nude,* 1905–1906, charcoal on paper, 24 9/16 x 18 7/8 inches, National Academy of Design Museum. Drawings of figures such as this one were a common part of the traditional nineteenth-century art school experience.

The High Renaissance (1480–1520) marked the first major turning point in the role of the artist in society. Patronage from important figures such as kings and popes allowed artists to gain entrance to the educated class, where creativity and individuality were prized. The three greatest artists to emerge from the period—Leonardo da Vinci (1452–1519), Michelangelo, and Raphael (1483–1520)—almost single-handedly secured the idea of the artist as a creative genius. This paradigm shift marked the birth of our modern concept of the artist.

This new concept of the artist as a creative and ingenious individual pursuing a dignified occupation naturally led to new techniques in training. In the mid-sixteenth century, following the High Renaissance in Italy, the apprenticeship method of training within the guild was slowly replaced by the art academy. Unlike a craft, which is purely hands-on, fine art was understood to have a strong theoretical component, which could be taught orally. The first art academy, the Florentine Academy of Design, was established in Florence in 1562 by artist and art historian Giorgio Vasari (1511–1574) with the support of Duke Cosimo I de' Medici. Other schools soon followed. For instance, the Carracci family founded an art academy in Bologna around 1580. By the seventeenth century, artists were firmly rooted in the educated class, trained in the lecture halls and studios in the academies.

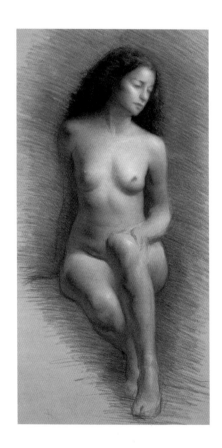

French artists also wanted independence from the guilds and, as the demand for academically trained artists grew, national art academies were established. These academies attracted students from across large geographic areas and educated them in a unified style of art. The first such national school was the French Académie Royale de Peinture et de Sculpture. It was founded in 1648 and at the end of the eighteenth century transformed into what we now call the École des Beaux-Arts. This institution set a high standard for artists and boasted a prescriptive course of study of artistic principles in which students learned drawing, expression, anatomy, proportion, chiaroscuro, composition, and color.

The Académie of that period sought to recapture the formal structure of Greek classicism and desired the art produced under their auspices to embody the Greco-Roman ideals of reason and order. To reach this goal they created works in the manner of the masters, starting with the ancient Greeks and Romans and continuing through Raphael (1483–1520) and Nicolas Poussin (1594–1665). The Académie opened a branch of the school in Rome in 1666 and winning the coveted Prix de Rome became the pinnacle of education. This prize, sponsored by the government, sent the best student to Rome for about four years to study directly from great works of art. A century after the Académie opened in Rome, the British Royal Academy opened in 1769. Various academies all over Europe soon followed, and by 1870 there were more than one hundred schools teaching a variety of traditional arts, including architecture, literature, dance, and music.

The Académie was centered on mastery of the nude figure with an eye toward producing history painters. History painting was often defined as large-scale, complex works containing multiple figures (in historically correct costumes) who portrayed an event from classical literature, mythology, history, or the Bible. To reach this goal the Académie taught students to reference nature through a series of well-defined rules of art that were primarily concerned with life drawing and other tangential subjects, such as perspective, anatomy, history, and composition. Drawing was seen as being an intellectual pursuit (in contrast to color, which was viewed as emotional) and it formed the bedrock of arts instruction. Although painting competitions were held at the École, painting itself was not taught until after 1863. Painting was taught in private ateliers (which is the French word for "artist's studio") that were headed by individual artists.

The shift from being a workshop apprentice to being a student at the Académie meant that budding artists no longer worked directly with a master. As a result, they gained freedom from the limitations imposed by a hierarchical workshop environment; however, they lost the intimate guidance that the apprenticeship fostered. The focus of artistic education during the seventeenth and eighteenth centuries was still based on mastering a respected body of inherited artistic knowledge and observing from nature. However, when artists moved out of the workshop and into the classroom, the seeds of modern art education were sown.

Contemporary Atelier Training

Present-day ateliers offer an alternative approach to the educational model offered at most art schools or universities. The origins of the contemporary atelier model reach back to a nineteenth-century French academician and painter named Jean-Léon Gérôme. Gérôme's studio was a popular place for Americans to study and he trained many influential American artists, including Thomas Eakins, Julian Alden Weir, Kenyon Cox, Abbot Thayer, George Bridgeman, and William McGregor Paxton. Paxton is not as well known for his paintings as his artistic counterparts, but he did beautiful work and brought Gérôme's teachings back to the United States, opened his own studio, and trained the artist R.H. Ives Gammel, who in turn trained Richard Lack. Lack, who is generally regarded as the founder of the contemporary atelier movement, started his own school, called Atelier Lack, in 1969, providing a place for serious students to study traditional art. Lack's studio provided an alternative method of education where likeminded people could focus on their artistic training. Lack trained roughly ninety students in his career, a number of whom have opened studios and ateliers of their own (I, myself, trained in Lack's studio). The proliferation of ateliers in this day is, in large part, a result of people either having studied directly with Gammel, Lack, or one of Lack's students.

The atelier movement of today acknowledges that a solid path to artistic greatness must understand and build upon knowledge of the achievements already attained throughout art history. Atelier instructors believe that combining

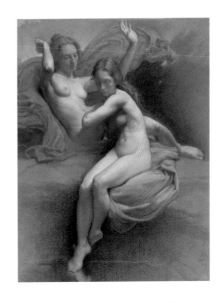

Above: D. Jeffrey Mims, *Aurora and the Moon,* 2003, charcoal and graphite on toned paper, heightened with white chalk, 23 x 17 inches

Opposite: Juliette Aristides, *Hadassa,* 2005, charcoal on toned paper, 24 x 13 1/2 inches

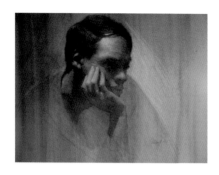

Above: Edward Minoff, *Thought*, 2005, black and white pencil on paper, 8 x 9 inches

Right: Lisa Joseph, copy after Leonardo da Vinci's *Drapery Study*, 2004, silverpoint on toned paper, heightened with white gouache, 14 1/2 x 11 1/8 inches, courtesy of the Aristides Classical Atelier

Opposite: Juliette Aristides, *Sutherland 1: Bowing*, 2004, charcoal on paper, heightened with white pencil, 19 1/4 x 16 7/8 inches

direct observation from life with knowledge of historical skills will revitalize the arts in our times. Atelier students look to prior revolutions in art to see this principle at work.

Nearly all of the innovative artists of the nineteenth century studied first academically. Auguste Renoir studied under Marc-Charles-Gabriel Gleyer, Édouard Manet under Thomas Couture, Edgar Degas studied with Léon Cogniet, Georges Seurat studied under Henri Lehmann, Jean-François Millet under Paul Delaroche, Henri Fantin-Latour under H. Lecoq de Boisbaudran, and John Singer Sargent under Carolus-Duran. All respected their teachers and spent a considerable time learning their craft. Artists such as Degas and the Impressionists combined their academic education with direct observation of nature and study of the masters to create a highly personalized artistic expression. They used their education as a springboard for their own vision and it ultimately shifted the art world in a new direction.

The atelier education movement seeks to revive the discoveries of the past while giving students the skills to move forward with their own vision. Ateliers take art students out of the classroom and place them back in the studio where

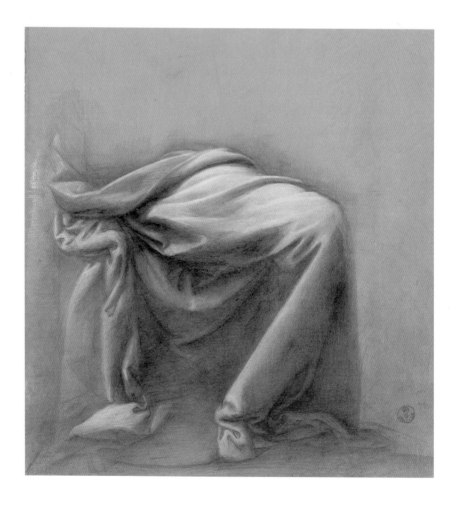

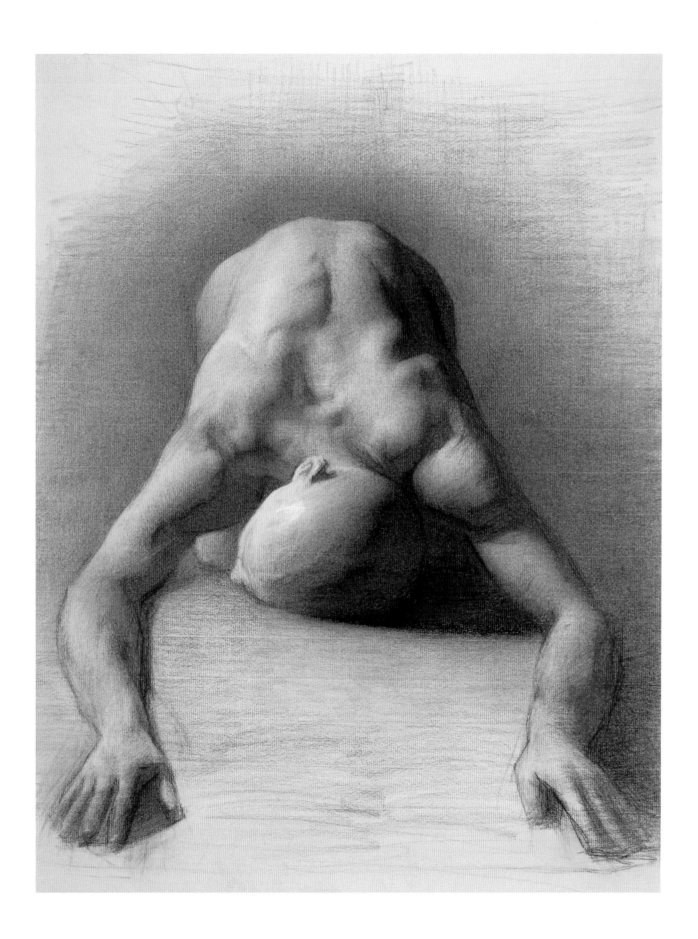

Ted Seth Jacobs, *Totem of Hands,* early 1980s, black chalk on prepared paper, 17 1/2 x 7 1/2 inches, courtesy of Frey Norris Gallery

they can learn their craft under the watchful guidance of a mentor artist, as so many great artists have done before them. Students are continually urged to study nature directly so they can make fresh discoveries that will contribute to the continuing flow of art history.

Present-day ateliers are generally small, artist-run studios that accept a limited number of students, sometimes no more than twelve. Small numbers allow a strong relationship to form between the teacher and the student. Each atelier is structured slightly differently, depending on the philosophy and experience of the instructor. The curriculum of a modern atelier, similar to the progression followed in nineteenth-century training, generally consists of a steady flow of ideas that are presented in a consecutive manner over the course of four years.

The ideas presented in this book reflect the way that I was trained and the way I train my students. The reference to years is somewhat arbitrary, as some people take several years to finish the year-one curriculum, which encompasses drawing. It should also be said that although I believe the atelier curriculum is the most thorough way to educate artists, it is not the only way to become well trained. Some drawings in this book are from artists who are not atelier trained. Understanding the foundational principles of drawing is the priority of the student, regardless of where they train.

The heart of the atelier curriculum is drawing from life and working on individually tailored independent projects. First-year students draw from a model each morning (or afternoon) for three hours. The length of the pose is determined by the goals of the instructor and can last anywhere from several days to several months. Shorter poses are often used to practice the first stage of a drawing, called the "block in." The goal of drawing short poses is to create a strong gesture (feeling of movement) and build accuracy through repetition. A longer pose offers a chance for in-depth study of the effects of light hitting form, which is crucial in the painting process. Longer poses also reveal inaccuracies in the drawing, giving students a chance to make corrections over an extended period of time. This focus on making small changes increases the sensitivity of the student's perception.

The first year of study also focuses on executing master copies and cast drawings using charcoal or graphite on paper. A master copy is a replica of a noteworthy work of art by a master artist. A cast drawing, or a drawing made from a replica of a classical sculpture, could be considered a master copy in which students begin to learn how to translate the three dimensions seen by the eye into the two dimensions available on the paper or canvas. Both of these exercises offer students a chance to work on an extended drawing without the inherent difficulties of drawing from life, such as the model moving or the pose ending before the completion of the drawing. Both exercises are solitary experiences that require an enormous investment of time and provide a glimpse into what

it is like to be an artist working in a studio. Students spend at least the first year of their training drawing from life and creating master copies and cast drawings before moving on to painting. Students will not attain a desired level of proficiency at drawing in one year. However, it is a minimum standard for those who have limited time for study.

The second year focuses on the study of grisaille, which is painting in a mono-chromatic palette or black and white. The same exercises that the students tackled using a drawing medium are now attempted in paint. In the morning, students are occupied with an extended painting from a life model, and in the afternoon they paint from a plaster cast. The practice of grisaille painting gives students familiarity with handling a different medium, while providing a transition between drawing and color painting. The year devoted to grisaille gives students confidence and a degree of mastery over their new medium.

The third year marks the progression from black-and-white to color painting and offers increased freedom to work on original compositions. Students spend mornings painting the figure in color and afternoons painting still-life

Michael Grimaldi, *At Rest*, 2003, graphite and charcoal on paper, 14 x 18 1/2 inches, private collection, courtesy of Arcadia Gallery

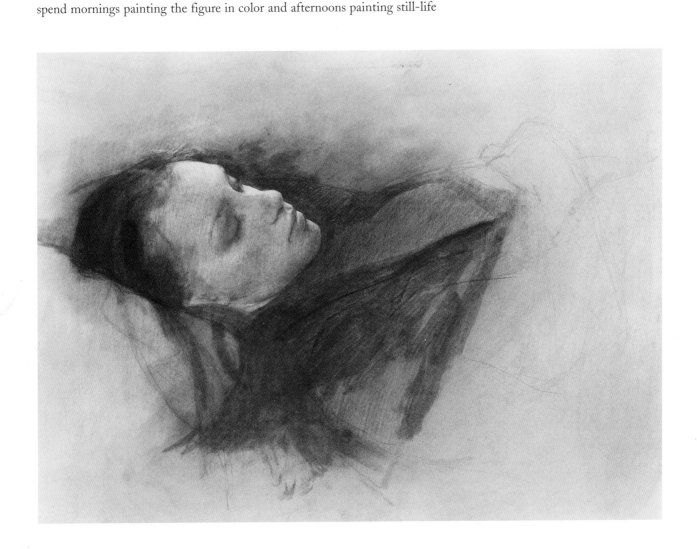

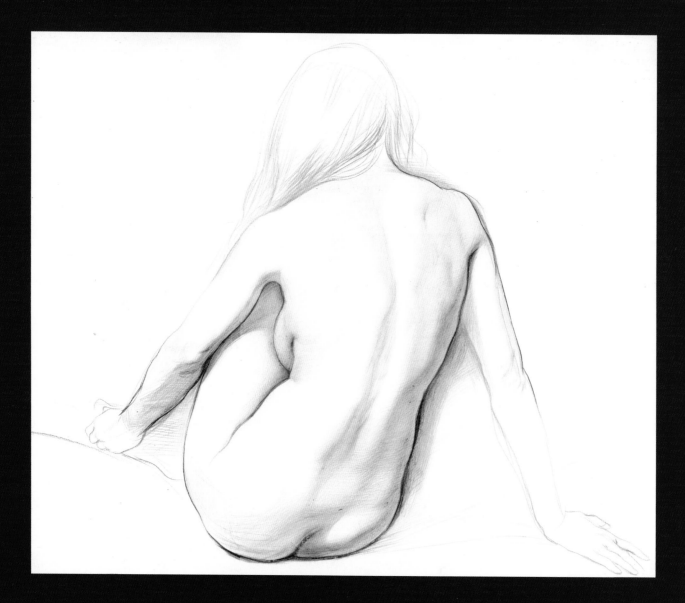

"We all draw when we are children. Drawing the things they love empowers children and reduces their feelings of vulnerability. I believe this is also true for those of us who draw as adults. Drawing is not just about expressing a visual mode or a well-articulated visual response; it is deeply connected to a natural impulse.

Begin with an emotional response. It could be motivated by something as simple as a twist of hair against a bony clavicle. Second, provide form to that initial response. Here begins the strategy or conception. The trick is to not allow the concept to become rigid, but to remain flexible through the visual journey and activity of drawing. Drawing from life is an accumulation of subtle events made evident on a page. Unlike photography, drawing is not instantaneous, but rather is sequential. A drawing can provide the viewer with a relic of compounded experiences that remains alive to the eye."

— STEVEN ASSAEL

compositions. Still-life painting provides students the opportunity to study content and compositions. Students may also augment their studies by executing master copies in paint to increase their understanding of composition, color theory, and how the masters solved various pictorial problems.

Year four brings together the various aspects of training as students begin creating more complex paintings. Mornings are still spent painting in color from the model while afternoons are spent studying portrait painting, still-life painting, and more complicated subjects such as figures in interiors. This year is a chance for students to work from their imagination as well as to focus on particular types of imagery they find most compelling through both master copies and sketching ideas for original work. The gradual introduction of many artistic concepts over four years gives students a great start to their training. However, true mastery comes only through a lifetime of study.

Below: Richard Lack, *Study for Andromeda*, 1968, sanguine on paper, 17 x 23 inches

Opposite: Steven Assael, *Seated Figure with Back Turned*, 1990, silverpoint on clay-coated paper, 12 x 13 ¼ inches

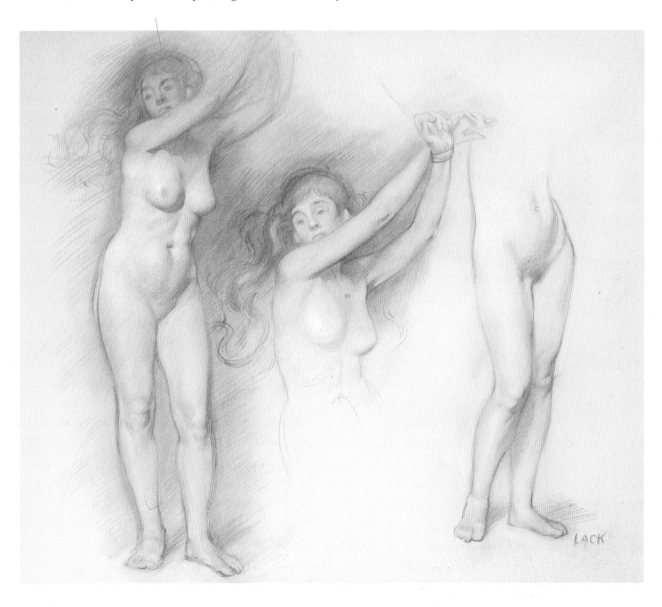

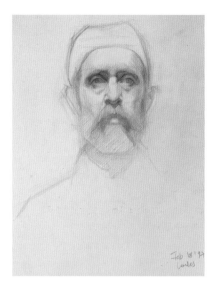

When students graduate from an atelier program, they have had the opportunity to work extensively from life and have gained the skills that will help them overcome many of the difficulties they will face in their professional lives as artists. An additional benefit of such a rigorous education is the self-discipline that comes from working six hours a day, five days a week, for several years. Artists learn not to be dependent on being struck by inspiration before getting to work. A strong work ethic develops, which is essential for a successful art career and can get the artist through dry periods that inevitably occur during their professional years.

Looking Ahead

Becoming a draftsman takes years of focused application and self-discipline. It is tempting to reduce the mastery of drawing to the completion of a few exercises. However, drawing would not have challenged and fascinated the many brilliant minds found in art history if it could have been mastered so easily. Unfortunately, there are no shortcuts to greatness; becoming a master artist takes a lifetime of sustained effort, study, and focus. The atelier curriculum points the way to the goal of mastery, but it is the diligent personal application of these principles over time that determines success.

This book is a study of artistic practices and how they are applied in contemporary work. The images shown throughout highlight the continuity between principles found in historical work and the same principles in use today. My hope is that our cultural life will be enriched when these fundamental artistic principles become commonplace and find their place in elementary schools, high schools, and universities. My aim in writing this book is to aid the serious students of art in understanding their artistic endeavors more fully and to help the layman gain insight into how to "read" a work of art, thus increasing the pleasure experienced when viewing a beloved work.

A subtext of this book is simply the desire to put together a collection of beautiful drawings, for, as the author Keats says, "A thing of beauty is a joy forever." It is affirming to study such a distinctive part of our humanity—our creativity and our ability to appreciate art. It is inspiring to realize that we can create objects designed for beauty alone and, in this, we recognize that a unique part of our humanity remains intact.

The lessons in part four of the book are intended to give the reader a chance to begin to apply the information discussed in the text. Art is a visual field and the greatest gains and insights will come not from isolated reading, but through hands-on application. However, it is important to remember that these lessons are not meant to create a virtual atelier; rather, they are provided to stimulate interest and to give an example of some of the exercises that are given in an atelier environment. If the reader has any interest in pursuing an atelier education, there is a thorough listing on the Art Renewal Web site at www.artrenewal.com.

Additionally, information on the schools that contributed some of the artwork in this text is provided in the back of the book.

Becoming a great draftsman is a noble calling with a glorious history. The goal of the draftsman has always been about far more than creating a mere record of a likeness in a photographic sense. Great drawing, rather, is the transformation of visual and emotional phenomena sifted through the temperament of an individual. The artist's vision transforms nature through the language of art to communicate the deepest expression of his or her worldview. Over the centuries, the means that artists have relied on for self-expression have been derived from observation and principles accumulated by their predecessors. These principles can be seen in all great artworks from every era, including our own. The principles are still sound and continue to be practiced today, as contemporary artists seek to learn from the past and create new work for our own time. Welcome to the atelier and welcome to this great tradition.

Below: Edward Orestuk, *Drawing of a Male Nude Holding a Hat*, 1939, graphite on paper, 24 x 19 1/16 inches, National Academy of Design Museum. This is an example of a nineteenth-century "académie," which is the name for a figure drawing created in an art academy.

Opposite Top: Kate Lehman, *Carlos*, 1997, pencil on paper, 20 x 16 inches

Opposite Bottom: William Bougereau, *Flagellation of Christ*, late nineteenth century, pencil on paper, 17 1/2 x 10 1/2 inches, collection of Fred and Sherry Ross, courtesy of Art Renewal Center

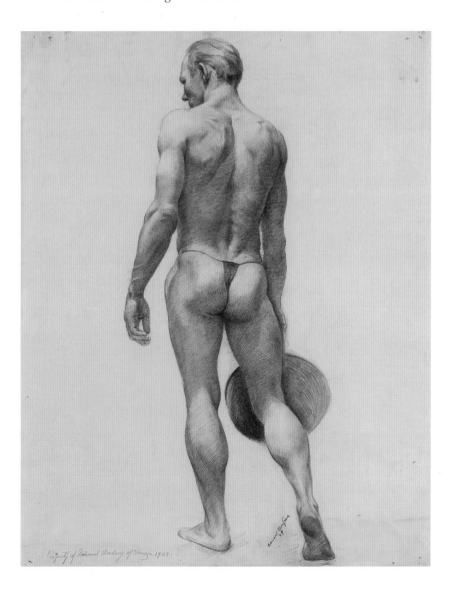

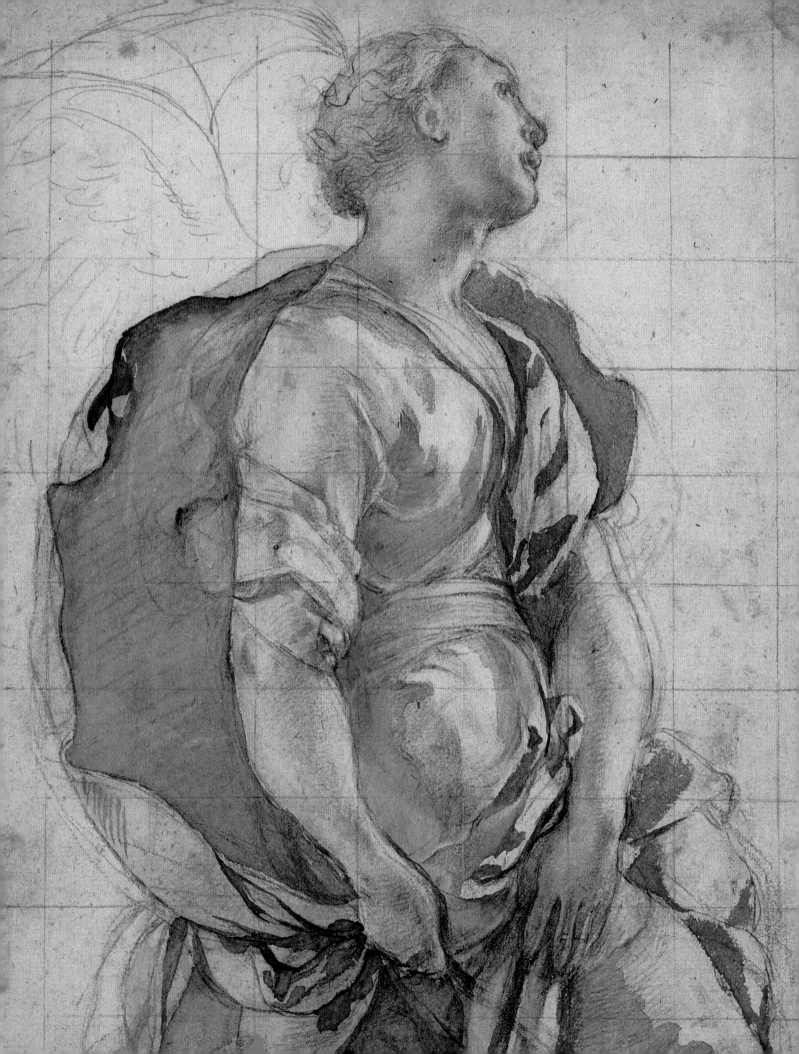

Timeless Principles

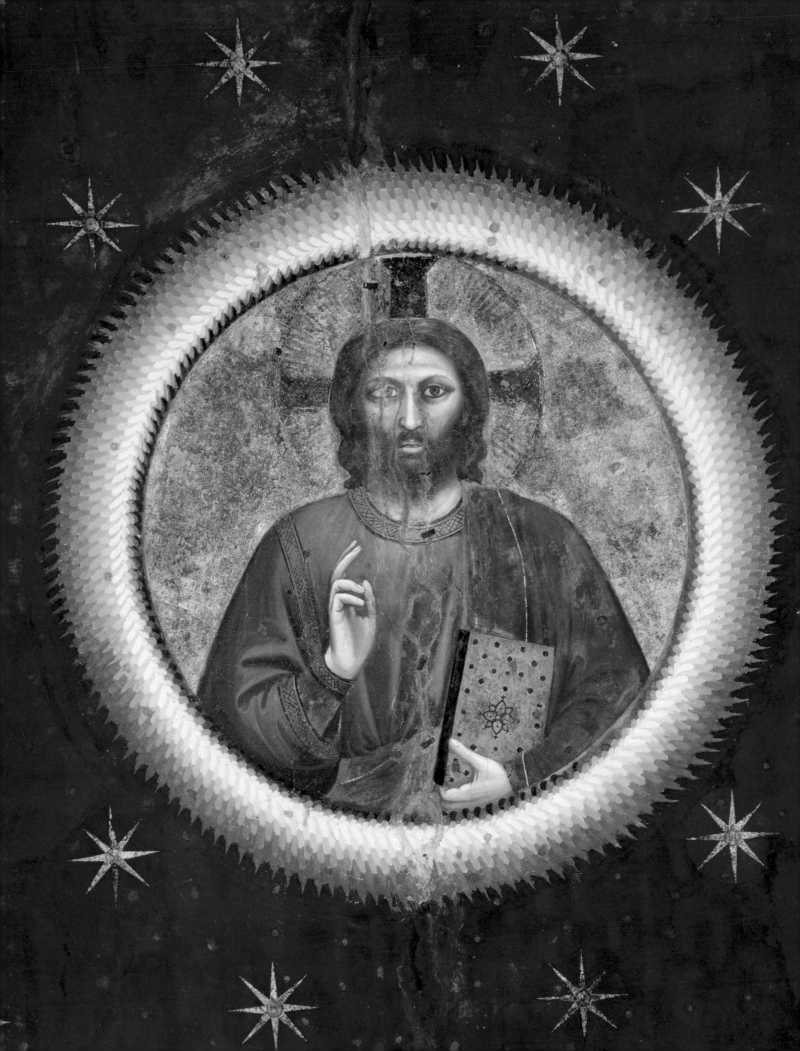

DESIGN

Nature and the Golden Ratio

"Sane judgment abhors nothing so much as a picture perpetrated with no technical knowledge, although with plenty of care and diligence. Now the sole reason why painters of this sort are not aware of their own error is that they have not learned geometry, without which no one can either be or become an absolute artist."

— ALBRECHT DÜRER (from *The Art of Measurement*)

The priests, scholars, mathematicians, and philosophers of ancient Egyptian and Greek civilizations spent much of their time searching for answers about the inner workings and purpose of the universe in which they lived. In their studies of the natural world, both the Egyptians and Greeks found a sense of order, what the Greeks called "cosmos." This order—such as the rotation of the planets and the passing of the seasons—showed, on a grand scale, that aspects of the universe were both periodic and predictable. Similarly, these two civilizations focused much of their thought on the development of mathematics. This study had practical applications, such as helping them build their pyramids and temples. However, particularly for the Greeks, the study of mathematics had philosophical implications as well—for the Greeks reasoned that order denoted intelligence, and that intelligent human beings must be created from an intelligent source, for intelligence could surely never be derived from unintelligence. Their deductive logic led them on a quest to understand this creator intelligence, which many refer to as "unity" and represent mathematically by the number 1.

What is known about the Greeks and suspected about the Egyptians is the discovery of a proportional ratio that is responsible for the order of design found in much of nature and man. The Greeks called this the "golden ratio" or the "golden section" (among other things) and their analysis of the golden ratio unveiled such astounding mathematical and philosophical characteristics that they aptly referred to it as the "logos," that is, the unifying principle of the universe. Greek mathematicians and artists considered the golden ratio to be responsible for the beauty within visual design and audible sound, and it was applied extensively in Greek art forms, such as sculpture, architecture, pottery, and music.

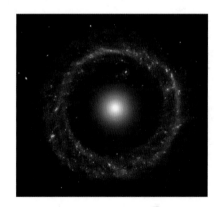

Above: Hubble telescope photograph of Hoag's Object

Photo Credit: NASA and the Hubble Heritage Team

Opposite: Giotto, *Christ Blessing* (detail), completed 1305, fresco, Scrovegni Chapel, Padua, Italy. The circle, a shape found throughout nature, is often used in art to represent God. It is a form without beginning or end. It contains the finite point, yet can be expanded infinitely.

Photo Credit: Scala / Art Resource, NY

Previous Spread: Jacopo Pontormo, *Study of Angel for the Annunciation*, circa 1527–1528, black chalk and yellowish brown wash over traces of red chalk, heightened with traces of white, on paper, 15 3/8 x 8 1/2 inches, Uffizi, Florence, Italy

Photo Credit: Scala / Art Resource, NY

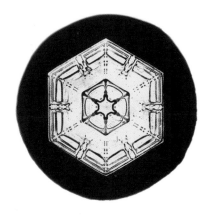

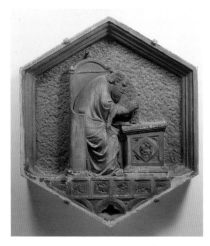

Top: Photograph by Wilson A. Bentley
of a snowflake

Photo Credit: Jericho Historical Society

Above: Andrea Pisano, *Architecture of Geometry,*
early fourteenth century, bas relief, Museo
dell' Opera del Duomo, Florence, Italy. Artists
frequently use the shapes found in nature as a
foundation for their art. The geometric struc-
ture of the water molecule retains its hexagonal
shape in the snowflake shown above. Andrea
Pisano framed his figure in this bas relief
sculpture within a hexagon.

Photo Credit: Scala/ Art Resource, NY

Right: The golden ratio creates a relationship
between the two parts of the equation such
that the proportion of the larger part (B) to the
smaller part (A) is the same as the proportion
of whole (A + B) to the larger part (B).

If today's artist has the objective of creating beautiful composition in his drawing and painting, he would be advised to study the work of the Greeks regarding the elements of design. Piero della Francesca, Leonardo da Vinci, Albrecht Dürer, and other master artists understood this principle well. As artists, they were also students of design and devoted much of their creative energy to studying the geometrical proportions of man and nature. Without understanding the elements of design, artists have to rely solely on their intuition when composing a picture. While intuition and feeling are, of course, a major defining element for an artist, they alone are not enough to consistently achieve a mastery of composition that rivals that of nature. Intuition and feeling without the knowledge and judgment of design principles are a liability in art—for without the knowledge and the know-how of design principles, the composition can easily appear chaotic and disjointed.

The Golden Ratio

Looking at nature, we see much variety. However, probe deeper into nature and we see a dominant proportional ratio responsible for much of its design. This ratio is $(1+\sqrt{5})/2$ to 1 (in other words, 1 plus the square root of 5, all divided by 2) or, in its approximate decimal format, 1.618 to 1. The Greek mathematician Pythagoras (circa 580–500 B.C.E.) is sometimes credited as the first to discover this ratio, though the Egyptians may have known about it more than a thousand years earlier. This ratio produces an order of such seemingly great intelligence that it was considered sacred by those who understood it. Yet, today, many scientists, philosophers, and mathematicians are unaware of this ratio, and of those who are aware of it, most merely refer to it as "peculiar."

Mathematically, the golden ratio produces a logically ordered progressive relationship between two parts such that the proportion of the larger part to the smaller part is the same as the whole to the larger part. In other words: B is to A as A + B is to B. The key is that the golden ratio is the only type of ratio whereby the whole and the part relate to each other in the same way. This is harmony.

$$\frac{\text{larger part (B)}}{\text{smaller part (A)}} = \frac{\text{whole (A + B)}}{\text{larger part (B)}} = \text{golden ratio relationship}$$

A + B

8

A B

3 5

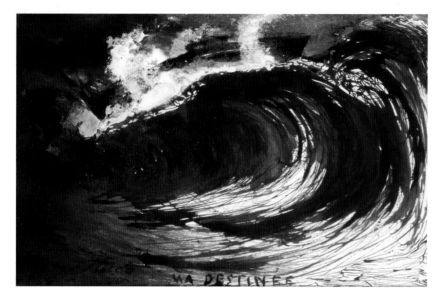

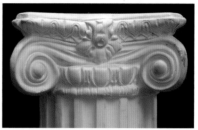

If we continue this relationship, we see that it becomes a summation sequence—that is, a sequence whereby the next part in the sequence is the sum of the two previous parts in the sequence. The sequence is: 1, 1, 2, 3, 5, 8, 13, 21, 34, 55, 89, 144, and so on. (In other words: 1 + 1 = 2, 1 + 2 = 3, 2 + 3 = 5, 3 + 5 = 8, 5 + 8 = 13, and so on.) This summation sequence is known as the Fibonacci sequence, named after the nickname of the mathematician Leonardo Pisano (1170–1252).

What is remarkable is that the Fibonacci sequence is the same sequence that represents a recurring growth pattern found in nature. As this sequence progresses, the larger number divided by its preceding smaller number will approach the golden ratio, which is called the "limit" of the Fibonacci sequence. In other words, as the sequence of numbers gets greater and greater, the ratios of the larger number divided by the preceding smaller number will get closer and closer to the exact number of the golden ratio, which is $(1 + \sqrt{5})/2$ to 1 (or approximately 1.618). The golden ratio actually oscillates up and down before settling to its limit of 1.618. For example, 3/2 = 1.50, 5/3 = 1.67, 8/5 = 1.60, 13/8 = 1.625, 144/89 = 1.61797, and so on.

An important aspect of the golden ratio—one in which the mathematical and philosophical aspects are intrinsically connected—is that it has an integrated relationship with unity, which (as we've said earlier) is mathematically represented by 1. The reciprocal is the opposite of a number, while the square is the self-multiplication of a number. The reciprocal of the golden ratio (i.e., 1/1.168) equals .618, and the square of the golden ratio (i.e., 1.618^2 equals 2.618. Therefore, the golden ratio minus its reciprocal (i.e., 1.618 - .618) equals 1, and the square of the golden ratio minus the golden ratio (i.e., 2.618 − 1.618) equals 1. In other words, the golden ratio stands in the center of its reciprocal and its square and is offset by a difference of unity, 1, in either direction. The golden ratio is the only known number to have this property.

Clockwise from Top Left:

Victor Hugo, *My Destiny*, 1887, pen, wash, and gouache on paper, Maison de Victor Hugo, Musée de la Ville de Paris, Paris, France

Photo Credit: Réunion des Musées Nationaux / Art Resource, NY

Nick Kelsh, *Baby Cowlick* from the book *Naked Babies*

Photograph by Joshua Langstaff of an ionic column. Spirals are a dominant pattern found in nature. They represent a design found in both a microcosm (i.e., a nautilus shell) and a macrocosm (i.e., a spiral galaxy). Since the days of antiquity architects have incorporated nature's spiral design into their structures, such as the Ionic column shown here.

Golden Ratio = 1+1
$$\cfrac{1}{1+\cfrac{1}{1+\cfrac{1}{1+\cfrac{1}{1+\cfrac{1}{1+1\ldots}}}}}$$

Golden Ratio = $\sqrt{1+\sqrt{1+\sqrt{1+\sqrt{1+\sqrt{1+\ldots}}}}}$

Here the golden ratio is presented as a simple continued fraction (top) and simple continued radical (bottom). Again, it is apparent that the golden ratio is uniquely integrated with unity, 1.

Right: The golden ratio rectangle has been used in art and architecture for thousands of years. For instance, the façade of the Parthenon fits within the golden ratio rectangle.

Below: To create a golden ratio rectangle, draw a square, locate the midway point on the base, and then use a compass to draw an arc from a corner opposite to that point to a position along the base.

This integrated relationship with unity becomes further evident when we format the golden ratio into what mathematicians call a simple continued fraction and a simple continued radical. If we indeed format the golden ratio in these manners, we end up with the equations shown to the left. From this mathematical perspective of the golden ratio, it is clear that the ratio responsible for a predominant design within the natural world is based in a play on unity. In other words, unity and functions of unity are adding and dividing themselves endlessly. It is precisely this integrated relationship with unity that sets the golden ratio apart from all other ratios and gives it a quality of awe-inspiring transcendence.

The Golden Ratio in Nature

Let us now turn our attention away from the geometry of the golden ratio and see how it applies to nature. Below is a golden ratio rectangle. In the rectangle, the length is in proportion to the width by a ratio of 1.618 to 1. It has been shown, using psychological tests, that human beings prefer this rectangle over all other rectangles. However, more importantly, the human preference for this shape indicates a certain resonance between man and nature. Human beings respond to designs that mimic designs based on nature. The ancient Greek and Renaissance artists understood this principle well and thus the golden ratio rectangle and golden ratio proportions became widely used for composition and design throughout their art and architecture. The façade of the Parthenon in Athens, for example, fits within the golden ratio rectangle.

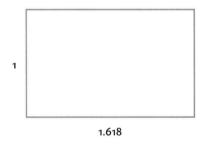

1

1.618

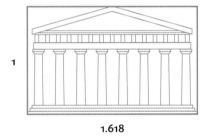

1

1.618

To create a golden ratio rectangle, draw a square, then draw a diagonal from the center of the base to an opposite corner. Next, using a compass, extend an arc outward from that opposite corner down to the base level of the square. Last, draw the remaining lines to complete the rectangle. The long side of the rectangle will now be in proportion to its short side by a ratio of approximately 1.618 to 1.

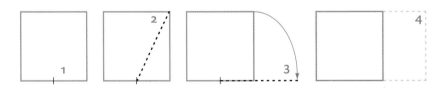

There are countless examples of designs in nature that contain golden ratio proportions, including nautilus shells, meadow daisies, pinecones, sunflowers, and the human body. A few of these are shown below.

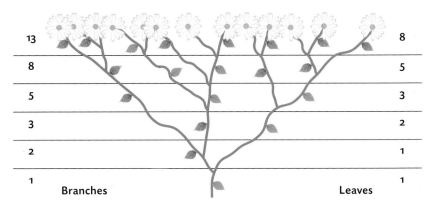

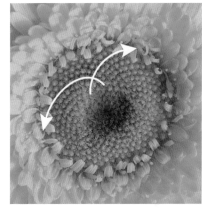

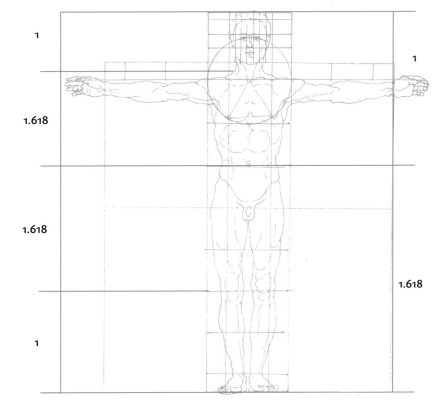

Clockwise from Top Left:

The Fibonacci sequence appears throughout nature. Here we see it in the number of branches and leaves of a simple meadow daisy.

Two opposite sets of spirals combine to form the design of a flower, and again the spiral rows follow the Fibonacci sequence. Here a large head is formed by 21 rows of seeds that flow counterclockwise and 34 rows of seeds that cross clockwise. This same phenomenon can be seen in the pineapple.

The human figure contains golden ratio pro-portions at a number of different levels.

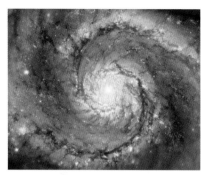

Above: Hubble telescope photograph of M51 Whirlpool Galaxy

Photo Credit: NASA and the Hubble Heritage Team

Right: Photograph by Greg Nyssen of a nautilus shell

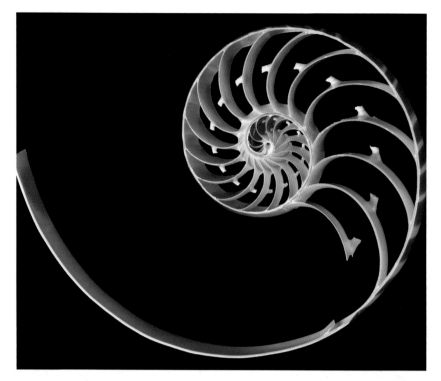

Below Left: Another name for the golden ratio rectangle is the "rectangle of the whirling squares." Here one can see squares expanding in a logarithmic spiral pattern where the size of the squares increase based on the Fibonacci sequence. The overall pattern formed at any point in the process is always a golden ratio rectangle.

Below Middle: Nature's logarithmic spiral idealized fits within the golden ratio rectangle.

Below Right: The two diagonals of the rectangle cross at a 90-degree intersection, revealing the origin of the logarithmic spiral. This is the focal point, or "eye," of the rectangle.

Nature's Spirals

Let's take a closer look at how the golden ratio applies to a design that occurs frequently in the natural world—the logarithmic spiral. And the spiral that manifests this design most readily is the nautilus shell. As can be seen from the illustrations below, a rectangle produced around this logarithmic spiral approaches golden ratio proportions. It should be explained, however, that nature's logarithmic spiral and its outlined rectangle is not of precise golden ratio proportion. It is an approximate golden ratio spiral and an approximate golden ratio rectangle. This situation exists because, according to Platonic thought, forms in nature point to eternal ideal proportions; they are not ideal proportions themselves. A pentagon-shaped leaf, for example, is not proportioned as a perfect mathematical pentagon, but its design points the viewer to the ideal pentagon shape.

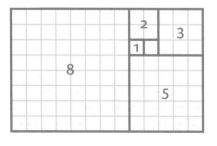

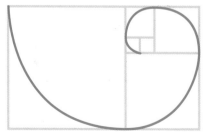

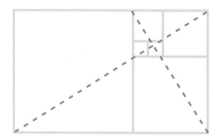

To create an ideal golden ratio spiral, all one would have to do is create a succession of connected squares based on the Fibonacci sequence. In other words, as in the example on the previous page and starting from the broadest point, the arc on the left is eight units high and eight units wide. After it touches the bottom of the rectangle and begins to swoop up and to the right, the arc is five units high and five units wide. The part of the arc that then swoops up and to the left is three units high and three units wide, and so on, down to one. These measurements directly mimic the numbers of the Fibonacci series (1, 1, 2, 3, 5, 8, and so on).

Let's continue our examination of the logarithmic spiral, as there are certain features of this spiral that are of special importance to the artist. First, any radial arm beginning from the center of the spiral and intersecting any curve of the spine will intersect that curve at an equal angle; as a result, while the spiral grows larger and larger in size, it retains its original shape and proportions. Put another way, as the spiral's curve grows, the radius grows also in a manner that retains a constant proportion throughout the entire spiral. The type of growth this spiral produces is called "gnomonic growth."

The objective for the artist is to use these features of nature's dominant spiral, idealize them, and then convert them into a similar straight line rectangular design. In other words, you can design a rectangle that mimics the idealized geometric proportions of growth found in nature's logarithmic spiral. To do this, start with an idealized logarithmic spiral. Next, draw four equal 90-degree radius lines extending from the eye or pole of the spiral outward until they intersect the spiral's outer curve; label these points of intersection A, B, C, and D, as shown to the right. Then, connect straight lines between the points of inter-section of the radius lines to the outer curve. This will form a series of whirling 90-degree triangles. If you use line AB as one end of the rectangle and line BC as one side, then you can complete the rectangle by extending the line AD until it is perpendicular with point C. Label this point E. Finally, drop a straight line down from point C to point E and the rectangle appears. You now have a golden ratio rectangle containing two diagonal lines intersecting at 90 degrees. This rectangle is constructed with the idealized geometric proportions found in nature's dominant logarithmic spiral and its measurements are of golden ratio proportions. This rectangle can become a natural starting point of design for the artist—nature's platform for the artist to compose drawings and paintings.

In looking at our rectangle, it is useful to understand the function of the two intersecting diagonals—the long diagonal (line AC) and the short diagonal (line BD). The long diagonal functions as a proportional or scaling tool for creating similar shapes of different sizes within the rectangle. We can increase or decrease the rectangle and its contained shapes by elongating or shortening this long diagonal, respectively. This proportional or scaling concept is well known among artists.

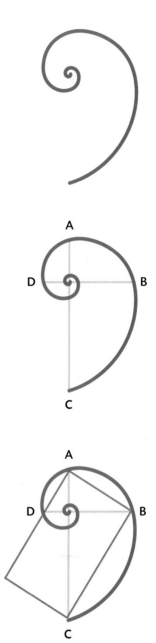

Nature's reoccuring logarithmic spiral contains golden ratio proportions. To see a golden ratio rectangle within nature's logarithmic spiral, start with a logarithmic spiral, draw four equal 90-degree radii lines that extend from the eye or pole of the spiral, label the points where these connect with the outer edge of the spiral A, B, C, and D, connect these points with straight lines, add a point E, which is beyond the confines of the original spiral, to define the fourth corner, and connect this point also with straight lines to complete the rectangle.

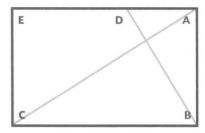

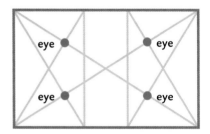

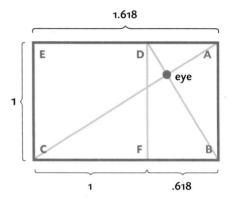

What is not generally known, however, is the function and importance of the short diagonal, line BD. This diagonal was once a diameter of the spiral, but now it has become a short diagonal line of the rectangle that intersects the long diagonal at a 90-degree angle. Line BD determines the placement of what is called the reciprocal line DF. The function of the short diagonal BD is of paramount importance. Its function is twofold. First, it divides the area of the rectangle at its reciprocal proportion, and second, its intersection with the long diagonal (AC) provides a visual focal point or an "eye" within the composition.

In our example, draw a perpendicular line down from point D to the side CB of the rectangle and label this point F. This is the reciprocal line DF. Two geometric shapes now exist: a square (defined by the points EDFC) and a smaller golden ratio rectangle (defined by the points ABFD). The area of ABFD is now the reciprocal area of the original rectangle ABCE.

Looking closer at our golden ratio rectangle, we can now see that if the length of the rectangle ABCE is idealized at 1.618, then the length-to-side ratio of its reciprocal rectangle, ABFD, is 1/.618 (which equals the golden ratio 1.618), and its remaining shape, DFCE, becomes a square with both its length and width equaling 1. Additionally, the intersection of the diagonals, the "eye," corresponds to the center (or the visual focal point) found in the original logarithmic spiral, from which this rectangle was created. Finally, a rectangle can have multiple divisions and subdivisions, thus producing multiple "eyes" within its composition. In short, the "eye(s)" of the rectangle, based on the intersecting diagonals, are proportionally in the same location as the focal point found in nature's logarithmic spiral. This concept is very helpful for the artist, as these "eyes" can be used to create the location of focal points within a composition.

Examining the reciprocal of the golden ratio rectangle visually highlights the unique characteristic of the golden ratio discussed earlier—that the golden ratio is the only known number whose reciprocal is based on the addition or subtraction of the number 1, a play on unity.

Top: Adding a point F to the golden ratio rectangle articulates another special feature of the rectangle. The line DF divides the rectangle into two distinct areas—a square and a smaller rectangle, which also has golden ratio proportions.

Middle: The lines that define the diagonals of the large golden ratio rectangle and the small golden ratio rectangle (AC and BD respectively) intersect at a point called the "eye," which corresponds to the center found in the original logarithmic spiral.

Bottom: A rectangle can have multiple divisions and subdivisions, thus producing multiple "eyes," which serve as focal points within the composition.

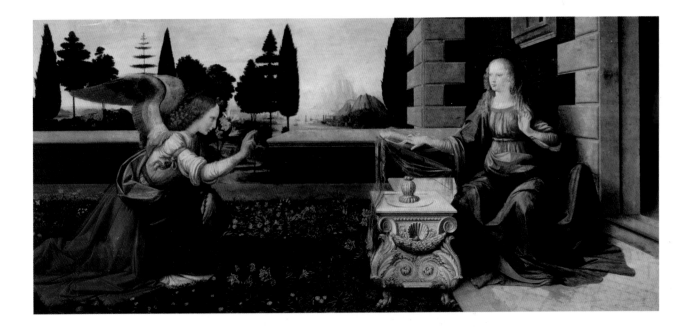

Art as Visual Music

Before we look at a painting based on nature's geometry of beauty in design, it would be useful to understand what makes a painting beautiful. A beautiful painting is like a beautiful song. A song contains rhythm, melody, and harmony—all of which perform unique and critical roles in the piece. The rhythm provides repetition and gives the ear a steady, if sometimes subtle, beat to follow. The melody provides the ear with a lyrical narrative and the harmony provides a counterpoint to the melody. Together melody and harmony create a sense of theme and variation. All three of these elements are used in music to create moments of tension and resolution, giving the whole piece a sense of following a full circle, or going from beginning to end.

Drawings and paintings utilize the visual equivalents of rhythm, melody, and harmony, and the deliberate and successful creation of tension and resolution is precisely what makes great art great. It is interesting to note that a beautiful painting and a beautiful song contain similar qualities of mathematical composition. Yet they differ in terms of presentation. A song presents a linear progression of aural vibrations through time, discerned by the ear, whereas a painting presents the visual vibrations all at one time, discerned by the eye. In other words, a painting is like a song frozen in time.

A masterpiece such as Leonardo da Vinci's *The Annunciation* contains divisions and subdivisions of space based on an interplay of golden ratio rectangles, squares, and logarithmic spirals. Da Vinci's use of these elements in his composition echoes patterns found in much of nature as well as creating spatial rhythm, melody, and harmony. One aspect of this balancing act, or successful arrangement of diverse parts, reflects a recurring theme in nature that we call

Leonardo da Vinci, *The Annunciation*, 1472–1475, oil on wood, 38 1/2 x 85 1/2 inches, Uffizi, Florence, Italy

Photo Credit: Erich Lessing/ Art Resource, NY

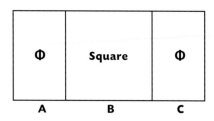

The *Annunciation* embodies da Vinci's mastery of mathematics, and his brilliance at creating complex and aesthetically pleasing compositions. The image is a rectangle that is formed by a square (labeled B) flanked by two golden ratio rectangles (labeled A and C).

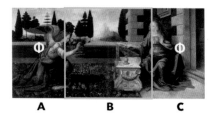

These three geometrical shapes each define a specific region of the painting. The first rectangle (A) contains the Archangel Gabriel, the second rectangle (C) encloses the Virgin Mary, and the central square (B) defines the meeting place between the two figures.

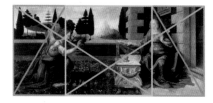

The long diagonals in the side rectangles create two triangles, each of which delineates key features of the two figures. The short diagonals within the side rectangles intersect with the long diagonals, creating the "eyes" of the composition. Additional diagonals, both long and short, create secondary focal points and delineate key areas of the composition.

"sameness and difference." That is, in the case of this painting, da Vinci has utilized the sameness of ratios of spatial parts and coupled them with differences of scale. In the end, his composition produces an integrated whole, and masterfully generates tension and resolution that provide the viewer with the experience of going full circle with these visual themes. Da Vinci was so focused on the design elements in his compositions that he is known to have said, "Let no one read me who is not a mathematician."

The overall size of the rectangle is based on the square root of 5, which is approximately 2.236. That is, the length is in proportion to the width by approximately 2.236 to 1. This rectangle includes a central square (labeled B), which is flanked by golden ratio rectangles on each side (labeled A and C) and identified with the character "phi" (ϕ) from the golden ratio. If the central square is joined with either of its adjacent rectangles, it creates yet another golden ratio rectangle. So there are four major golden ratio rectangles in total, two of which overlap. To summarize, A + B is a golden ratio rectangle, B + C is a golden ratio rectangle, and A and C are both phi rectangles.

The two overlapping golden ratio rectangles create the original whole rectangle while also creating two major vertical divisional lines, which da Vinci used to border the two figures in his composition. Da Vinci also cleverly used the square, which many philosophically regard as the symbol of earthly unity, as a point of unification between heaven (the Archangel Gabriel) and earth (the Virgin Mary).

When we examine the two flanking golden ratio rectangles (A and C), we see that da Vinci placed the majority of each of the two figures within the triangles formed by the long diagonal of the rectangles. Additionally, da Vinci used the 90-degree intersection of the long diagonal with the short diagonal within the outer golden ratio rectangle on the left to lead our eye to Gabriel's wing and then straight up to the thin vertical tree. And on the right, he used the 90-degree intersection of the two diagonals to lead our eye to the top of Mary's left hand. These two intersections correspond to the focal points, or "eyes," of nature's logarithmic spiral.

Visual spaces in the shape of triangles whirl around the eyes of the rectangles, keeping similar proportions to each other while increasing their size geometrically just like the relationship of parts found in nature's logarithmic spiral. Nature's design of harmony is represented here in da Vinci's composition.

Da Vinci used additional golden ratio rectangles to subdivide his composition. The two most notable ones are contained—in fact, overlap one another—within the central square. The outlines of these two rectangles create two horizontal lines, which da Vinci used to create the major horizontal divisions of the picture plane. These divisions can be seen running along the surfaces of the two low walls.

Using the geometry of nature and philosophy as his tutor, da Vinci coupled his artistic intuition and talent to create a powerful composition that continues to intrigue and inspire us centuries after its conception.

In summary, the overall theme or goal for an artist when composing a picture is to arrange the objects and spaces on the canvas in a manner that creates rhythm, melody, and harmony. When used well, these elements can generate a recurring theme of sameness and difference. This theme is nature's most prevalent design. When they understand nature's proportional system, artists have a sound compositional system at their disposal. This system can be used to create an unlimited amount of varying compositions.

Within nature, one system of design can create an extreme amount of variety. Once the artist visualizes a drawing, he can set up the skeleton of the composition first and then arrange the objects and spaces to be drawn. Or he can arrange the objects and spaces to be drawn first and then adjust them to comply with a sound compositional system of design. Once he uses a sound visual framework to compose his work, he can then couple his intuition with design knowledge and technical ability—a powerful combination in the pursuit of great art.

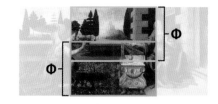

Above: The central square can be segmented into two overlapping golden ratio rectangles. The central outlines of these two rectangles correspond precisely with the surfaces of two low walls in the image.

Below: Leonardo da Vinci, *The Annunciation* (detail), 1472–1475, oil on wood, 38 1/2 x 85 1/2 inches, Uffizi, Florence, Italy

Photo Credit: Erich Lessing/ Art Resource, NY

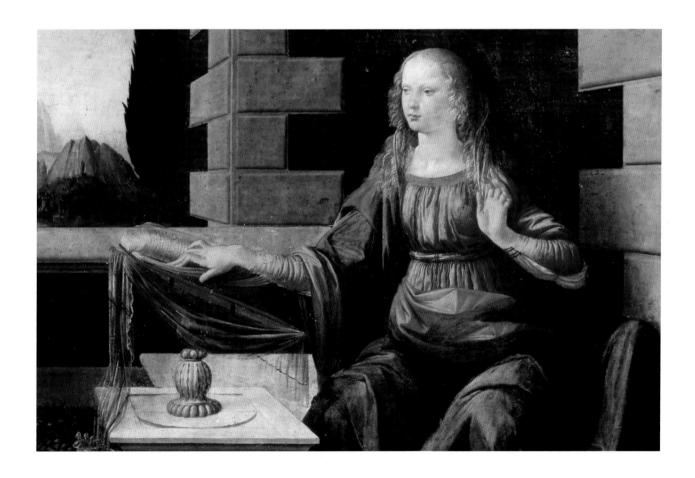

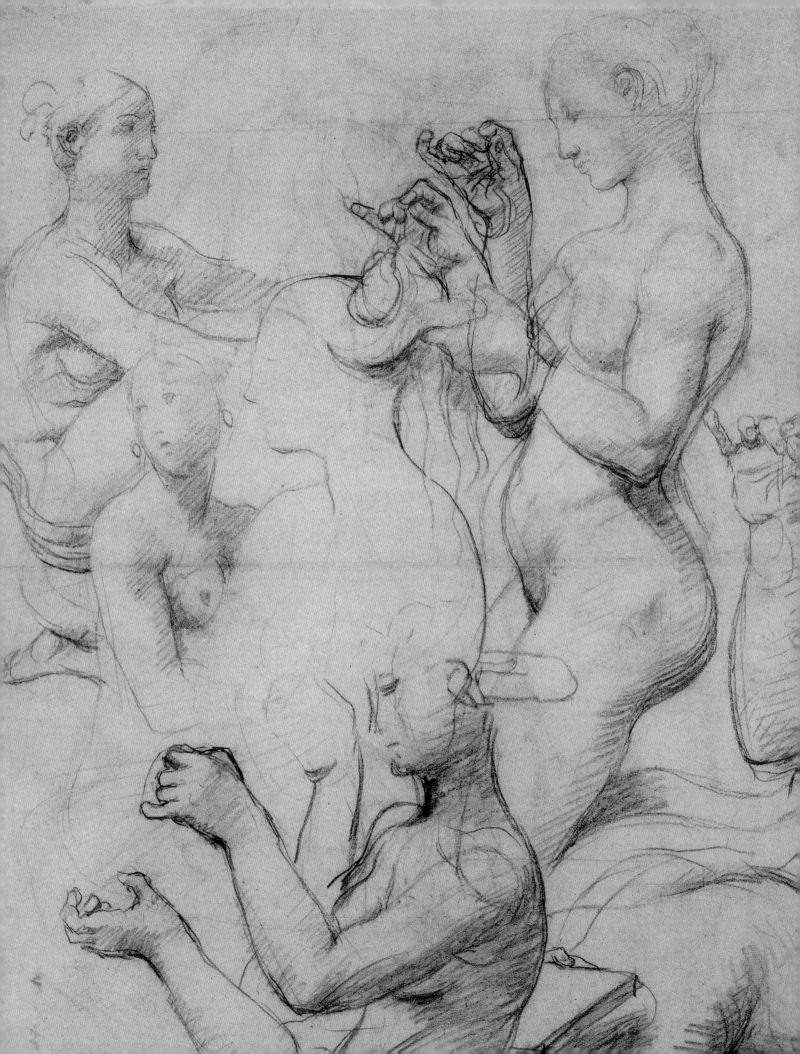

LINE

Two-Dimensional Dynamics

"The aims [of the draftsman] are first, to develop in the highest degree the abstract beauty and significance possessed by lines in themselves, more or less independently of representation." — KENYON COX
(from *The Classic Point of View*)

In its purest form, drawing is an abstraction. The lines are symbols used to re-create visual phenomena. In children's alphabet books or drawing books, simple vertical, horizontal, diagonal, and semicircular lines are often presented as fundamental building blocks. Once the children master the creation of these few kinds of lines, they are then encouraged to put them together to form patterns and shapes. So these four lines are used to make the letters of the alphabet, or such things as animals or spaceships.

This distillation of the infinite number of lines into a few powerful directional lines gives us an entranceway into complex visual work. Not only is this concept useful for drawing individual objects, but it also provides a means for designing compositions. This aid to seeing has at times been formulated into rigid schemas that artists have followed. When it becomes too codified, this idea can become a barrier to seeing rather than an aid. However, when it is combined with direct observation it becomes an indispensable point of departure.

The Use of Line

We don't see lines in life, we see forms. Looking out a window, for instance, I see trees, grassy fields, cars, and a building. The lines we think we see in life are most commonly the edges or boundaries of greater forms. We observe an outline around the curve of a figure model's shoulder, for example. However, this perceived line is not a line at all, only the appearance of one caused by the juxtaposition of the curve of the form against the background. The line, in its purest sense, is implied everywhere in nature and found nowhere. It is a mathematical concept that does not exist, but rather denotes placement and direction.

Opposite: Jean-Auguste-Dominique Ingres, *Study for the Turkish Bath*, nineteenth century, charcoal on paper, 24 3/8 x 19 1/4 inches, Louvre, Paris, France

Photo Credit: RMN, copyright © Michèle Bellot / Art Resource, NY

The tetraktys is a secret symbol from ancient Greece that represented the mysterious transformation of spirit to matter.

The tetrakys could represent the drawing process, which starts with a point, continues with the representation of a line and a plane, and ends with the expression of a form.

The ancient Pythagorean brotherhood, founded by the Greek philosopher and mathematician Pythagoras in 529 B.C.E., had a secret symbol called the tetraktys, shown to the left. This symbol could represent many different things, one of which was the mysterious transformation of spirit to matter. The single point at the top of the pyramid indicates a position; the two points below, when connected, reference the creation of a line (one dimension); connecting all three of these points delineates a plane (two dimensions); and adding a fourth point creates a solid form—the pyramid (three dimensions). In this example, the single dot at the beginning of the progression represents spirit and the final pyramid represents matter. Italian Renaissance theorist, artist, architect, and writer Leon Battista Alberti (1404–1472) reiterated this familiar progression in the opening pages of his well-known book *On Painting*.

The tetraktys could represent the drawing process. The point happens when the artist first puts his pencil to the paper and makes a dot. The artist moves the pencil, stops at the next point, and lifts his pencil. He has made a line. As he continues to draw and adds more lines, they become less abstract and eventually form a three-dimensional shape. Adding even more lines gives volume to the image, articulating the third dimension with light and shade. In this way a drawing is created, but first we must start with a line.

Drawing a line is a bit like playing a game of tennis. When a ball is hit into the air, the player does not have to wait for the ball to hit the ground before running to the spot where he expects the ball to land. The ball is on a particular trajectory and the eye follows the direction of the ball more than it follows the ball itself. Likewise, when a line begins in a work of art it invites the eye to continue in a particular direction whether or not the line itself continues. A line segment moves the eye in a particular direction whether or not the line itself continues. When drawing a line the artist places the tip of his pencil on the paper, which creates a dot. Then, much like our tennis player, he focuses not on the line itself, but on where the line will end. The two points (which represent the ends of the line) become more important than the line itself. Working point-to-point helps keeps the artist focused on bigger line directions and helps create the feeling of movement in a work.

The concept of leading the eye through the picture is integral to the concept of design. Rather than copy exactly what they see, artists manipulate nature to express themselves emotionally, giving weight and emphasis to what they think is important. This ordering of the image into a significant hierarchy of pattern is an essential component of great work. It reveals that there is a designer, a captain at the helm. Artists exercise their knowledge of visual phenomena by using strong line directions to lead the eye to key areas in the drawing. For example, if the artist puts a vertical line in the lower part of the picture, the viewer will unconsciously search for the continuation of the line in the upper part of the picture.

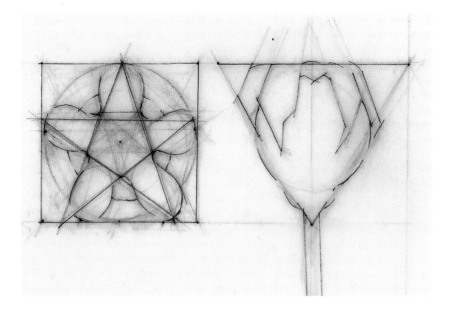

In addition to using line to create movement and guide the eye, artists use line to create rhythm and mood. The tension, resolution, and repetition of various line directions keep the work interesting and varied. Tension is established when a line or movement is opposed by another element. At its simplest level, tension breaks up the perfect unity of one by adding a second element. Resolution is achieved when a binding element (the mean) reconciles the dynamic between the two elements, creating not just a new form, but harmony. The two individual elements are joined in a relationship. When an artist determines which line directions are emerging as dominant in a work of art, he can repeat those angles to create a theme. By consciously limiting certain line directions and repeating others, he will be able to heighten the effects or gestures of his compositions, infusing breadth and power into his work.

Types and Uses of Lines

Line is the first, and most fundamental, element in the language of art. Like the preschooler learning his letters, we will start at the beginning and examine the differences between straight and curved lines—and then proceed with other kinds and uses of lines. Each of these lines has not only particular aesthetic characteristics, but emotional characteristics as well. Artists throughout the ages have used line to create very different effects.

STRAIGHT LINES

Straight lines, as can be seen in Ichirakutei Eisui's *The Courtesan Segawa of the Matsubaya,* have always been an important tool in the artist's repertoire. They function as a vector or an indication of movement in a particular direction. They are also one of the most useful devices artists employ to help them identify an overarching design and simplify complex forms. Straight lines are used more frequently than curved lines for drawing because they are easier for the

Juliette Aristides, *Analytical Studies of Gourds and Rose Hips,* 2005, pencil on paper, various sizes

When a curved line is formalized into a straight line the subtle changes in angle direction become more obvious. The relationships are simplified into increments that become easier to measure. For example, the subtle curves of a contour line of a leg can be difficult to draw correctly; by using straight lines minute changes can be more easily recognized and transcribed.

The straight line is really a subset of a curved line, it is one option out of a myriad of possible line directions.

Above: The strong use and repetition of perpendicular diagonal lines create a zigzag pattern that moves the eye from the top to the bottom of the print. Repeating a limited number of line directions gives a rhythm and strength to this work.

Right: Ichirakutei Eisui, *The Courtesan Segawa of the Matsubaya,* circa 1798, woodblock print on handmade mulberry paper, 15 x 9 7/8 inches, A.J. Kollar Fine Paintings, LLC, Seattle, Washington

mind to comprehend. The curve is very difficult to copy directly, while straight-line relationships can easily be measured.

The straight line is imbued with symbolic attributes that denote a moral uprightness. We think of a pillar of strength, the plumb line of truth, or the straight and narrow path. The straight line is woven into the imagery of our literature and media to represent order, strength, stability and constancy. The love of the straight line is a love of reason and intellectual purity.

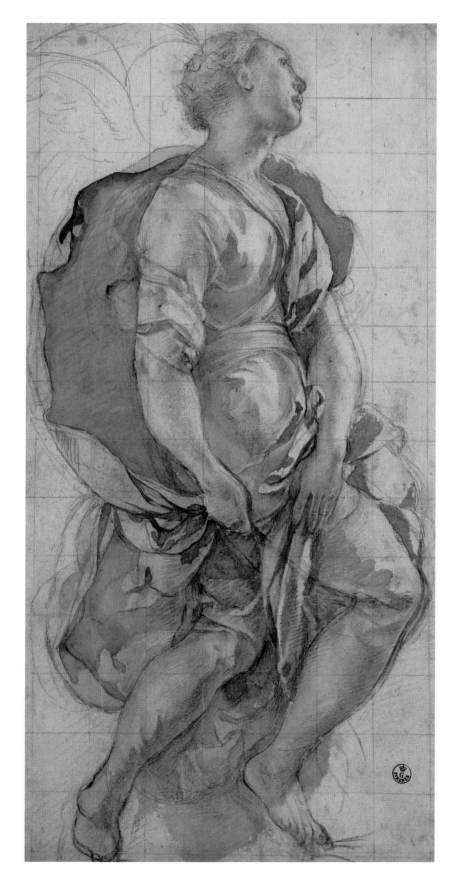

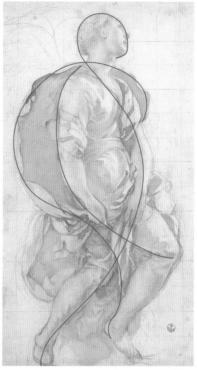

Jacopo Pontormo, *Study of Angel for the Annunciation*, circa 1527–1528, black chalk and yellowish brown wash over traces of red chalk, heightened with traces of white, on paper, 15 3/8 x 8 1/2 inches, Uffizi, Florence, Italy

Photo Credit: Scala / Art Resource, NY

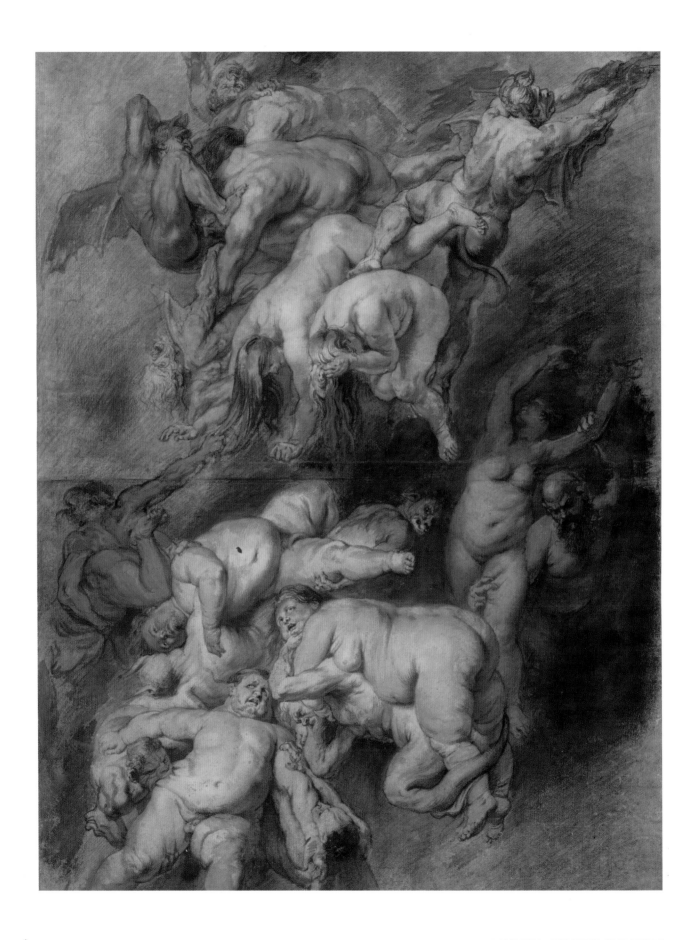

CURVED LINES

According to its formal mathematical definition, a straight line is actually a subset of a curved line, just as a circle is a subset of an ellipse. A straight line is a curve generated by a point moving in one direction. A curved line is a curve generated by a point moving in a continuously changing direction. The use of curved lines is well illustrated in Jacopo Pontormo's *Study of Angel for the Annunciation.* Another artist who embodies this love of the curve is El Greco (1541–1614), whose energetic curved figures mirror the swirling clouds in his landscapes.

Curved lines provide art with the spark of life. They are organic, energetic, childlike, and dynamic, and are often used to contrast with straight lines—with the former being used to emphasize emotional aspects of the world and the latter used to emphasize intellectual aspects. This balance between the emotional and the intellectual has oscillated throughout art history depending on the times. Rococo (1715–1774), a style of art popular with the French aristocracy, was playful, light, and decorative, capturing the mood of the day. The pendulum swung and along came Neoclassicism (roughly 1750–1850), with its stark high moral tone and the brewing of revolution. Or, to cite another example, the fluid, curvilinear lines of Art Nouveau (late 1890s to early 1900s) were based on designs found in nature. By comparison, the aesthetic of the Bauhaus movement (1919–1933) was industrial and austere.

DIAGONAL LINES

The work of Peter Paul Rubens is inextricably bound with seventeenth-century Baroque art. The energy, movement, and power conveyed in his narrative paintings were found not only in his dramatic subject matter but also in the abstract design of his compositions. The armature of his works of art was often based on the diagonal, commonly called the "Baroque diagonal." In this drawing for the painting *The Fall of the Damned* we see pyramids of figures tumbling and falling through space. Two strong Baroque diagonals are successfully repeated all the way through the image; in fact, these diagonals actually echo the diagonals that cut across the rectangular frame itself, forming an X. (In the diagram here only one diagonal is depicted, for clarity.)

Because of their instability, diagonal lines convey a feeling of movement or dynamic energy. They tip in space and are not oriented in a static way in relation to the edges of the canvas or paper. Think of a running figure that is lunging forward, which contrasts with a figure standing (in a vertical position) or at rest (in a horizontal position). By limiting his angle directions, Rubens was able to create a single-minded, concise, and forceful image that could be clearly interpreted by his audience. He avoided the pitfall of being vague and uncertain in his design.

Above: Peter Paul Rubens arranged his composition on the diagonals of the rectangle, a device favored during the Baroque era. His cascading figures are anchored onto these diagonals and that same angle is repeated everywhere, giving a powerful message of movement and single-mindedness of vision. Rubens also organized his two main groupings of figures into larger shapes. One can see two triangles, one pointing up and the other pointing down, so that although the falling figures might be in chaos, the work of art is not.

Opposite: Peter Paul Rubens, *Study for the Fall of the Damned,* circa 1614–1618, black and red chalk, watercolor, and bodycolor on two sheets conjoined, 27 7/8 x 18 5/8 inches, The British Museum

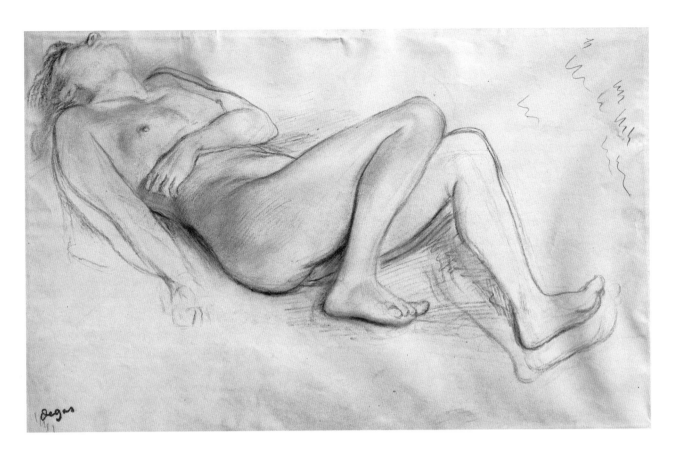

Top: Edgar Degas, *Drawing for the Misfortunes of the City of Orleans, Nude Woman,* 1865, black pencil on paper, 8 7/8 x 14 inches, Louvre, Paris, France

Photo Credit: Scala / Art Resource, NY

Above: This drawing of a writhing figure contracts and expands depending on how we look at it. The lines of the legs radiate from a point above the figure. The tension between the strong diagonal and the radiating lines succeeds in sending a message of an introspective and pained figure.

DIRECTIONAL LINES

One of the most basic tools available to the artist is the ability to organize a drawing through the use of directional lines. Using parallel lines as directional lines is one common way for artists to design their images. Ichirakutei Eisui's *The Courtesan Segawa of the Matsubaya,* shown on page 34, illustrates this idea well. Another way to systematize the directional lines in an image is to have them radiate from a single vantage point.

Edgar Degas used radiating lines to organize his figure in *The Misfortunes of the City of Orleans.* These lines function as a design device to organize what otherwise could have become a series of unrelated and chaotic angle directions. Through his use of radiating lines (which fall within an arc), Degas shows the movement of the figure and the expansion of the legs with one clear principle in mind. Creating the illusion of movement in a reclining figure is a difficult feat, but through his clever use of this dynamic drawing device, Degas was able to communicate the feeling of pathos in his writhing reclining figure.

ENCLOSURES

We have discussed the point and the line. Now comes the third tier of our tetraktys—the organization of lines into shape. When lines become shapes they take on a fixed form, which is easier for the eye to see. The human mind looks for recognizable shapes to create order out of a complex and often chaotic

visual world. The artist can apply this aspect of visual perception to connect various and diverse parts of a drawing together. In the lithograph *A Stag at Sharkeys,* you can see how George Wesley Bellows used very simple, easily identifiable shapes to create a strong and coherent image.

The enclosures in this image lay out the basic composition, but Bellows further directs the viewer's eye through his use of values within those enclosures. The portions of the two boxers that fall within the circular form represent the principal contrast area of the image, with the white areas of their torsos strongly contrasting with the black background. Bellows diminished the value contrast in the area that contains the umpire and the spectators to ensure that they are subdued and do not pose any competition for his principal focal point. Bellows articulated the edges of the triangular form by juxtaposing contrasting values—the shadow along the boxer's outstretched leg forms the left edge of the triangle, while the floor of the boxing ring forms its base. The apex of the triangle further reiterates the focal point of the composition. Through his masterful organization of shapes and control of value, Bellows has created multiple tiers of interest in this image.

COMBINATIONS OF LINES

It is ultimately the marriage between the straight line and the curved line that brings beauty to both life and art. The strength and order of the straight line is used for balancing the whimsical grace and elegance of the curve. They live in a symbiotic relationship, each dependent on the other. The straight line without the curve becomes monotonous and heavy-handed. The curve without the straight line looks indecisive. The balance between them provides the life

Below Left: George Wesley Bellows, *A Stag at Sharkeys,* 1917, lithograph on paper, 18 1/2 x 24 inches, A.J. Kollar Fine Paintings, LLC, Seattle, Washington

Below Right: The simple, geometric shapes that are used to organize this picture ensure that, within the many figures and dynamic action, the picture functions as a harmonious whole. Bellows has locked his fighters into a single geometric structure, entwining them together in a circle. Their heads form a corner of a square and relate to the referee and the platform. A triangle follows the fighter's leg, the armpit forms the apex, and then turns down till it rests on a spectator's head. The square helps to include the referee, who then becomes part of this entity of the two fighters.

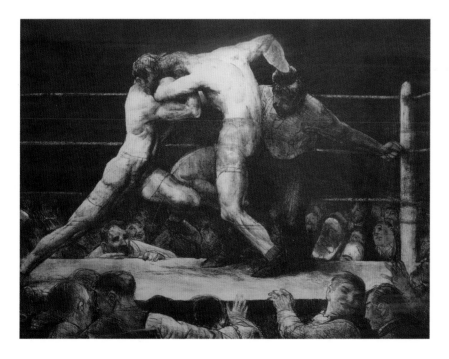

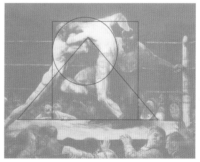

Above: The white lines highlight the horizontal directional lines. These horizontal lines are balanced by the occasional curve, such as those created by the outlines of the vases. By combining these two kinds of lines, Faigin has created a dynamic composition.

Below: Gary Faigin, *Paradigm Shift*, 2002, charcoal on paper, 22 x 30 inches

and structure of art and they cannot be separated without losing greatness. The two halves work together to create a beautiful and powerful work. As the French artist Thomas Couture (1815–1879) said, while referencing drawing from sculptures, "You may always observe in these admirable statues, that the straight line is in just relation with the curve. Is this a system? No, it is the perfect knowledge of nature."

Artists create compelling images by selecting and using the artistic devices that are best suited to their current purpose. Gary Faigin's *Paradigm Shift* repeats horizontal lines throughout the drawing, but balances them with occasional curves such as the arc of the vase on the far left. Normally the use of a landscape-format rectangle and repeating horizontal directional lines would give the work a restful, passive quality. (Imagine a quiet horizon line along a peaceful seascape.) However, in this work the residual images of the cup and the directional lines moving off to the left give the impression of an object moving at great speed. The artist plays against our expectations and gives the viewer a very charged image of still life in motion.

The Block In

Now that you have a better understanding of the aesthetic and emotional power of lines in a finished drawing, let's discuss the lines that are positioned at the earliest stages of a drawing, when the basic forms are being established. The "block in," or first sketch, indicates the placement and proportion of the image. It also offers a chance to analyze key elements within a composition and is essential for determining the visual hierarchy of the various parts. The main goal of this initial phase is to distill the multitude of line directions of the subject into a few significant lines that capture its dynamic. This distillation process gives an order and rhythm to the piece.

The beginning of a work is often the key to its success. The initial lines of the drawing form its structure and function the same way as the foundation of a house—dictating the shape and scale of the creation that will be constructed upon it. However, when blocking in a drawing, it is easy to be overwhelmed by the complexity found in nature and it takes experience to begin to sort out what is relevant from what is unnecessary. It is no wonder then that beginning students often find facing a clean, white sheet of paper somewhat daunting.

The way an artist sees the world makes the vision uniquely his, so a slave drawn by Michelangelo is transformed from a typical nude into an unmistakable Michelangelo. Part of what differentiates the drawing of one artist from that of another is the choices the artists make—what is emphasized and what is suppressed. Since many of these choices are made during the block in stage, the importance of this stage cannot be overemphasized. However, keeping a few simple goals in focus can dramatically improve your success at this stage: sketch your block in lightly, capture the essential angles, work from the general to the particular, identify the vital facts, and try to create a basic likeness.

Often the more masterful an artist is, the more cautiously and lightly he will begin a drawing. Experienced artists build up the beginning of the drawing slowly, with an eye toward accuracy, knowing that a good beginning will make the entire drawing process proceed more quickly. By contrast, beginners often etch in deep and dark lines and then quickly find themselves "finished" with the drawing, no longer knowing what to do, yet not quite happy with the outcome. They get locked into decisions that they made too early in the drawing and without enough information. To avoid these mistakes, take your time with the block in stage—and keep your initial lines light.

One of the initial goals of this stage is to summarize the work using a few simple angles. These angles will then provide an armature for the rest of the piece. Straight lines are essential during the block in because they are best suited for simplifying the complex forms of nature and capturing the general angle directions. Often it is useful to look at an internal directional line rather than an external contour, or outline, for clues to the dynamic of the subject.

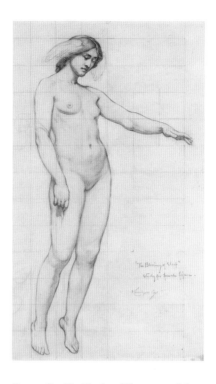

Kenyon Cox, *The Blessing of Sleep,* turn of the twentieth century, graphite on paper, 19 15/16 x 15 3/8 inches, National Academy of Design Museum, purchase of NAD students

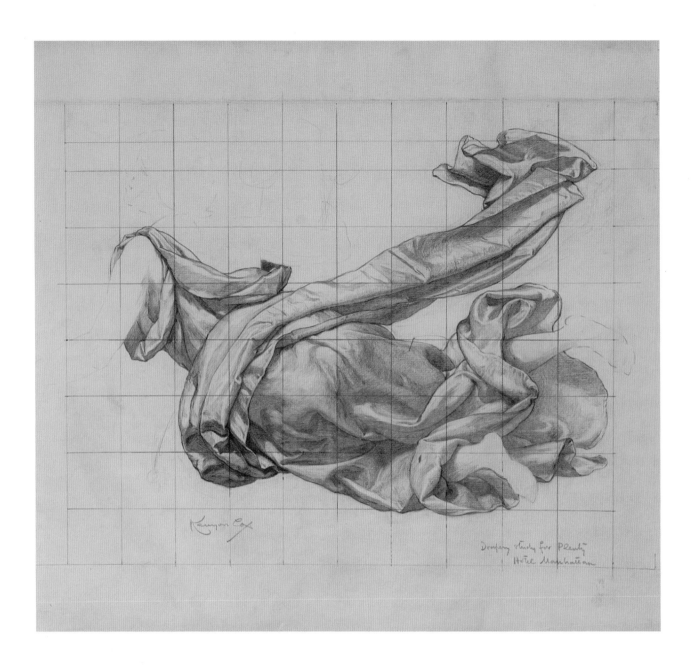

Kenyon Cox, *Drapery Study for Plenty*, circa 1897, graphite on paper, 16 x 19 15/$_{16}$ inches, National Academy of Design Museum, gift of Allyn Cox, Caroline Cox Lansing, and Leonard Cox, the Children of Kenyon Cox

This is because the contour is a rather arbitrary point that indicates little more than where the mass of the object is seen against the background. By contrast, the internal directional line can expose critical structural elements of the subject. Try to capture the essential angles of your subject with a minimal number of lines.

Daniel Parkhurst said, "All good work is from the general to the particular, from the mass to the detail. Keep that in mind as a fundamental principle of good work, whatever the kind." This is excellent advice for the block in stage of a drawing. Although there are various ways to start a drawing, a reliable way to begin is to capture the bigger shapes before moving on to the smaller ones.

This will help to establish the relationships among the various elements—and will make it easier to capture the smaller forms.

Sir Arthur Conan Doyle's character Sherlock Holmes once said: "It is of the highest importance in the art of detection to be able to recognize out of a number of facts which are incidental and which are vital." That statement could have just as easily been made about the art of drawing. The key to the power of the drawing and the pose is often hidden. It takes skill and insight to unveil the relationships that are responsible for creating the energy of the subject. The artist cannot simply pile one detail onto another, impartially recording all of the facts, regardless of their significance. Rather, she must subordinate certain aspects of the drawing to create a greater effect of the whole. The simplification process inherent in the block in stage creates a clear mission, giving the artist direction for the drawing by allowing her to arrange it according to a purpose and a particular emotional content.

Another one of the goals of the block in stage is to create a likeness of the subject—whether it be a human form or a scene from nature. If a likeness is not captured with a few lines, additional lines often will not help. To understand this principle is to comprehend that a resemblance does not lie in the small forms, but in the big ones. If I saw a blurry black-and-white photograph of a crowded scene, I could recognize a family member out of the multitude. Even if the figures had no detail or color, their shapes and gestures would contain enough broad information to make my kin recognizable and distinctive. Thus, we understand that it is not by infinite minutiae that a portrait or any other drawing gains a likeness.

As said so well by author John Berger, "Strangely, you can tell whether a likeness is [in a drawing] or not when you've never set eyes on the model or seen any other image of the model." The proof of this principle is illustrated in the work of one of the greatest portrait draftsman of all times, Hans Holbein (1497–1543). Holbein's simple line drawings contain minimal detail yet express such a unique presence that a personal likeness is conveyed even though the model is unknown to us. In the presence of Holbein's drawings, we have the feeling that if we were to walk around the court of King Henry VIII, we would be able to identify each noble who passed by just on the strength of the portraits.

The block in, or drawing composition, is one of the most crucial stages in the evolution of a drawing and it can also be one of the most enjoyable ones. During the block in the artist gets to redesign life. If two people have similar skills, their ability to create a powerful block in will separate one drawing from the other. Understanding the abstract nature of drawing is instrumental to an artist's ability to manipulate the viewer's eye and is also key for his self-expression.

Top: Annie Rosen, cast drawing of the hand of Michelangelo's *David*, 2000, charcoal on paper, 10 x 8 inches, courtesy of the Aristides Classical Atelier

Above: Annie Rosen, *Venus*, 2000, charcoal on paper, 10 x 8 inches, courtesy of the Aristides Classical Atelier

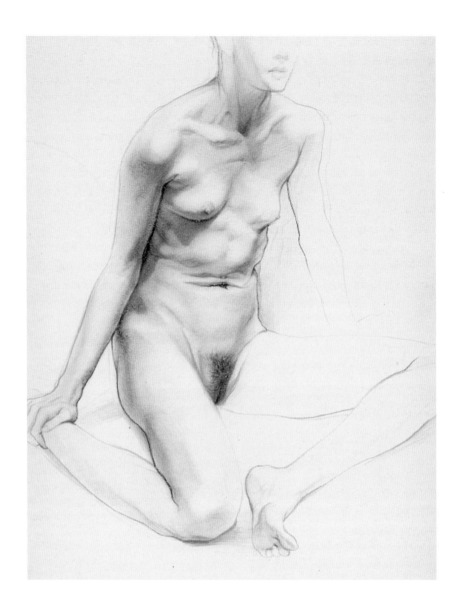

Measuring

The initial block in stage of the drawing captures the artist's highly personal, intuitive reaction to the subject. Once the block in is complete, the artist can begin to undergird this subjective rendering with the structure of objectivity through the process of measuring. Sometimes artists start their drawings with key measurements in place so that they can block in the initial forms confidently without worries about proportional difficulties. Measuring is one of the most useful tools for increasing the accuracy in a drawing regardless of the style or technique the artist uses in his work.

Measuring is also useful when a drawing is not progressing as planned and the cause of the difficulty is unknown. The artist is able to confirm or disprove his initial thoughts about the pose by using an objective tool to determine distances

and relationships. Although good measuring and faultless technique are not the end goal of a drawing in and of themselves, they are important tools in the artist's repertoire. The point of measuring is not to filter out the artist's personal vision, but to let the subject become a transparent vehicle for his vision unencumbered by unintentional proportional errors. Measuring is an excellent way for an artist to train his eye to ensure that the only distortions in a drawing are those that he deliberately created.

There are many ways of measuring. Three of the most common methods are comparative measuring, sight size measuring, and relational measuring. Comparative measuring quickly locates the relative proportions of one part of the drawing to another. Sight size measuring gives an edge to seeing value relationships. And relational measuring interweaves forms, ensuring that all parts are structurally connected to each other. It is a good idea to be familiar with all three methods, though you will probably end up favoring one.

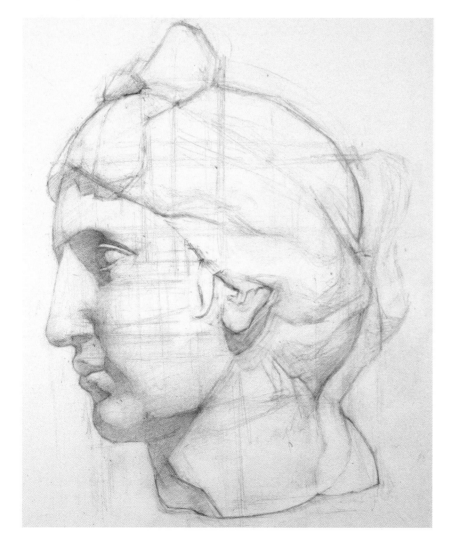

Joshua Langstaff, cast drawing of the head of the *Callipygian Venus,* 2006, graphite on paper, 14 x 12 inches, courtesy of the Aristides Classical Atelier

With comparative measuring, the artist determines the length or width of an object and sights it against another object to determine the relative size relationships. For example, if he determines that the model is two head lengths long from the chin to the navel, he can then see if his drawing has that same proportion. This method of measuring works extremely well and is accurate for larger relationships.

Generally, the artist measures with a straight stick, such as a thin knitting needle or a wooden skewer. While holding the stick out directly in front of him and keeping his arm very straight, the artist closes one eye, examines one area of his subject (such as the head), and uses his thumb to mark the measurement on the skewer. Keeping his arm outstretched, eye squinted, and thumb in position,

Right: Ginette Chalifoux, copy after Leonardo da Vinci's *Study of a Head* (detail), 2005, ink on tinted watercolor paper, 12 x 14 inches, courtesy of the Aristedes Classical Atelier. With relational measuring critical points within each line are coordinated with other points. Da Vinci used this technique in his original drawing to confirm the location of nose in relation to the eyes, mouth, chin, and neck.

the artist then moves the skewer down to the next area he wants to examine and sees how the two compare in size. Next, the artist takes his skewer and uses it to measure the same elements in his drawing—first the initial area of the subject (such as the head) and then the area to which he wants to compare it. By comparing the answer he got from life with the answer that appears in his drawing, he can identify any discrepancies and make any necessary adjustments.

With sight size measuring, the drawing can be either the exact same size as the object or the size that the artist sees the object. As illustrated in the diagram to the right, the cast and the paper are set up at eye level to the standing artist. The artist stands back to look at the object and the drawing and then walks up to the paper to draw. He must remember what he saw and draw it without referencing the object (because the object seen up close is an entirely different view than the one seen from the position where he stands to view the setup). By standing back three times the height of the object to view the object and the drawing, the artist can very easily compare the two and see what is different. When he is standing back, he faces the middle of the setup—that is, equal distances between the cast and the drawing.

With sight size measuring it is important to keep the setup stationary because measurements are taken directly from the object. If the setup moves, it will no longer be an accurate source from which to measure. The artist will measure, using a plumb line and skewer, until he is sure of the accuracy of the drawing. Then he will render the object in charcoal and compare the rendering with the original object for value considerations.

With relational measuring, the artist coordinates critical points within each line with other points to confirm their location. This process carefully locks each element into place by orienting its relationship to other key elements. For example, in the drawing on the facing page, da Vinci wanted to lock in the location of the nose, so he drew a line indicating the underside of the nose that carries all the way across to see where it hits on the ear. From each side of the nose he extended a line up to see where it hits the eyes and down to where it intersects the mouth, chin, and neck. These lines helped him determine the positioning of the nose in relation to the other features; other lines confirmed the position of the remaining features. In this way da Vinci was able to ensure each part of the drawing was oriented in relation to every other part.

There are pros and cons to all three methods of measuring. The strength of comparative measurement is that it gives the artist a lot of control over what he chooses to emphasize in his drawing. He is not bound to the original subject, but can design his drawing separately from the subject. He can also quickly place a few key markers from which to work, which will ensure the accuracy of the whole drawing and enable him to continue with greater confidence. The weakness of comparative measuring is that the measurements obtained this way

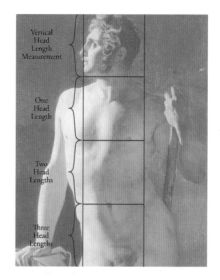

Top: In comparative measuring, any increment can be chosen and measured into the whole to check for accuracy. A common measuring device for drawing the figure is to check head lengths, because they often reveal landmarks. This diagram shows the torso subdivided into three head lengths—one head length to the nipples, two to the navel, and three to the pubis.

Above: This diagram represents a sight size setup viewed from above. The footprints show the placement of the artist. The line coming from the feet shows the walking path of the artist. The circle represents the cast and on the same plane is the drawing board of the artist. (If the artist is right-handed, the paper should be on the right side and the cast on the left.) The light is shown hitting the paper and the cast. The artist stands at the footprints to look at the cast and the drawing and walks up to the paper to draw. It becomes easy to compare the object with the drawing when they are side by side. Notice that the artist is a significant distance from the setup. This ensures that the whole ensemble can be easily seen without distortion.

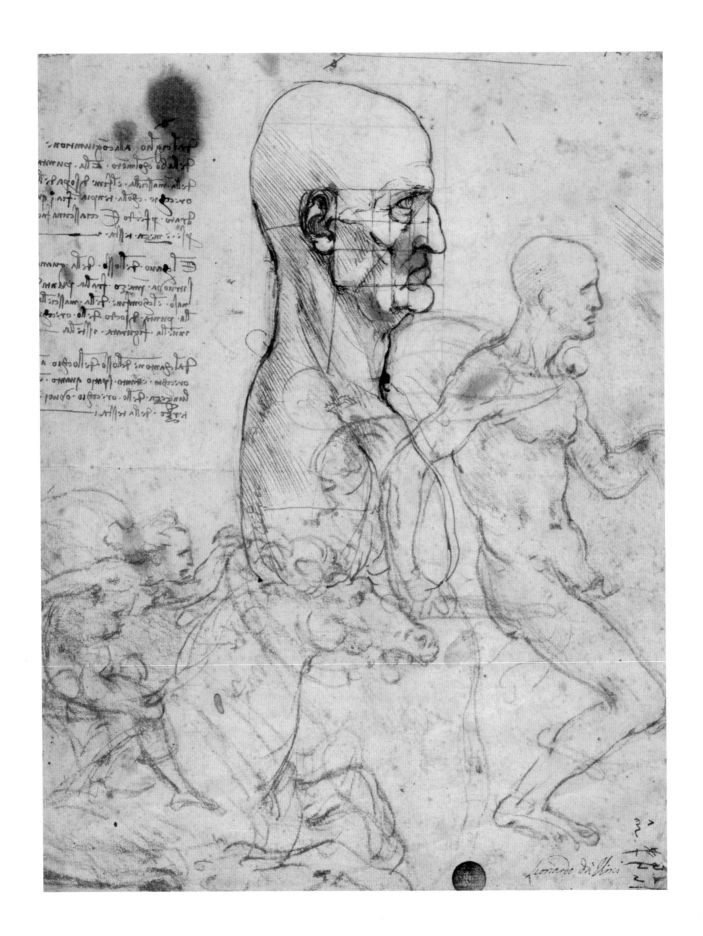

can give a false sense of accuracy. Some measurements are so small that there is no margin for error. If the artist isn't careful and accidentally bends his elbow or tips his hand during the measuring process, he could render the measurements inaccurate without knowing it. Also, if he isn't watchful, the repetition of vertical and horizontal relationships can have a stifling effect on the gesture.

The advantage of sight size measurement is that it is excellent for comparing value and, when applicable, color. Because the object being rendered is sitting right next to the artist's rendition, even an untrained eye can see the differences. These obvious discrepancies become easy to identify and fix, which helps train the eye to become very accurate and see small changes that need to be made to increase the likeness. The limitation of the sight size method is that it is less useful than comparative measuring for design and is less suited to turning form in a precise, sculptural way. Also it is much harder to deviate from nature, which leaves much less room for individual interpretation and self-expression. Rather, the effect rendered is a big wash of value—something seen as a whole, all at once, and as a result is more atmospheric in its use of value. Artists tend to use sight size measurement when they want to make a very literal transcription of the objects they are viewing.

The advantage of relational measuring is that it gives the artist much structural information about the subject. This is a more intellectual than optical way to draw. He becomes aware of the patterns and relationships that exist within the subject and gains an intimate understanding of what he is drawing. The artist

Below: Francisco José de Goya y Lucientes, *And There Is No Remedy* (detail), plate 15 from the *Disaster of War* series, early nineteenth century, etching and aquatint on paper, 5 1/2 x 6 3/4 inches, A.J. Kollar Fine Paintings, LLC, Seattle, Washington

Opposite: Leonardo da Vinci, *Studies of Human Physiognomy,* late fifteenth–early sixteenth century, pen, ink, and red chalk on paper, 11 x 8 3/4 inches, Accademia, Venice, Italy

Above: Mark Kang O'Higgins, *Emma*, 2000, graphite on card stock, 3 x 2¹/₂ inches

Opposite: Gary Faigin, *Emergence*, 2003, charcoal on paper, 46 x 60 inches

can then use this knowledge to abstract his work, repeating or distorting the structural lines to suit his design needs. This secret underlying grid of lines provides a very well thought-through foundation where each part is woven into the whole. This method is the least effective of the three for creating proportional accuracy. It only measures certain types of relationships and if the artist misses any points in the web of relationships, the drawing can end up disproportionate. For example, the artist can interconnect all the features by accurately capturing the angle directions, yet the distances between them can be off. I normally combine this method with comparative measuring to ensure that this doesn't happen.

Artists tend to use the measuring system that they were trained in. However, all give excellent results. Comparative measuring and relational measuring favor a conceptualized manner of drawing that tends to be more dynamic and structural than sight size measuring, which is more optical. One could think of the approaches advocated by George B. Bridgman, Burne Hogarth, Andrew Loomis, and Gottfried Bammes, who all wrote instructional books using these methods of drawing. The sight size technique enables great accuracy in naturalistic drawing and painting. Its strength is in directly transcribing value and, when applicable, color shapes that give the illusion of nature. It is impressionistic in the sense that it only references what the eye sees. Ultimately, it is a matter of personal taste and each artist must find the method that works for him and is in keeping with the art that he wants to produce.

Mastering measuring skills is an important step in becoming an artist. However, measuring itself points to a larger skill that is even more essential—being able to self-critique one's work. Self-critique is crucial because the artist who lacks the ability to see his work from a new perspective lacks room for improvement and unwittingly fosters artistic stagnation. Some tricks that artists commonly use to see their work in a fresh way include looking at it in a mirror, viewing it from different locations (such as from a distance), soliciting input from peers, or putting it aside and viewing it anew after some time has passed. As each person develops as an artist, he discovers the self-critique methods that work best for him.

This completes our discussion of line, but before we move on let's think back for a moment to the symbol of the tetraktys. The second tier (the two points) suggests a line direction. This lead us into a discussion of design and the philosophical underpinnings of line and to an introduction of the first stage of making a drawing—the block in. The additional point on the third tier of the tetraktys organizes our lines into shapes. These shapes describe representational objects that must be correctly drawn to convey meaning. This leads us into discussions on how enclosures and measuring systems can be used to accurately organize and convey our shapes. The last leg of the tetraktys, the four points, represents the third dimension. This leads us to the content of the next two chapters—discussions of value and form.

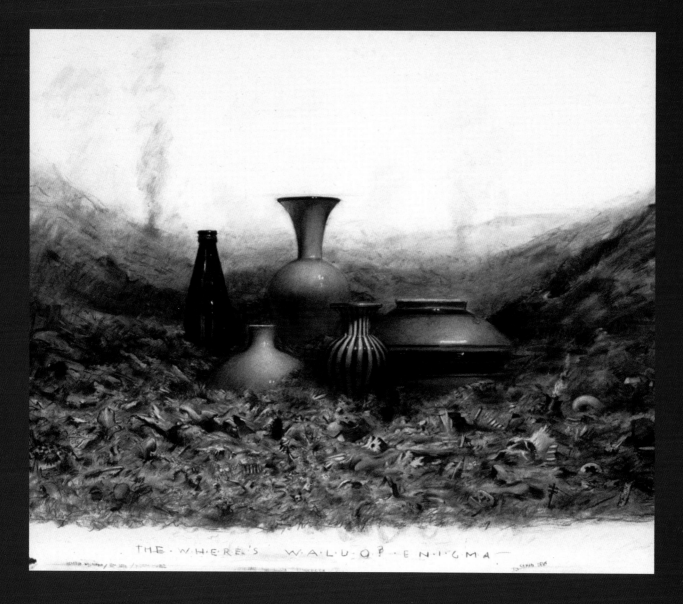

THE · WHERE'S WALDO? · ENIGMA

"*Exceptional drawings are the record of an artist's most unencumbered response to the world. All great drawings share a sense of vivid engagement with the subject seen or imagined. Drawings connect observation with conception and vision to inspiration. Great drawings are often astonishing in their degree of energy and spontaneity (Rembrandt comes to mind), but spontaneity is not required. The nature studies of Albrecht Dürer are anything but spontaneous, but they thrill us with the clarity and the intensity of the artist's vision. Both Rembrandt and Dürer combined an exceptional level of skill with a predetermined idea of what it was they wanted to express. The artists' ability to use the most humble means of expression to communicate a compelling idea or emotion distinguishes great drawings from ordinary ones. Without skill, great ideas can go for naught; without ideas, great skill can go unappreciated.*"

— GARY FAIGIN

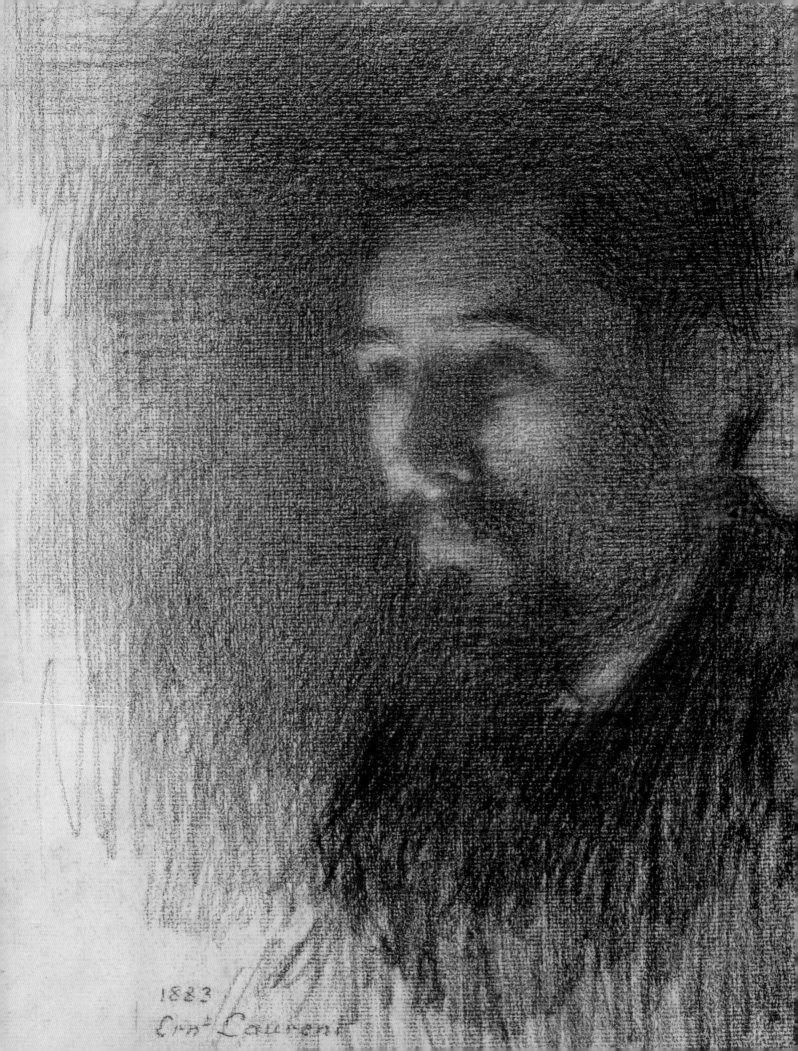

1883

Crlt Laurent

VALUE

The World in Black and White

"*If you, who draw, desire to study well and to good purpose, always go slowly to work in your drawings; and discriminate in the lights, which have the highest degree of brightness, and to what extent and likewise in the shadow, which are those that are darker than the others and in what way they intermingle. And when you have thus schooled your hand and your judgment by such diligence, you will acquire rapidity before you are aware.*" — LEONARDO DA VINCI (from *The Notebooks of Leonardo da Vinci*)

The previous two chapters have dissected different facets of design and line with the aim of understanding how each element contributes to the process of drawing as a whole. Now let's move on to a study of value. Just as line has an abstract quality that can be applied to representational ends, there is an aspect to value that functions as pure pattern divorced from any kind of realism. One can imagine a Persian carpet with lots of value change but no representation. By separating value into the two (nonrepresentational) categories of pattern and light and dark we can examine its compositional and emotional aspects and consider how these can be used in the art of drawing. Later, in chapter five, we will see how value can be used in its third (largely representational) role—to create volume.

Opposite: Ernest J. Laurent, *Georges Seurat*, 1883, pencil on paper, 15 5/8 x 11 1/2 inches, Louvre, Paris, France

Photo Credit: Réunion des Musée Nationaux / Art Resource

Perception in Life and Art

If life were completely chaotic and unpredictable—so that sometimes the plate we dropped fell up rather than down, or water on the stove froze instead of boiling, or the chair we were sitting on suddenly disappeared—our confidence would be rattled. It would be impossible to function in a world so erratic because this world could not be understood through the intellect. Thankfully, the world we inhabit has many logical and predictable patterns that combine to provide a necessary structure. As a result, we not only function but can flourish in this world, anticipating the effects that will be caused by our actions and tailoring our activities to help us achieve our end goals.

Art, mirroring life, is composed of principles and relationships that, when applied consistently, create a structure that conveys the feeling of truth or reality in design. A work of art does not necessarily have to abide by all the laws of physics to be believable, but it must be consistent to its own laws, because the

 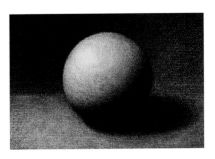

Above Left: This is a light value sphere arrangement in which the shadow shape and cast shadow separate from the background. The darks form the smallest area of the drawing and thus become a focal point. The local tone of the sphere dissolves into the background creating a sense of atmosphere. The lost edge would appear in the light side of the form rather than in the shadow or core shadow area. Drawings by Nancy Engstrom

Above Middle: In this midtone value arrangement the sphere is significantly lighter than the background. The background is slightly lighter behind the shadow side, and darker next to the lit side of the sphere. The lost edge between the sphere and the background falls in the halftone area.

Above Right: In this dark value arrangement the dark background puts the sphere in high relief. The background merges with the sphere all the way from the core shadow back into the cast shadow. The halftones are generally lighter than the background and the lost edges are pushed back. The light shape becomes the clear focal point as it is the area of highest contrast and the shape is easier for the eye to apprehend than the surrounding areas.

viewer will suspend his disbelief only until he senses inconsistency. For example, an audience can believe a science-fiction film, no matter how far-fetched, until it starts violating its own rules. When a fantasy story becomes inconsistent with its own reality, it suddenly feels unbelievable. Within a work of art, creating consistent relationships that mirror the viewer's own life experience is essential.

Our experience of life is accumulated through the five senses, and all sense-based knowledge is derived by our ability to discern differences. If we always existed in an environment of complete darkness and silence, with nothing to stimulate our sense of touch, taste, or smell, then we would have no contextual basis for perception of any kind. The juxtapositions of various sights, sounds, touches, tastes, and smells provide us with valuable information about our world that help to define our perception of life. For example, we understand pleasure because we have pain, hardness is defined by its contrast with softness, heat exists in relation to cold, and so on. These comparisons not only form the framework of how we perceive life, they are also the essence of art—because without difference there would be complete uniformity and, hence, nothing to draw.

It has often been said that light is the true subject of art, because without light we would not be able to perceive differences between objects—or indeed many of the essential qualities of the objects themselves. Light is necessary for us to maneuver in the world. The gradations between light and shadow fully reveal form and give us depth of space. Light and shadow help us determine how deep a step is so we do not fall and how much girth an object has so we can grasp it successfully. Variations in light and shadow allow us to figure out whether something is receding or advancing. Everything that is visible is revealed to the eye because of the light that bounces off the surface of the form. Light is the first element necessary for the creation of difference and thus the most important factor in the creation of visual art. The interplay between darkness and light is the keystone of realism in art and is worthy of much study on the part of the artist.

The Structural and Emotional Uses of Value
In terms of art, discussions of light and darkness most often fall under the broad heading of value. Value is the range of tones from black to white that underlie an image. (Think of the different gradations found in a black-and-white

photograph.) The concepts of value apply even when an image is in color. Because value gives viewers much of the information they need to know about the subject, drawing owes much of its power, structure, mass, and volume to careful consideration of value.

One of the fundamental aspects of a piece of art is communication—forming a bridge between the artist and the viewer via the visual and emotional information generated by the artwork. Light and dark not only convey the mood of a piece but also describe for the viewer what kind of light is hitting the subject, where that light is coming from, and how the surface topography of the object is unique. In addition, value presents the viewer with patterns of light that convey

Susan Hauptman, *Self-portrait in Coitus*, 1998, charcoal and pastel on paper, 54 x 38 inches, courtesy of Forum Gallery

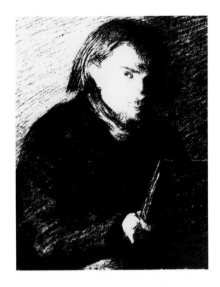

Above: In this diagram of Fantin-Latour's self-portrait, the value scheme is simplified into flat shapes to reveal how much the image is dependent on the pattern formed by the large simple masses of tone.

Opposite: Henri Fantin-Latour, *Self-portrait,* 1860, charcoal on paper, Louvre, Paris, France

Photo Credit: Réunion des Musées Nationaux / Art Resource, NY

Simultaneous contrast reveals how one value can give the appearance of being multiple tones. In this value step scale, a single midtone appears to be lighter when surrounded by dark, and darker when surrounded by lights.

the depth of space through the relationship of one value to another. Often a work that has a beautiful use of value will appear finished and completely satisfying even when no color has been added. Because so much information is conveyed through value, it is clearly one of the most important subjects to which students can give their attention. On a fundamental level, value is responsible for establishing the basic characteristics of a work of art—including its organizational structure and its emotional tenor.

VALUE IN COMPOSITION

One of the primary functions of value in a work of art is to form a pattern of light and shadow, called the "value composition." The value composition is comprised of large, flat (unvaried) areas of value that form a simplified version of the finished piece. In searching for the perfect arrangement of tones, artists do not just copy the values found in nature, they consciously organize these values to their best advantage. The artist's job is to create a powerful abstract foundation of values on which to build his work of art. One reason why artists often create small preliminary sketches in preparation for a larger work is so they can examine how the values and shapes work together without the distraction of smaller details. In order for a work of art to communicate with breadth and power, this underlying value composition must be considered just as carefully as all of the smaller variations of value considered later in the drawing process.

A simple, powerful composition of limited tones is often more effective and more difficult to attain than a complex composition that has a large number of values but no unifying pattern. One tone can read a number of different ways, depending on what it is placed against. For example, a midvalue gray will appear light when placed next to black, and will appear dark when placed next to a lighter tone. An important tool that aids artists in the quest for effective composition is the principle of simultaneous contrast. This principle is based on the concept that the careful positioning of a limited number of tones in a composition can create maximum effect and the illusion of variety.

By composing every aspect of a picture—from the flow of lines to the distribution of lights and darks within the rectangular frame—an artist can elevate a drawing from a sketch into the category of high art. Master draftsmen create unity by limiting value differences and applying simultaneous contrast rather than infinite actual changes. They choose simplicity by careful placement of tones, knowing that more is not always better. Understanding these principles can transform the marks of burnt sticks of wood on paper into a powerful vehicle for self-expression.

VALUE AND MOOD

In addition to helping to create a strong composition, the tonal arrangement in a work also dictates its mood. Even if the value scheme in a work is presented as a completely abstract pattern, with nothing representational, the eye is still

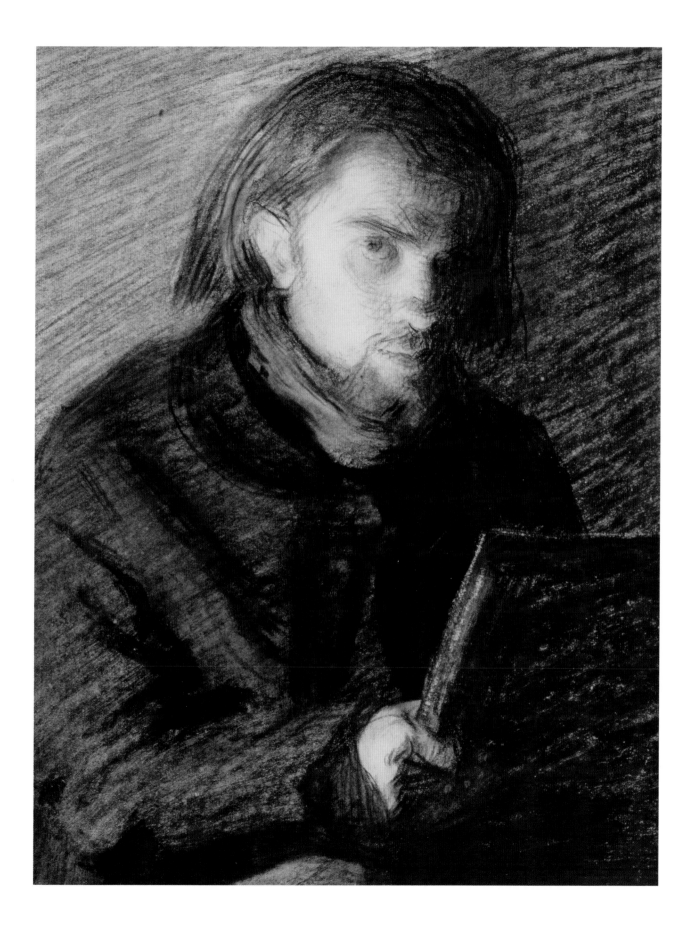

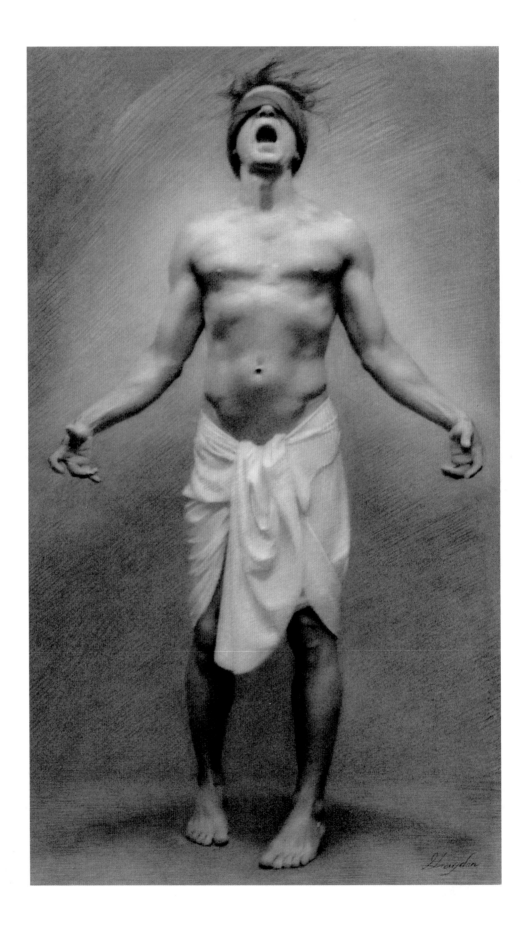

drawn to certain key areas that convey a certain emotional tenor. Three distinct moods can be created by different value schemes. I call these "night," "dawn," and "midday." Each value scheme results in a different atmosphere and emphasis dictated solely by the relationship of the values to one another.

The night scheme is a series of value arrangements taken from the darker end of the value step scale. (See page 65 for a complete discussion of this scale and how it is used in drawing.) If white on the value step scale is represented by the number 1 and black by the number 9, then the dark tones might be visualized as ranging from 7 to 9. This close-knit series of dark tones is normally punctuated with a light principal focal area. Imagine a painting of a beach at night with people sitting around a fire pit, the fire illuminating a few key faces. The majority of the composition (the water, the sky, and the beach) would be dark, and the spark of life would come from a few well-placed moments of light. This value arrangement may also be referred to as a light figure on a dark ground. The emotional content conveyed by the night value scheme is one of strong drama, mystery, and melancholy—a Baroque palette. The world created

Below: Juliette Aristides, *Mary Reclining*, 2000, sepia pencil and charcoal on paper, 16 x 18 inches, private collection

Opposite: Graydon Parrish, *Tragedy*, 2002, charcoal and white chalk on light blue paper, 24 3/4 x 15 1/4 inches, collection of Lloyd and Renee Greif, courtesy of Hirschl & Adler Gallery

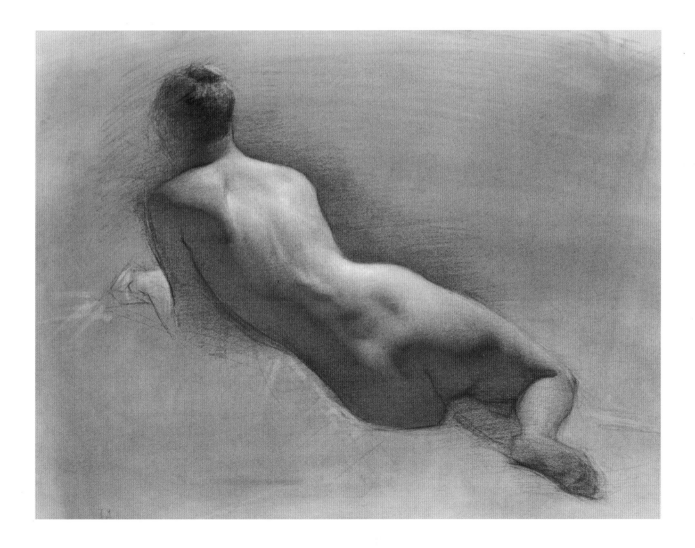

is one of shadows and ambiguity. Earnest J. Laurent's portrait of Georges Seurat, which appears on page 52, is an excellent example of a night scheme.

The dawn scheme is a series of value relationships taken from the lighter end of the value step scale, roughly between 1 and 4, and is more in keeping with what we think of as a light-filled, or "high key," Impressionistic palette. A drawing with a dawn scheme would be punctuated by a well-placed dark value as its focal point. Imagine the same beach from the example above now viewed in a misty morning with a milky white sky, pale sand, and light gray water. Two figures in dark sweaters walk along the beach, interrupting the uniformity of the value scheme and thus becoming the focal point of the piece. This value scheme could also be referred to as a dark figure on a light ground. The emotional content conveyed by this arrangement of values is one of light, space, and air. It is more serene and playful and is less ponderous in its mood than its dark counterpart. The dawn value scheme is superbly demonstrated in Jeffrey Mims's *Head Study 1*, which appears on page 71.

The midday value scheme is characterized by an almost equal distribution of both the dark and light ends of the value step scale, going from 1 all the way to 9. We can picture the sun shining down in full force onto our beach. The bathers and their gear are hit by strong light and cast dark shadows onto the ground. The eye beholding this scene would flit across the surface, being drawn successively to each strong contrast as it appears. The mood described by this work is one of clarity and illumination. Nothing is hidden or concealed;

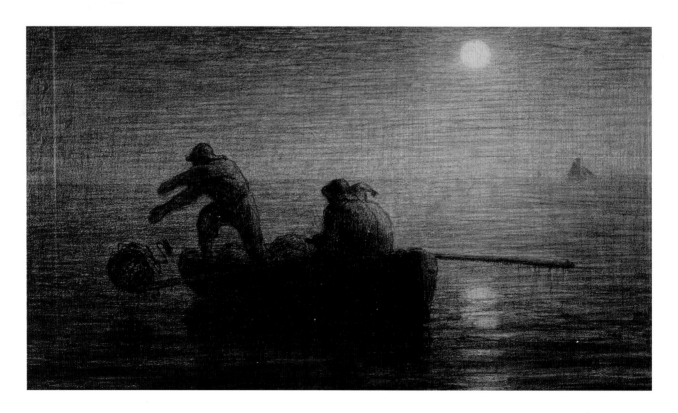

everything is laid bare before the eyes of the viewer. The work communicates a starkness and guilelessness as each element is perfectly lit, revealing everything to the watching world. Anthony Ryder's *Light Study*, which appears on page 72, demonstrates how the midday value scheme can be used to wonderful effect.

Separating the values into these three categories provides an important model and helps the artist use value thematically and emotionally to her advantage. However, in truth, these categories really are a codification of an organic process that oftentimes defy such cut-and-dried classification. Once an artist has internalized this idea, he can deviate from these groupings. With art, as with many things, one must know the rules before one breaks them.

Hierarchy in Composition

The art theorist and writer André L'Hote said, "Exaggeration, diminution, and suppression are the three operations which the artist must constantly practice whether it is a matter of lines, values, colors, or surfaces." Artists need to develop the ability to order visual differences into significant patterns and relationships. By determining what he wishes to express, the artist orchestrates the whole image to commemorate one moment. We might call this process the creation of a visual hierarchy.

Visual hierarchy is important because it mirrors the way our eyes see nature. We take in the whole picture but can only focus on one part at a time. When you are at a market, you might focus on one apple even though you are surrounded by thousands of objects designed to catch your eye. When talking to another person, it is very difficult and uncomfortable to keep his whole face in focus at the same time. One's eyes travel from the other person's eyes, to his mouth, and up to the nose. We superimpose a hierarchy of significance wherever we go and whatever we look at because our eyes are designed to seek order.

Another principle used to organize information and establish significant patterns is the use of theme and variation, which can be captured in both line and value. When an artist senses a strong dynamic in a subject he is viewing, he starts to capture it by limiting the angle directions. He will choose a strong line direction and try to find as many places as possible where it can be repeated in order to create a theme and suppress any unnecessary angles that do not aid his vision. You might think of this as pruning a tree, removing all the extraneous branches to encourage growth and help the overall aesthetic of the plant.

When tones are organized into undulating patterns of lights and darks, they guide the viewer's eyes across the surface of the picture. So, once the artist has established his overarching theme with line, he can concentrate on communicating his larger vision through value. A number of different strategies can be employed to create this effect. One way to organize values is to create a vignette, which is a gradual fading of value intensity toward the edges of the picture.

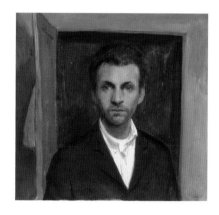

Above: Bo Bartlett, *Bo Self-portrait*, 2004, gouache on paper, 24 x 24 inches

Opposite: Jean Francois Millet, *The Lobster Fisherman Throwing Their Traps, Night Effect*, 1857–1860, black pencil on paper, 12 5/8 x 19 3/8 inches. Louvre, Paris, France

Photo Credit: Réunion des Musées Nationaux / Art Resource, NY

Right: Carlos Madrid, *Star Gazer,* 2002, charcoal on paper, 46 x 34 inches

Opposite: David Linn, *The Path,* 2004, charcoal and graphite on bristol, 15 x 15 ½ inches, courtesy of Frey Norris Gallery

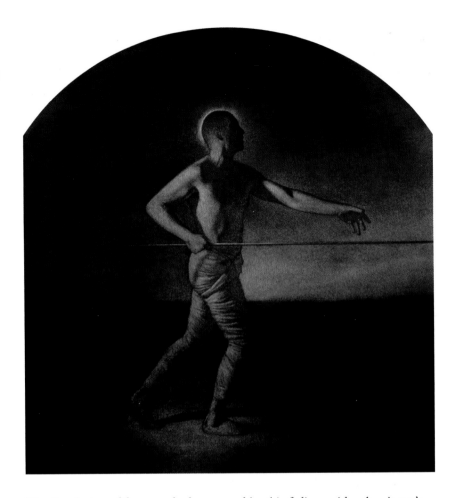

The dissolution of forms and edges caused by this fading guides the viewer's eyes into the center of the picture. Another system is to congregate the darkest darks toward the edge of the picture, which helps create luminosity—as the drawing will mimic the flame of a candle or the sun, both of which have indistinct edges that are softened by a flood of light. A third method is to continuously counterchange between darks and lights. For example, the light of a background might come up against the dark of a model's hair, which frames the light side of the face, which is next to the shadow side, and so on. A final technique is to organize the whole picture around one moment, where the area that juxtaposes the lightest and darkest values becomes the focal point and the rest of the picture is the supporting cast. The tools for creating a significant and compelling abstract pattern as a substructure of a drawing are many and varied—and are limited only by the temperament and inclination of the artist employing them.

Visual Unity in Values

A major struggle for representational artists is how to preserve the bigness of vision while trying to bring the drawing to a finish. As the artist zooms in on the small forms, the big picture can disappear. One of the reasons to do master copies or cast drawings is to see how master artists have handled this issue. The

painter Jean-Auguste-Dominique Ingres himself said, "Nothing is more difficult than to combine this attention, these details, with what is called the broad manner." However, that big vision is an essential part of having a work feel time-less, relevant outside of the narrow gap in space and time when it was created.

This concept can be observed when we look at ourselves in the mirror. We cannot look at an individual feature (such as our nose) and see our whole self at the same moment. When we try to focus on the feature, the face fades away, and when we try to focus on the face, the feature disappears. The successful composition must convey the effect of something seen at a glance and reconcile that truth with the essential details of form that only reveal themselves through patient observation. Good drawings have a unity that comes from a delicate balance between the abstract elements of the picture-making process and the specific details that characterize the unique aspects of individual objects. Great art is the reconciliation of a paradox of generality and detail.

One way the master artists of previous eras achieved simplicity in their work was to squint—and then render the simplified values that they saw in their drawing. By squinting, the artist can apprehend the impression of a subject seen as a whole and thus offset the tunnel vision that often accompanies pro-longed study of a subject. Squinting subordinates all of the extraneous details into bigger value relationships, allowing a greater breadth of visual understanding. Squinting also eliminates all of the smaller changes in value, grouping them into a larger context with the bigger surrounding shapes. Looking at a subject in a black mirror (which has a black reflective surface) or with a camera obscura (which is a darkened box equipped with a lens that allows an outside image to be reflected onto a surface such as a piece of frosted glass, albeit not precisely) has the same effect.

There has been a shift in contemporary realism away from the visual unity in values found in most masterworks. Masters of the past had a breadth of vision and were able to unite their values, thereby creating compelling compositions. Artists today belong to a culture that has become visually desensitized and as a result are used to looking at visual chaos. Contemporary realist artists are adept at making things look three-dimensional. However, when every object is ren-dered in infinite detail, with no value organization, the work can end up having a mechanical, photographic uniformity. In order to regain some of the language of picture making achieved by past masters, we have to strike a balance between the desire to achieve a breathtaking realism and the willingness to subordinate single objects into larger abstract patterns for the sake of the whole image.

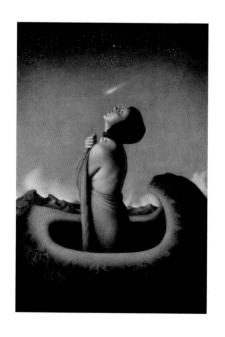

Simplifying Light and Shadow

Value has numerous aspects, and, like many things, it can be more easily understood when these aspects are broken up and studied individually. We have discussed the abstract qualities of value. In the next chapter we will examine

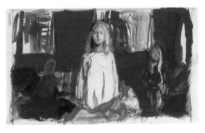

Top: Henri Fantin-Latour, *Odalisque*, late
nineteenth century, lithograph on paper,
10 x 8 inches, A.J. Kollar Fine Paintings, LLC,
Seattle, Washington

Above: Bo Bartlett, *Untitled*, 2005, gouache on
paper, 22 1/2 x 30 inches

the three-dimensional component of value—how it is used to create the illusion of volume. So now let's look at how value can represent light and shadow in two-dimensional representation. Like the block in stage of a drawing, where the lines form shapes that describe a subject, value can capture patterns that convey both the subject and its light source.

Artists are able to separate the light and dark areas of their subject, and then define these areas into particular shapes, using what is called "the core shadow." The core shadow is the line that distinguishes between the lights and the darks. This line shifts and weaves over every surface change on an object, revealing where the light stops and the shadow begins. It is also referred to as a "terminator line." In the nineteenth century, the core shadow was named a "bedbug line," giving us a peek into the living conditions of art students who knew all too well that bedbugs hated the light and would scurry along the edge of the shadows.

If you look carefully at a shadow, you will see it is not one flat value but many shades of light and dark. However, artists often draw shadows in a simplified way. Simplification is necessary in order to balance the infinite nuances that are found in the halftones and lights. If lights in the shadows were not subordinated, the drawing would be at risk of dissolving into minutiae when halftones are rendered. Downplaying the lights within a shadow gives it the illusion of transparency and unity. The shadows are meant to recede in order to contrast against the light.

Shadows in drawings should be rendered close in value so that they read to our eyes as shadows do in actual life—transparent, vaporous, and insubstantial. They are there to reveal and lend substance to the light. When we see something in an instant we do not look into the shadows but rather at the lit forms. In a drawing, it is important to respect that sameness of value relationships in order to have those values function as the eye sees them. You can put as much information in the shadows as you wish as long as the value range stays within a close range and mirrors this twilight world.

Larger divisions of light and shadow help the viewer get a sense for the direction of the light and create a strong graphic image. However, these strong divisions of light will not convey weight and volume. To understand how a drawing can have strong values yet lack form, imagine the characters on a playing card—there is black and white yet no sense of depth. The illusion of three-dimensionality is the domain of the halftones, that small band of values that bridge the shadow and the light. The area between the core shadow and the local tone of the object is filled with small gradations of value as they turn from dark to light. (The local tone, which is also called the "average tone," is the tone of an object that appears in a middle light situation.) These halftones are almost single-handedly responsible for the illusion of form on an object.

Classic Order of Light

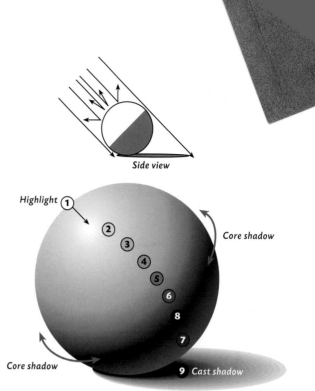

Light

White

1. Highlight
2. Light light (center light, the halo surrounding the highlight.)
3. Middle light (local value)
4. Dark light

Middle

5. Light halftone
6. Dark halftone

Shadow

7. Light shadow
8. Middle shadow (bedbug line, the core shadow)

Black

9. Dark shadow (cast shadow)

Copyright © 2001 Juliette Aristedes/Mike Kloepfer

Side view

Highlight ①

Core shadow

Core shadow

9 Cast shadow

Nature presents an almost limitless number of values. These values cannot possibly be described with an artist's tools. Artists can approach the darkness found in nature with black charcoal, but white chalk or paint cannot come close to representing the glow of light emanating from a light source. Because of the limitations imposed by these tools, the artist is forced to condense the value range found in nature. To help promote unity in the work, it is far better to have a few well-placed values than it is to have lots of arbitrary, unrelated values. Simultaneous contrast should enable a single value to appear lighter or darker by comparison to the value it is placed against, thus extending the feeling of even a very limited value range.

The light and shadow shapes created during this process form masses that serve almost like continents on a map. This helps cement a drawing into a tangible reality and provides the artist with important ways to cross-check the accuracy in his work. Rather than use the linear measuring techniques discussed in chapter three, at this stage the artist can correct these continents of value by flicking his eye back and forth from his drawing to the set up to determine how the shapes are different from one another. To continue this analogy, drawing the core shadow is equivalent to creating the coastline; it articulates the unique character of the land mass by providing a major division between light and shadow. As important as it is to have a simplified shadow shape, it is key to create a core shadow shape that is specific and nuanced. This sets the stage for form drawing, which will be discussed in the next chapter.

There could be an infinite number of value shifts in the progression from white to black. However, it is easy for our mind to conceptualize and for our eye to clearly distinguish the way light hits form by simplifying it into nine steps, which is why the nine-value step scale is so useful to artists. Here the values on the scale correspond to the values seen in a simple image of light falling across a sphere. The light-range values of the scale form the white highlight as well as the light areas in the sphere. The midrange values form the halftones. The dark end forms the core shadow, reflected light, the shadows, and the dark accent under the sphere. Because it breaks down the infinite number of values into clearly defined lights, halftones, and shadows, the value step scale is a tremendously useful drawing tool.

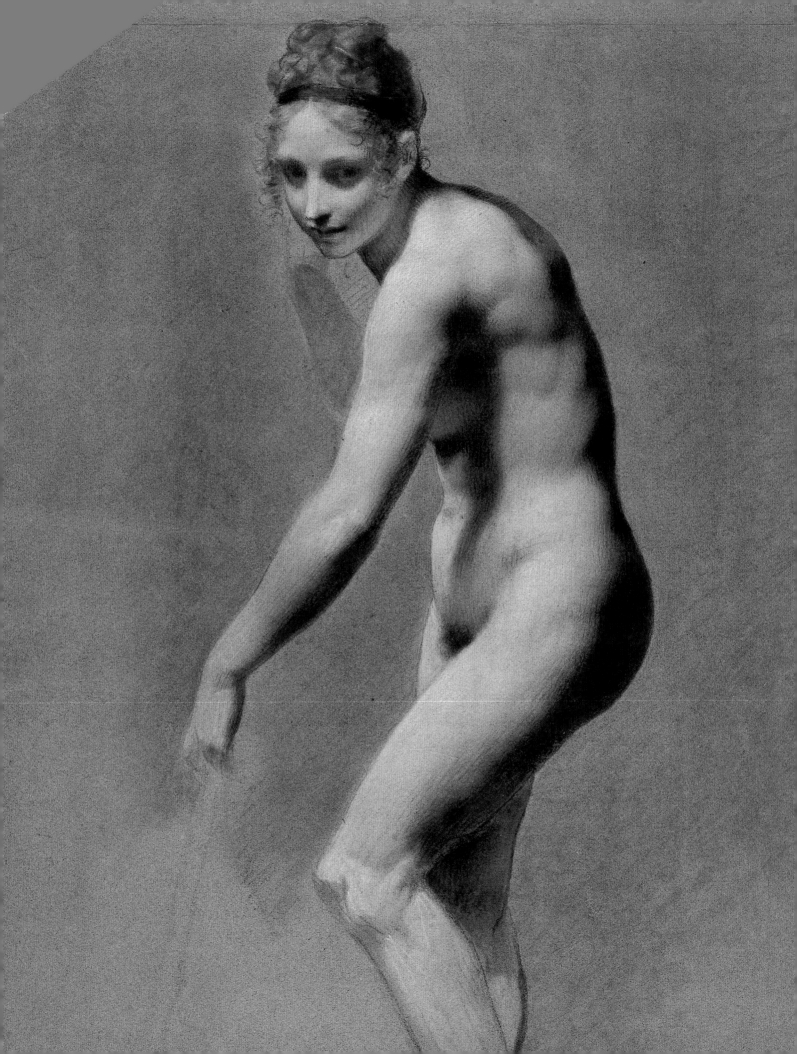

FORM

The Third Dimension

"The long and painful interaction between ideal form remembered and natural appearances observed is the foundation of all great drawings, from Michelangelo to Degas." — KENNETH CLARK (from *The Nude*)

In the previous chapter we looked at the ability of value to create pattern and mood separate from pictorial representation. We followed the tetraktys from the creation of a point, line, and plane. Now we will finish the pyramid with a discussion of the third dimension and how light and dark generate illusion of volume. This chapter focuses on the characteristics of form—its philosophical undercurrent and how to manifest it in drawing. The creation of form is linked to an objective reality and deeply rooted to observed nature. Joseph Conrad said that "there is not a palace of splendor or a dark corner of the earth that does not deserve, if only, a passing glance of wonder and pity." Turning form is the domain of this passing glance, capturing the transitory but actual existence of each place or living creature or thing.

Understanding Form

Creating form, or the illusion of three-dimensionality, is of great importance for the representational artist. The hope of the realist artist is that by using the common language of humanity, the visible world, he can communicate as directly to the viewer as nature does. The culmination of value pattern and shape into the illusion of solid forms is one of the few differences that separate representational artists from their abstract counterparts. Theoretically, artists who create abstract work are interested in all of the elements of two-dimensional design. However, they stop short of depicting narrative and therefore of creating recognizable objects that give the illusion of volume.

A number of twentieth- and twenty-first-century artists have spent their careers rebuilding knowledge and techniques of traditional representational art that were lost in the decades when abstraction was en vogue. These realist artists were intent on rediscovering the secrets of creating depth, weight, and

Opposite: Pierre-Paul Prud'hon, *Standing Female Nude* (detail)*,* circa 1810, black chalk, heightened with white, on blue paper, 24 5/8 x 16 1/2 inches, The British Museum

Photo Credit: HIP / Art Resource, NY

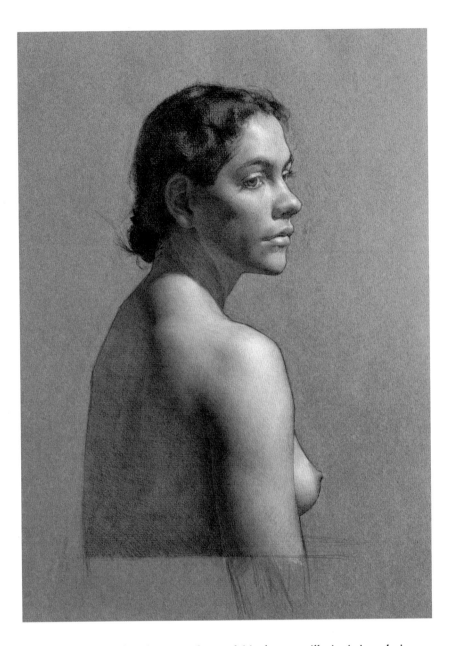

volume in their work and were understandably drawn to illusionistic techniques.
Like all pendulum shifts, there is first a tendency to excess before self-correction,
and as important as the creation of volume is, it unfortunately has become the
focus of realist art to the exclusion of almost everything else. However, if con-
temporary artists hope to achieve the grandeur reached by the master artists
from previous eras, we must to look at the broader knowledge base that formed
the structure of these masterpieces of art.

As we discussed in chapter three, when measuring a drawing an artist can
employ different techniques, each of which uses different strategies. For
instance, the comparative method is conceptual and the sight size method is
observational, yet both can be used to accurately measure drawings. Likewise,

there are two ways of rendering form. They might be named the classical and the impressionistic. Both create the illusion of volume in drawing. However, they look slightly different and have different philosophical underpinnings.

Classicists rely on reason, believing, as did Plato, that nature in all its imperfections reflects an ideal model. Classicists seek an objective reality that exists apart from our ability to fully observe it. For example, they might render a section of a foot as if it were a truncated cone, believing that this geometric form captures the essential quality hinted at in nature. They build solid forms in a sculptural way by conceptualizing their notion of how light washes over geometric forms to create the illusion of the third dimension. The very exercise of studying light on a pure form, such as the sphere, reflects the classical desire to study the timelessness of nature's underlying principles. The classical mode of seeing dictates that the brain informs the eye. In other words, reason and observation are used in equal measure in the creation of art.

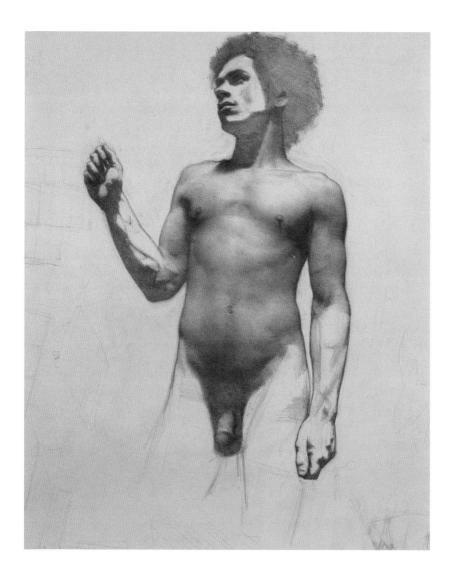

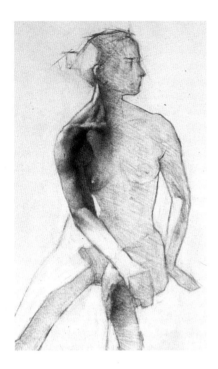

In his book *The Man Who Was Thursday,* British novelist G. K. Chesterton describes the impressionistic method of creating form. Chesterton places his main character in the woods, where the moments of bright sunlight punctuate the darkness and play tricks on his eyes. He wrote, "Gabriel Syme had found in the heart of that sun-splashed wood what many modern painters had found there. He had found the thing which the modern people call Impressionism, which is another name for that final skepticism which can find no floor to the universe." ·

Chesterton's jab at artists who follow the impressionistic model actually gets to the heart of the philosophical underpinning of this worldview—the belief that there is no underlying objective reality that exists beyond what is perceived by the viewer. In other words, when perception changes, so too does reality. The impressionistic method of capturing light is a mode of seeing that is interested in the shifting changes of light as an end in itself. The light becomes the subject of the work. By closely observing nature and rendering pixelated dots of light, the impressionist artist renders a beautifully observed, yet philosophically different, take on the world than does the classicist.

Universals and Particulars

In the last chapter we discussed the virtues of a drawing rendered with simplicity, subordinating small value changes to bigger ones. As necessary as breadth of vision is to a powerful work of art, there are some pitfalls inherent in taking a broad view. A drawing that is strong in generalities can feel cold and impersonal, for instance. It may describe everything but yet specify nothing. Attention to particulars also has its own set of perils, however. All the particular forms can become a morass that bogs down the viewer, causing him to get lost and bored before ever seeing the point. The minutiae of the work can remain earthbound

Above: Mike Kloepfer, *Drawing of Tamara* (detail), 2000, charcoal on paper, 24 x 18 inches, courtesy of the Aristides Classical Atelier

Right: Juliette Aristides, *Sutherland 2: Stretching,* 2004, charcoal on paper, 15 1/2 x 21 inches, courtesy of John Pence Gallery

Opposite: D. Jeffrey Mims, *Head Study 1,* 2005, charcoal and graphite on toned paper, heightened with white chalk, 13 x 9 1/2 inches

Photo Credit: The Pierpont Morgan Library / Art Resource, NY

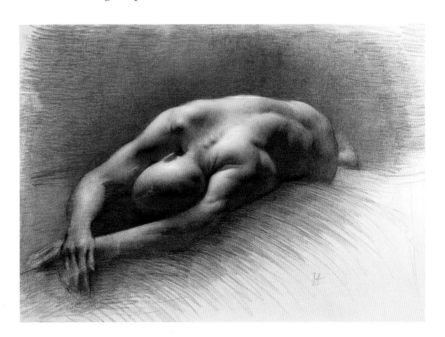

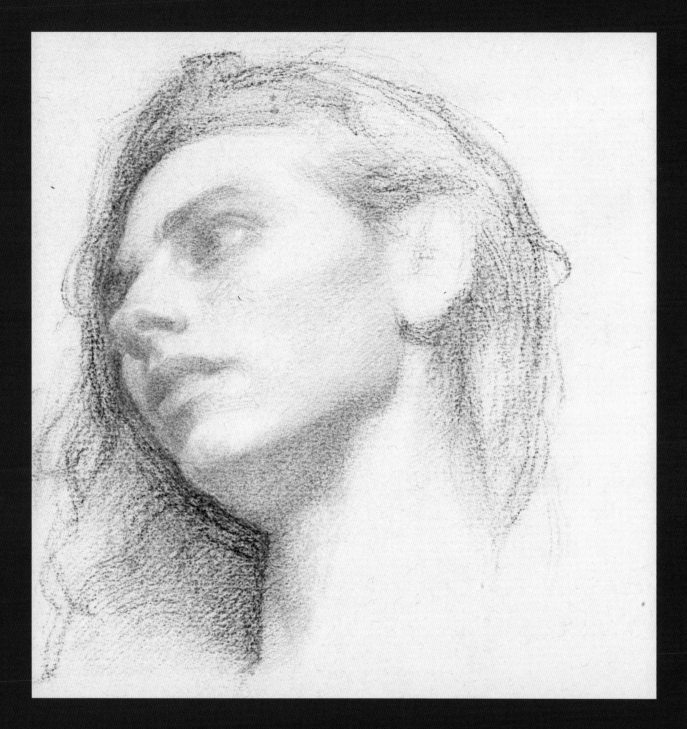

"*A masterful drawing is more than a faithful copy of an object. It is a description of both something seen and something imagined. At its most successful, there is a balance of carefully observed naturalism grafted onto classical conventions of structure and design. Whether the subject is a majestic ensemble of complex layers or the most humble observations of detail, the wonderful drawings that live on through the centuries have always demonstrated profound sympathy to their subjects.*"

— D. JEFFREY MIMS

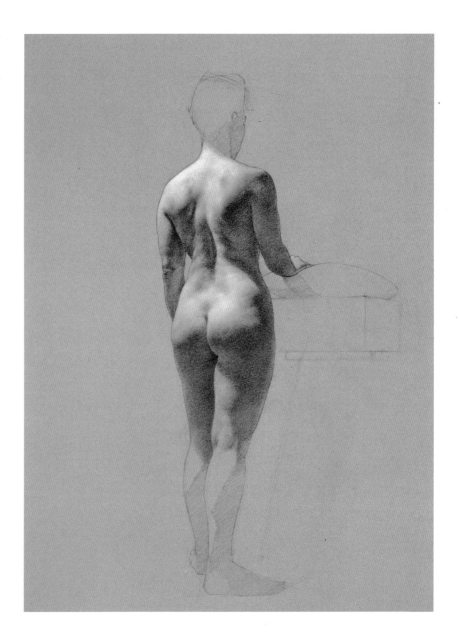

and never become transcendent. The work may not contain anything universal enough to make it applicable to anyone outside of the very narrow confines within which it was created.

Finding the balance between universals and particulars is a matter of temperament as much as training. Each artist tends to lean one way or the other. Universals deal with archetypes. One may love the idea of humanity, for instance. By contrast, a person who loves particulars, as Joseph Conrad has said, "desires to snatch and preserve a particular moment out of the remorseless rush of time." Such a person would be interested in "my neighbor Herb with white hair and glasses from Brooklyn." Focusing on specific forms that are unique to each individual is essential to creating a feeling of reality in art, and this is the

special domain of form drawing. Attention to detail is necessary to describe someone or something that truly lived in a specific time and place, with its own unique history. This personalized humanity makes art accessible. It shows that something is loved for itself, not for what it represents. It is a matter of taste and temperament whether an artist is more of an Ingres or a Rembrandt.

In great art there is always a balance between universals and particulars. If the work is too broad, it looks generic. If the work is not broad enough, it looks small and uninspired. Uniting the breadth of humanity with the specifics of a human life is a difficult challenge. The tightrope analogy can help illuminate this paradox. In order to balance on a narrow path, the tightrope walker has a pole to help him keep his balance. Rather than use a short stick, which keeps his weight close to the center, he uses a very long pole that extends equally in two directions. Likewise, in art, truncating the stick does not help us achieve equilibrium. Rather, we need to embrace both extremes. When we extend our range with equal depth into the universal and the particular, we achieve balance.

Creating Form

Leon Battista Alberti wrote that "the ancient Greek painter Zeuxis did not believe any price could be found to recompense the man who, in modeling or painting living things, behaved like a god among mortals." Today our culture is so oversaturated with film, television, and photography that it is easy to forget what great power the visual image had in times past. It gave people the god-like quality to create a world out of nothing and even provided an afterlife of sorts, enabling someone's likeness to live on after death. In this section we are going to study how artists have been able to create the illusion of the third dimension in drawing.

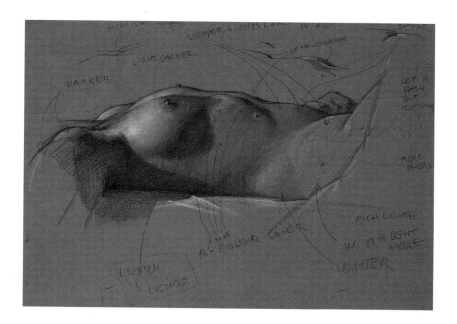

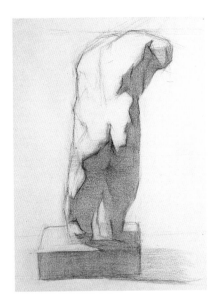

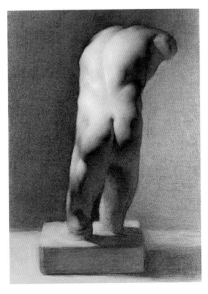

Juliette Aristides, cast drawing of the back view of a sculpture by an unknown artist, 2004, charcoal on paper, 18 x 12 inches. First, the shape of the figure is blocked in and shadow shapes are positioned. Then, the form is defined.

When seeking to understand the process of form drawing, it is helpful to break the drawing process into three distinct stages: the block in; the separation of dark and light shapes; and the creation of form. Although it is an oversimplification to reduce a drawing into stages, it helps the artist conceptualize the complex act of drawing by creating a manageable system. Often the advanced artist will pass back and forth from one stage to another, combining them all into one masterful moment where the drawing seems to appear out of nowhere.

The initial block in concerns the overall placement, design, and proportion of the drawing, as described in chapter three. In this stage, the artist establishes the dominant, abstract design of the drawing as well as measuring the various components to make sure they are properly positioned. In the second stage, the artist draws an exact likeness of the shapes found in nature by delineating the light and shadow. The goal of this stage is to subdue smaller differences of value into big, simple shapes until the drawing looks almost like continents on a map, creating a breadth of vision and a large structure. This paves the way for the third stage, in which the artist undertakes the construction of form. During this final stage of the drawing process the artist focuses on the smallest shapes and areas of value, turning all his attention toward the unique small forms of nature.

The illusion of form is the domain of the halftones. The shadows can be simplified and unified, as to some degree can the lights, but the halftones must be gradated in order for the image to read as turning form. Unless something is flat, like a piece of paper, there will be some changes of value to indicate its girth. Generally, the smaller the range of halftones there are in an object the quicker the turn can be described. For example, if you have a strongly lit block, you can expect a razor-sharp edge between the shadow and the lit side of the cube. In that circumstance there would be no halftones. Anything that has a more gradual curve, however, such as a cylinder, would have a more gentle transition between the core shadow and the light. The way an artist models this halftone area gives us information about the light source and tells us about the surface of the object hit by that light. Looking at the halftones we can discern something about the objects—from the quick turn on our cube to the gradual one on our cylinder.

When an artist renders the halftones—either with line as in the linear hatching used in a work by Rubens (see my master copy on page 82) or with the seamless rendering found in a Prud'hon drawing (see page 66)—he tends to wrap them around the form being developed. Rather than do striped lines of tone going down the form, he will place his tones perpendicular to the light source. This wrapping of tones around the object helps create a feeling of sculpted form and provides a fuller description of particular characteristics of the object. For example, if we are drawing a cylinder and have a shadow cast all the way down the length of it, the shadow looks like a long rectangle. The shadow describes

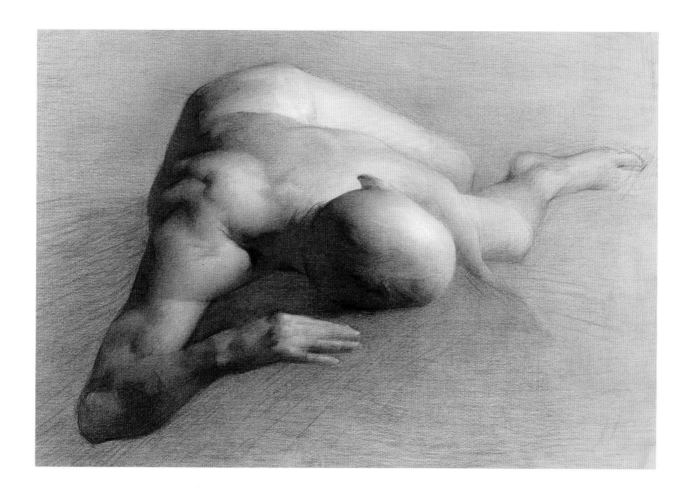

the long, narrow characteristic of the cylinder. When we render the halftones we don't want to emphasize the length once again but rather to give information about its girth. We want our rectangle to become a cylinder and we do that by wrapping our tones perpendicular to the line of the core shadow.

In conclusion, value—or, to be more specific, turning form—grounds drawings in reality, creating both solidity and the illusion of three dimensions. Value is fundamental to the representational artist, and its use has philosophical undercurrents. The universal aspects of an image provide a transcendent viewpoint and create a meaningful context for individual forms. The particulars make it real, applicable, and relevant. Great works in all art forms need both aspects to communicate well and outlast the time in which they were made. In the next section we will see how all of the concepts discussed thus far can be applied to particular subjects.

Juliette Aristides, *Sutherland 3: Resting,* 2005, charcoal on toned paper heightened with white pencil, 15 1/2 x 21 inches, courtesy of John Pence Gallery

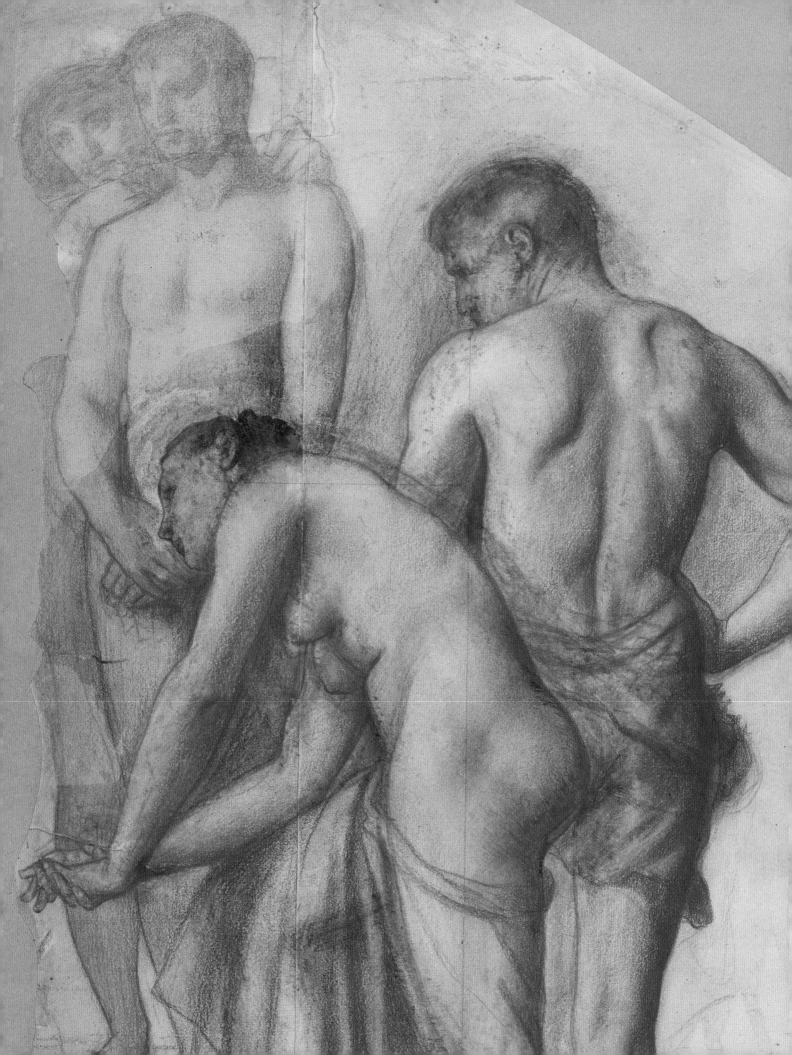

Timeless Subjects

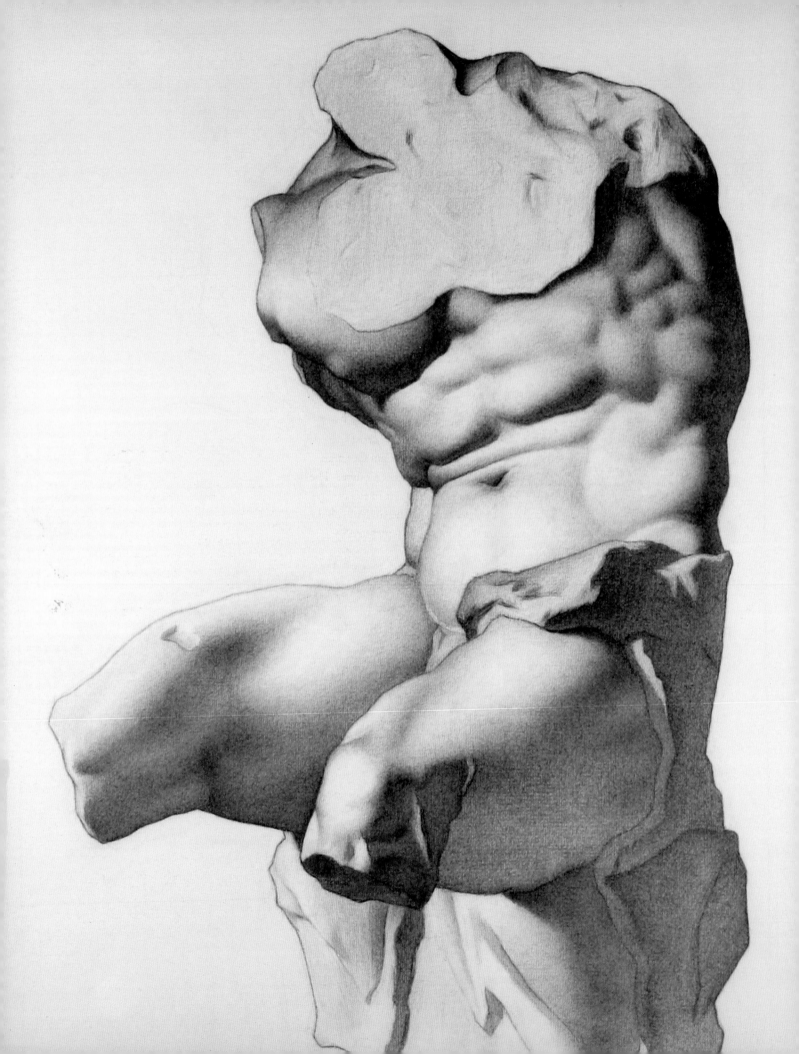

MASTER COPY DRAWING

Learning from the Past

"On whom then can [the artist] rely, or who shall show him the path that leads to excellence? The answer is obvious: those great masters, who have traveled the same road with success, are the most likely to conduct others." — **SIR JOSHUA REYNOLDS** (from *Sir Joshua Reynolds's Discourses*)

The practice of master copying used to be an intrinsic part of an artist's education, one that he often continued throughout his career. Paul Cézanne, quoting Thomas Couture, said, "Keep good company: Go to the Louvre." The goal of a master copy exercise was to duplicate, either exactly or in essence, an individual work. Through the procedure of master copying the student could commune with greatness and identify the master's modes of representation, methods, and ways of problem solving.

In the preceding chapters we looked at the building blocks of the artist's vocabulary—design, line, value, and form. Now we will look at application. If one were studying writing, one would learn the basic framework of writing—such things as spelling, grammar, and composition. The next question might be one of style and content. By reading great literature with a critical eye the student gains insight into how great writers composed their masterpieces. Each work becomes a beacon of sorts, a guide and an encouragement, from one who has arrived to one still traveling. In art, through copying the work of a master a student is inspired and pushed beyond his current level of ability.

The History of Master Copying

The process of directly copying other artists' work was routine in the Middle Ages, where each workshop had its own model book of patterns and drawings of such things as figures, drapery, animals, and plants. However, Renaissance artists revolutionized the concept of copying—and established the traditions that we revere today. Rather than copy out of model books, Renaissance artists turned to the masterworks created during the height of the ancient Greek and Roman civilizations and intently studied these creations in order to become proficient at their craft. They also copied each other; Michelangelo copied

Opposite: Michael Hoppe, copy after Charles Barque's *Belvedere Torso*, 2004, vine charcoal on white paper, 18 x 13 1/2 inches, courtesy of the Aristides Classical Atelier

Previous Spread: Pierre Puvis de Chavannes, *Group of Four Figures, One a Woman Who Is Turning to the Left* (detail), mid-nineteenth century, black crayon and sanguine, heightened with white, on beige paper, 29 x 17 1/4 inches, Louvre, Paris, France

Photo Credit: RMN, copyright ©Michèle Bellot / Art Resource, NY

Giotto, Leonardo da Vinci copied Michelangelo, and so on. They viewed study of the masters as a gateway to studying nature—and believed that they should be done in tandem.

The Florentine artist Cennino Cennini (1370–1440) recommended that the student find all the best works created by master artists and study them intently. As so eloquently stated in his book, *The Craftsman's Handbook,* he said, "You will find, if nature has granted you any imagination at all, that you will eventually acquire a style individual to yourself, and it cannot help being good; because your hand and your mind, being always accustomed to gather flowers, would ill know how to pluck thorns."

The practice of creating master copies continued until it reached a zenith of activity in the nineteenth century. It became so popular it was considered an art form in its own right, generating commissions in the thousands from the Musée des Études and the Musée des Copies. In fact, despite their otherwise incompatible outlooks, the practice united academic artists, Realists, Romantics, and Impressionists—because they all had a deep desire to connect with the past.

David Dwyer, copy after Leonardo da Vinci's *Seated Figure Drapery Study,* 2005, vine charcoal on paper, heightened with white pencil, 14 x 11 inches, courtesy of the Aristides Classical Atelier

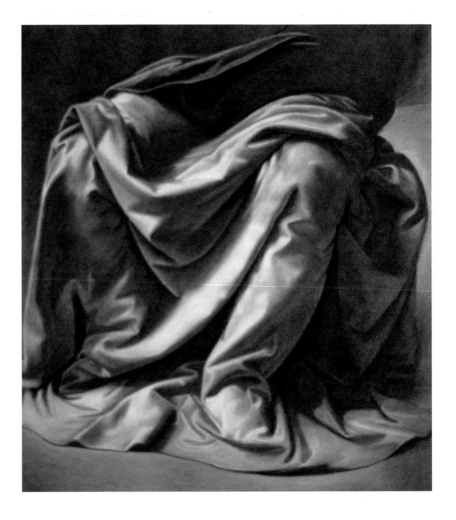

Artists as varied as Eugène Delacroix, Théodore Géricault, Jean-Auguste-Dominique Ingres, John Singer Sargent, Henri Fantin-Latour, Edgar Degas, Édouard Manet, and Paul Cézanne all copied throughout their careers. Degas observed that "No art was ever less spontaneous than mine. What I do is the result of reflection and study of the great masters; of inspiration, spontaneity, and temperament."

Even as art changed, the practice of master copying remained relevant, and continued into the twentieth century with such unlikely practitioners as Henri Matisse and Pablo Picasso. What changed was the works they chose to copy and the methods they employed. The practice of master copying moved away from an interest in technique and on to the expressive qualities of a work of art. Artists freely interpreted the master's works to suit their own needs.

The Value of Copying

This practice of master copying has not stayed in the past. André L'Hote said, "In art there is no progress, only discovery illuminated by methods as old as the world itself." By looking to the accomplishments of artists who came before us we can have a dialog with the past and speed our artistic journey. There is no better place to start than with the practice of copying master works.

Much artistic training these days (atelier training aside) is centered on the student's personal creative vision. With this cultural backdrop it can be difficult for the contemporary mind to understand the role and practice of copying. To do so, it can be helpful to compare the process of learning how to make art with the process of learning a foreign language. The goal of pursuing a foreign language is to communicate with others. By growing up in a home where a language is spoken, a child learns to speak. The process is fluid, and often somewhat unconscious. However, when an adult wants to learn a second language, the process generally is much more formulized. Through imitation, immersion, and study the adult student is able to gain command of a foreign tongue. Trying to be creative with a language before it is mastered would result in many embarrassing episodes for the beginning student.

Making copies of work by earlier masters allows the student to draw from a static two-dimensional subject, gaining dexterity in the handling of a medium and hands-on understanding of how master artists use line, value, and form to advantage in their work. Emulation in search of academic enlightenment has been recognized for centuries as a natural part of the artistic learning process. The practice of executing master copies forms an important part of the contemporary atelier curriculum. As interest in the ancient art of picture making increases, so too does the interest in the practices that helped to create these great works. As in the days of the old European workshops, students once again are copying excellent drawings done by masters in their field. Doing these copies cultivates their aesthetic sense and gives them an intimate understanding of

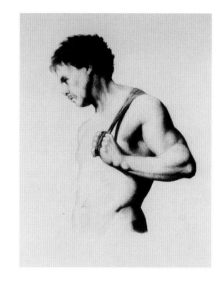

Top: Annie Rosen, copy after Georges Seurat's *Male Torso*, 2006, charcoal on paper, 8 x 10 inches, courtesy of the Aristides Classical Atelier

Above: Annie Rosen, copy after Georges Seurat's *Prometheus*, 2006, charcoal on paper, 8 x 10 inches, courtesy of the Aristides Classical Atelier

Above: Juliette Aristides, copy after Peter Paul Rubens's *Three Nude Warriors in Combat*, 2004, sepia ink on paper, 11 x 14 inches

Opposite: Peter Paul Rubens, copy after Leonardo da Vinci's *Battle of Anghiari*, circa 1600, black chalk, pen, and brown ink on paper, heightened with gray-white chalk, 17³/4 x 25 inches, Louvre, Paris, France

Photo Credit: Réunion des Musées Nationaux / Art Resource, NY

how different masters transformed life into art. By studying the great drawings of the past, the artists of today are participating in an historical tradition and having a dialog with the master artists who came before them.

Copying Versus Constructing

The dynamic relationships found in life are hidden under the surface. Careful observation is required to determine their pattern and organization. By identifying what is superfluous and what is structural, the artist can create a drawing that captures the power and beauty of life. Edgar Degas declared that picture making requires as much trickery and conniving as the perpetration of a crime. Rather than jumping in with both feet and hoping that all the small pieces will eventually create a feeling of order and power, the artist must envision, plan, and orchestrate both the big picture and the small details.

The same principle applies when copying a masterwork. In order to successfully replicate the work of a master, an artist needs to investigate the motives and actions that led to the original action—what Degas describes as the crime. In other words, the copier must study how the original work was constructed, determine which elements set the theme and tone, and identify where timeless principles of good design and sound technique have been used to translate what was observed in nature into a masterful drawing.

The greatest imitation is not the greatest art. Today, people commonly think of representational artists as human cameras, painstakingly copying each detail as it hits the eye with the goal of creating an image that looks like a photograph. However, such a goal is not only outmoded, it would not produce art. Transforming life into art requires careful translation and refinement.

Surface details may obscure as much as they reveal about the complex visual relationships we observe. Many aspects of life seem to defy ready translation into art because of their subtlety and complexity, while other aspects are just as hard to translate because they are so apparently unartistic, ordinary, or chaotic. While the gap between life and art is immense, master artists are able to bridge that gap by looking beyond the surface seen by the eye to find the beautiful even in the mundane, and by skillfully separating the surface details from the essential structure of an object in order to present us with a distilled reality. Life does not often appear in its ideal form. The amount of knowledge and skill used to execute a brilliant work of art is breathtaking. The artist must simplify, design, and construct the reality that she is looking at in order to convey it as she has seen it.

Methods of Execution

Eugène Delacroix, like other artists of his day, had several methods for doing master copies, depending on his goals. One way is to create a finished facsimile, or faithful reproduction, of the work. This helps the artist gain insight into the

technique and working methods of the master. The underlying philosophy of this method is that when an artist lays aside his own goals and studies the master's lessons completely, he will become a more pure vessel to express himself.

A second method is to create a sketched version of the original drawing. With this approach the artist interprets the drawing, trying to capture the essence or first thought of the master artist. Ideas such as value distribution, composition, and content are examined independently of representation and execution. Rather than concentrate on the look of the finished work, the artist focuses on his process and applying the master's lessons to his own style.

By studying masterworks and making master copies, the artist learns to see through another's eyes. Emulation becomes the first step toward self-expression, and eventually the artist will begin to see in life what he has been learning to see in art. Through the study of Raphael, Jean-Auguste-Dominique Ingres was able to more fully manifest himself, and through Caravaggio we have Jusepe de Ribera. Artists of all kinds are drawn to one another by their temperament, allowing themselves to be influenced and led to a greater vision. When an artist submits to the practice of copying, he begins to master the art of seeing nature.

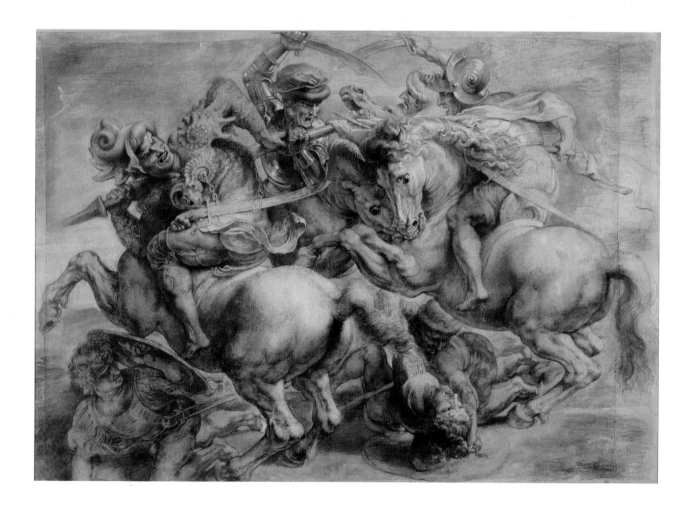

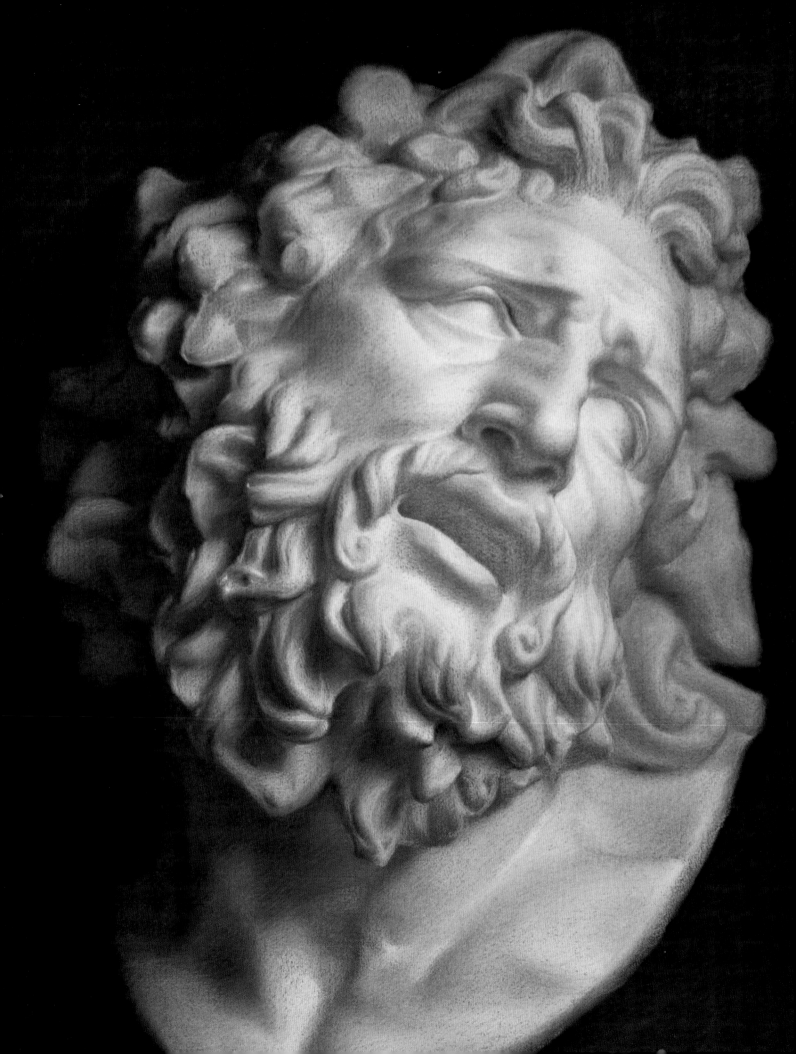

CHAPTER SEVEN

CAST DRAWING

Lessons from Master Sculptors

"In order to attain the highest perfection in painting it is necessary to understand the antique, nay, to be so thoroughly possessed of this knowledge that it may diffuse itself everywhere." — PETER PAUL RUBENS
(from John Rupert Martin's *Baroque*)

The artists of ancient Greece strove to outdo nature by adding to their art an elegance, beauty, and strength that was only hinted at in the natural world. Over the course of the two millennia that have since passed, many people have believed that classical art was one of the greatest artistic achievements of humanity. Adulation of the works of antiquity has asserted itself periodically and fiercely throughout art history. Peter Paul Rubens wondered why it is that "our groveling genius will not permit us to soar to those heights which the ancients attained by their heroic sense and superior parts."

Cast drawing, the practice of drawing from plaster casts of classical sculptures, is an integral part of the initial phase of the atelier curriculum. It follows the process of making master copies, and thus literally adds another dimension to the student's awareness and abilities. Where the two-dimensional master copy allows a student to closely examine the execution of a two-dimensional work, cast drawing allows the student to practice translating the three dimensions he observes into two dimensions on the paper. Cast drawing is the natural link between making master copies and learning to draw from life.

More than two thousand years ago, Greek sculptors formulated a system that combined graceful naturalism with extremely sophisticated design systems and, in the process, created a triumph of human achievement. Classical sculptors carefully studied the principles of balance and perfected the visual relationships among the design, line, and form that made up their three-dimensional compositions. The small forms and the larger shapes were accurately considered, each small piece designed to suit the context of the whole. This skillful balance is part of the reason why a classical sculpture is still beautiful even though it might be missing arms, a nose, or a head, or might itself be only a fragment

Opposite: Christopher Neville, cast drawing of the *Laocöon*, 2004, charcoal and white chalk on paper, courtesy of the Corry Studio of Figurative Art

Above: Nancy Fletcher, *Cast Drawing of Jean-Baptiste Carpeaux's Flore Accroupie,* charcoal on paper, 19 7/8 x 13 1/2 inches, courtesy of the Angel Academy of Art

Opposite: Dave McClellan, cast drawing of the foot from the *Hercules Farnese,* 2004, charcoal on paper, 14 x 20 inches, courtesy of the Corry Studio of Figurative Art

from a larger sculpture. Even the fragments of classical work feel complete in their own right.

To this day, great artistic minds continue to work from casts of classical sculptures precisely because they embody a perfect culmination of observed nature and archetypal form. Students are led to the classical works as a means of helping them see nature using a combination of their minds and their eyes. The underlying presupposition is that someone cannot truly see until he knows what to look for. Through rendering classical sculptures, the student enters into a silent dialog with the master artist, carefully absorbing the knowledge of the master and strengthening the skills that constitute his own repertoire. Hands-on study of classical sculptures cultivates a student's aesthetic sense, provides insight into how the ancients simplified nature and transformed it into art, and builds knowledge and skills.

The History of Cast Drawing

Historically, art students were expected to study works that contain ideal compositional elements before attempting their own study of nature. Classical sculptures provide the perfect vehicle for this study. Not only do they contain the ideal material (in terms of design, line, value, and form), but, because they don't move, they naturally lend themselves to prolonged study. Moreover, because these great sculptures and casts are mostly figurative works, they provide excellent preliminary study in figure drawing, which helps prepare the student for working from the life model. These sturdy artworks have survived the ages, leaving tangible records of how ancient sculptors transformed the human figure with all of its idiosyncrasies into transcendent works of art. Nearly every artist who lived from the time of the Renaissance to the turn of the twentieth century studied the work of these master sculptors at some point during training.

The first classical revival occurred during the High Renaissance. This style is easily recognized in the work of all the artistic luminaries of that era—though perhaps Michelangelo's experiences articulate this influence most precisely. Michelangelo was trained in the sculpture gardens of Lorenzo de Medici's palace in Florence, which contained many fine classical examples, and later was influenced greatly by Greco-Roman sculptures discovered during his lifetime. In 1506, when he was in Rome, he watched the *Laocöon* being unearthed. He was asked to help restore the damaged sculpture, but declined, saying he was not as skillful as the Greek sculptors who created it.

This love of antiquity has continued throughout art history. The Flemish Baroque artist Peter Paul Rubens did many drawings after classical sculptures, including the *Laocöon.* Nicolas Poussin (1594–1665), the originator of French Classicism, spent almost his whole life in Rome. Sir Joshua Reynolds (1723–1792), who was the first president of the Royal Academy, spent two years

in Rome studying Greco-Roman art. Neoclassicist Jacques-Louis David (1748–1825) studied at the Academy, won the Prix de Rome, and subsequently spent five years there studying studying classical sculpture. Edgar Degas spent several years studying antique sculpture and Renassance painting in Rome.

Nineteenth-century European ateliers often required that a student show mastery of classical compositional techniques before drawing from life or creating original work. European academies also stressed copying from the classical as a link to the past and for the formation of taste. Classical training did not come to the New World until a significantly later date than their European counterparts. During the early years of our nation's history, Europe looked on us as a provincial outpost with an unsophisticated local art history. Likewise, Americans who wanted to train seriously as artists studied in Europe. Many great American painters, such as Thomas Eakins, Mary Cassatt, Cecilia Beaux, William Merritt Chase, Robert Henri, Julian Alden Weir, William McGregor Paxton, Kenyon Cox, Frank Duveneck, Abbott Thayer, Dennis

Above: Artist Unknown, cast drawing of
Venus de Milo, mid-nineteenth century, charcoal
with white chalk on paper, 23 5/8 x 18 1/16 inches,
National Academy of Design Museum, gift of
Daniel Huntington

Opposite: Yumiko Dorsey, cast drawing of an
unknown nineteenth-century artist's rendition
of Moses, 2004–2005, vine charcoal on paper,
26 x 18 inches, courtesy of the Aristides
Classical Atelier

Miller Bunker, and others studied overseas and then returned to the United States either to teach at art schools or to open studios, where they shared the knowledge they gained from their classical studies.

The acquisitions of casts were important to the newly opened American art academies. The Pennsylvania Academy of Fine Art opened in 1805 following a shipment of casts authorized by Napoleon under the direction of the famous French sculptor Jean-Antoine Houdon (1741–1828). Some of the founding members of the National Academy of Design gave or lent casts of antique sculptures that were in their possession, when the academy opened in 1825. The acquisition of casts by American academies finally gave them the chance to be on a par with the European academies and gave American art students the same access to the past that they could get by going overseas. By the late nineteenth century many American institutions in all parts of the country had impressive cast collections. The casts also lent a sense of legitimacy and scholarship to the American academies and gave them a feeling of being on an equal footing with the Europeans—a position that continues to this day.

Bringing the Past into the Present

Since the days of ancient Greece both individuals and institutions have acquired casts. The casts in private homes, academies, and museums were sometimes house in long hallways or large rooms, called "cast halls." These beautiful and often vast rooms were filled with freestanding sculptures, busts on pedestals, and reliefs hung on the walls. The scultpures were stationary and well lit, allowing viewers to walk around and draw from them at any angle. The works, which were sometimes enormous, evoked a feeling of awe as the viewers felt the presence of thousands of years of art history.

Although the great cast halls of the past are essentially gone, the practice of learning fundamental skills by drawing master casts need not stay in the past. Cast drawing offers numerous benefits that are valuable for today's art student, which is why it is a fundamental part of the atelier curriculum. Students work from classical statuary under unchanging, single-source light conditions. The light and cast setup is specifically designed to clarify value relationships and enhance form.

Cast drawing is useful for beginners because it forms an entryway to transform the three-dimensional world into a compelling two-dimensional image. Working from a uniformly white and stationary object in a controlled environment presents the student with an opportunity to face all of the problems that arise in the artistic process, break them down into their composite parts, and deal with them in a nonthreatening manner. It provides an ideal situation under which the student can train his eye to see the halftones and train his hand to capture the evasive washes of tone that bridge between the lights and shadows. It also allows him to progress at his own speed and with minimum pressure. When drawing from a cast, an atelier student learns how to first lay down the linear block in, establishing the main elements of the composition

and the basic contours. He proceeds to define the division between light and shadow areas of the sculpture, and then to render form by further subdividing the tonal values seen in the original work. As he studies these transcendent works, he becomes fluent in the language of prior centuries.

A successful cast drawing is well proportioned, beautifully designed, and masterfully rendered. The drawing should be enveloped in atmosphere, yet also present the dynamic found in the original cast. The aim of a cast drawing can be tailored to the goals of the artist. Peter Paul Rubens preferred his drawings of sculptures to look like people made of flesh and blood rather than stone. For others the process offers a chance to study the flow of light over the surface of the cast, and still others see it as an opportunity to master turning form. Once a student has learned to draw a cast well, he can draw anything.

FIGURE DRAWING

Man as the Measure

"The Greeks perfected the nude in order that man might feel like a god, and in a sense this is still its function, for although we no longer suppose that God is like a beautiful man, we still feel close to divinity in those flashes of self-identification when, through our bodies, we seem to be aware of a universal order."
— KENNETH CLARK (from *The Nude*)

Often the art of a culture is its greatest legacy, and in Western art this heritage is inextricably bound with the figure. Because of its formal complexity and symbolic meaning, the human figure has constituted the principle subject of art throughout the ages—featuring in religious, historical, mythological, and portrait work. The figure is at once universal and individual. Consequently, it is particularly suited to convey deep and profound mysteries with veracity and power. Ancient Greeks incorporated elaborate decorative narratives in their architecture, using the human form as a vehicle to express eternal truths about the human condition and to venerate the unique qualities of heroic characters. During the Renaissance, the figure was used to adorn churches, thereby both educating and inspiring worshippers. Up to the nineteenth century, epic figurative paintings decorated palaces and public institutions from courthouses to opera houses; they projected personas, recorded history, relayed allegories, and represented the highest possible form of artistic achievement.

From the artist's perspective, the human form has long been considered the most serious and challenging subject he could attempt to master. This is, in part, why drawing from a nude model has been the bedrock of art education for centuries. This art form was established by the Greeks in the fifth century B.C.E., was revitalized during the Renaissance, continued through the years that followed, flourished in the academic curriculum in the nineteenth century, and lives on today in atelier training. Depiction of the figure represents a supreme challenge for the artist.

The Figure in Art

Artistic expression is always an extension of the worldview of the culture that created the art. Not every culture represents the figure in its art. However,

Opposite: Raphael, *Nude Youth* (detail), 1508–1509, black chalk on paper, 14 x 8¼ inches, Uffizi, Florence, Italy

Photo Credit: Scala / Art Resource, NY

many cultures not only include the human form in their artwork, but elevate it. For example, as discussed earlier, the ancient Greeks were constantly searching for explanations of the natural phenomena that they observed in the world around them. They believed that gods (such as Zeus, Aphrodite, and Poseidon) were responsible for many of these phenomena and devised elaborate mythologies to explain certain occurrences. The Greeks, who put great emphasis on physical beauty, believed their gods looked like heroic people. Consequently, many of the ancient Greek statues that we revere today are of their gods, and these gods represent the ultimate expression of beautiful human form.

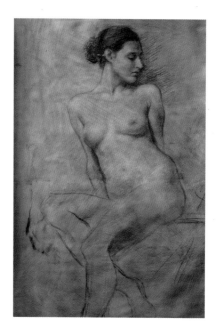

The Judeo-Christian worldview, which formed the early foundation for European and American artistic culture, explained that people are made in the image of God. The implication of that worldview is that people are not like the rest of nature. Human beings have a transcendent quality that imbues their lives with consequence and their struggles and triumphs with eternal significance. This worldview provided the backdrop for the production of great figurative art, including Michelangelo's *Creation of Adam*, which is featured on the Sistine Chapel ceiling. This triumph of painting shows God bringing Adam to life with a touch of his finger, transforming him from earth to man. Adam is triumphant, powerful, and the crowning glory of God's creation.

In our postmodern era, the prevailing belief that human beings originated from the primordial soup rather than from the heavens makes it unsurprising that heroic figures seem outdated and that the focus of art has moved away from the figure. Nevertheless, the human figure will always have a place in art. The human being is unique in that it has not only an external reality but an internal one—and this provides one of the most varied sources of interest imaginable.

Above: Kamille Corry, *Figure Study for Muse*, 2003, charcoal and white chalk on gold paper, 48 x 30 inches

Left: Martha Mayer Erlebacher, *Torso X*, 1990, pencil on paper, 15 1/2 x 20 3/4 inches

Opposite: Pierre Puvis de Chavannes, *Group of Four Figures, One a Woman Who Is Turning to the Left*, mid-nineteenth century, black crayon and sanguine, heightened with white, on beige paper, 29 x 17 1/4 inches, Louvre, Paris, France

Photo Credit: RMN, copyright © Michèle Bellot / Art Resource, NY

Right: Graydon Parrish, *Standing Female Nude,*
2000, charcoal on paper, 22 x 11 1/2 inches,
collection of Lloyd and Renee Greif, courtesy
of Hirschl & Adler Gallery

Opposite: Robert Liberace, *Male Figure
Throwing Ball,* 2003, conté crayon on paper,
15 1/2 x 23 inches, courtesy of Arcadia Gallery

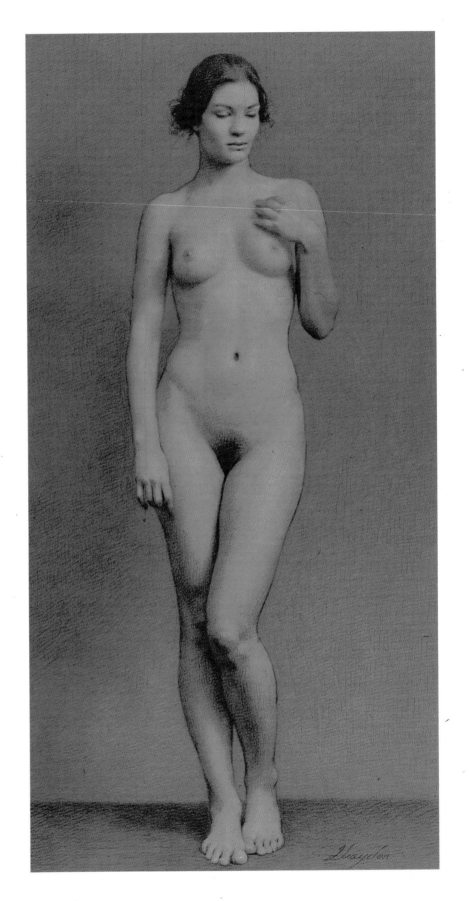

PART THREE: TIMELESS SUBJECTS

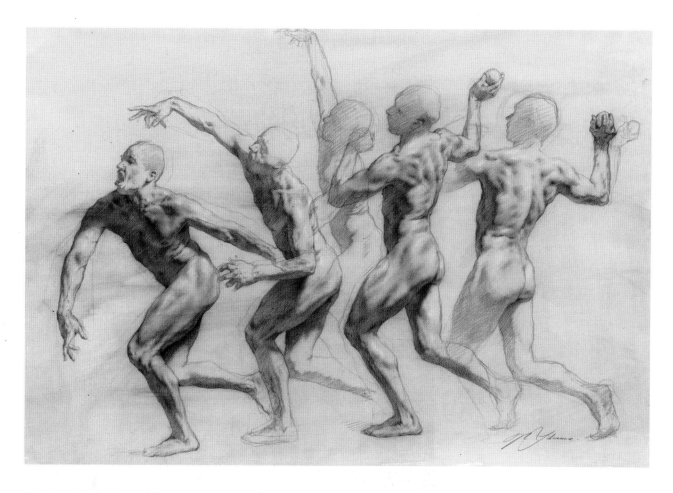

The impulse to elevate the human condition may conflict with popular philosophies, but we find ourselves too fascinating to edit ourselves out of the content of art. Contemporary artists tend to reflect the disillusionment of our era, sending Adam back into the mud from which he came. The marred, disfigured, fragmented figure is commonplace in twentieth-century art. The figure is often shown as no more transcendent than a piece of clay.

Capturing Life

All of the knowledge and experience an artist has acquired from various principles of artistic study is applicable in figure drawing. A mastery of design, line, value, and form is required to create a strong work of figurative art. Good design ensures that the figure drawing has a strong cohesive organization. Abstract linear organization (including the measuring steps associated with the block in stage) give the figure drawing an individual character and prevent it from falling into unintentional inaccuracy. The study of value gives the work a believable tonal structure. And an understanding of form ensures that the surface topography reads convincingly in relation to a light source.

Technical mastery of the foundational principles that constitute good drawing makes the process of drawing second nature. A work of figurative art cannot

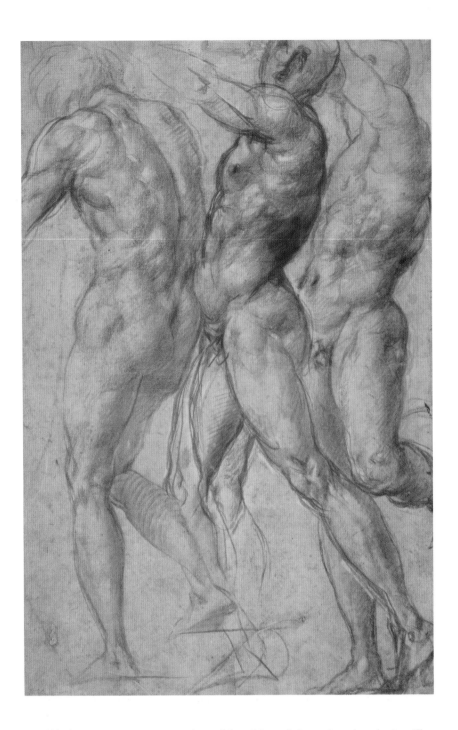

possibly be a transparent expression of the vision of the artist when he is still
learning how to get the proportions correct. The human body is highly complex
and there is little margin for error in a subject so familiar to everyone. Even
small inaccuracies create a sense of serious distortion—and the more finished
the drawing is, the more the mistakes feel wrong.

A figure drawing needs to be more than just technically proficient; it must
have a strong gesture or expression that contains life and a feeling of purpose.

When this challenge is handled by a master, the result can be sublime. For many, there is nothing more rewarding to see than a compelling representation of the human figure. Neither is there anything more difficult to accomplish.

When an artist has mastered the tools, principles, and techniques of his trade, he can focus on self-expression, knowing with confidence that the expression that follows will be one of choice rather than accident and will fully embody his vision. As Harold Speed, writer and artist, said so simply, "Originality is more concerned with sincerity than peculiarity." Often the most unique, compelling work comes not from a concept or an idea but from a deep, wordless place inside the artist. It is an expression of who he is rather than what he says. When we look at such a work, our own emotions, thoughts, and worldview are reinforced, interpreted, or challenged. All great art acts as a form of communion, silently inspiring our internal dialog with a wordless reality.

Elements of Figure Drawing

Figure drawing represents the culmination of all the fundamental principles of art that were discussed in the first five chapters. It was believed that if you could draw the figure, you could draw anything. Above and beyond the basic elements that are fundamental to all drawing, figure drawing involves the mastery of additional elements, the most essential being the accurate representation of structure, anatomy, and gesture. The mastery of these essential components is combined with the intuition of the artist. Like the great athlete who has practiced hard all season and when the game finally comes he just plays, when drawing, the great artist lays aside what he has learned in order to concentrate on expressing himself. Although it is the result of much labor and diligence, the act of drawing appears effortless. The elements used to create these great drawings are often hidden in their graceful execution, and we must take a drawing apart piece by piece in order to understand how it was made.

STRUCTURE AND ANATOMY

To a beginning draftsman the nude body can appear to be a muddle of indiscriminate lumps and bumps. Study of anatomy is essential for the artist in a number of ways. Having some knowledge of how the body is constructed can help him interpret the many ambiguous areas of the human form. It can provide an armature, or framework, onto which he can build his figure drawings. And it can help him make decisions of structure and emphasis. An artist can use the frame of reference that anatomical study provides to recognize small signs on the nude that can help him maintain his bearings within the grand structure. He will know which details are noteworthy and can seize upon the noteworthy details, thus transforming a nondescript naked body into a monument to the human form.

Theoretical knowledge is useful when it opens doors to help the artist see and make sense of the visual world, but it can become a hindrance when the head

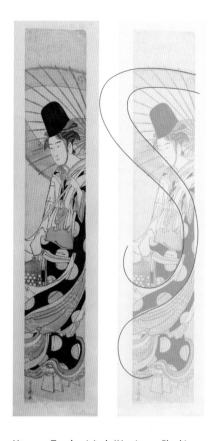

Utagawa Toyokuni, *Lady Wearing an Eboshi,* circa 1796, woodblock print on handmade mulberry paper, 24 3/4 x 4 1/4 inches, A.J. Kollar Fine Paintings, LLC, Seattle, Washington. The lines indicate the movement of the eye as it follows the curves in the print. They extend outside the picture and loop back around.

is full of so many principles that it becomes inflexibly closed to direct experience—for then the eyes are no longer able to see. For this reason it is not surprising that some great anatomists are not great draftsmen. Anatomists can know so much about anatomy that they draw what they want to see rather than what is in front of them. Theoretical knowledge about the physical structure of the figure needs to be coupled with direct observation from life and personal interpretation in order to create a successful drawing.

To have true understanding and insight it is important to go straight to the source and gain firsthand knowledge. However, a drawing must achieve more than just accurate recording to be successful. The art historian Kenneth Clark noted that "the body is not one of those subjects which can be made into art by direct transcription." Rather, the goal is to infuse the observed human figure with grace and balance, drawing on a grasp of geometric proportions of the idealized human figure without losing sight of the emotion, spontaneity, and beauty of the model being drawn.

The skillful artist uses anatomical knowledge not to create figure drawings entirely from memory but to become a detective, able to see small clues and deduce bigger truths. A foundation of anatomy helps the artist determine which folds, creases, and indents on the body are significant and which muscles can be grouped together. It also enables the artist to simplify complex and unclear

Right: Raphael, *Nude Man with Raised Arms,* **circa 1511–1512, black chalk on paper, 11 1/2 x 12 3/4 inches, The British Museum**

Photo Credit: Art Resource, NY

Opposite: Randolph Melick, *Study for Fat Man and Little Boy,* **2000, carbon pencil, sepia wash, and white gouache on paper, 13 1/2 x 8 1/4 inches, courtesy of Hirschl & Adler Gallery**

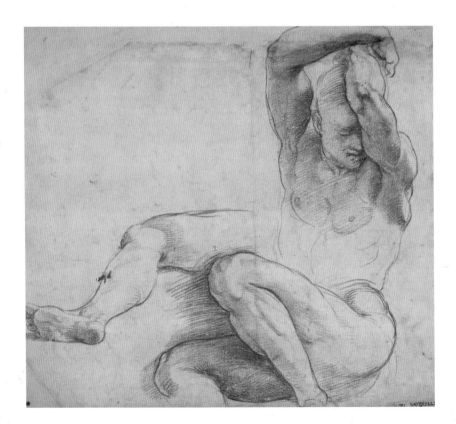

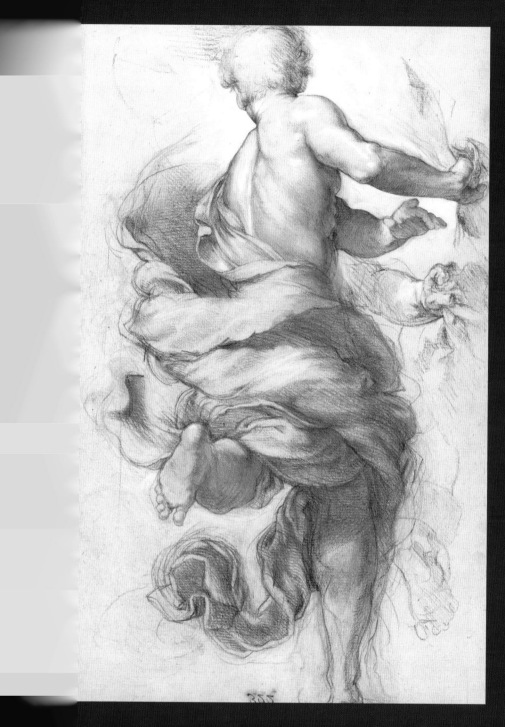

"The human body presents an observer with many shifting, unclear, contradictory, or unsatisfying visual cues. Rather than transcribe all of these effects, the draftsman draws just those that can be shown as examples of shapes and patterns that will represent the visual truth of the figure. Raphael's ovoids, for example, afforded him (to use art critic and scholar Arthur Danto's phrase) the 'swift, unstudied, gestural transcription of presumed feeling.' The abstract flame pattern that formed the basis of Michelangelo's figural poses evoked Platonic themes. And da Vinci's use of the whorl pattern made his ideas of movement and energy both vivid and precise.

The deployment of new shapes in figure drawings will enlarge the scope of our responses to the body as well as further open our eyes to its potential. This, more than mere visual imitation, is figure drawing's true goal."

— RANDOLPH MELECK

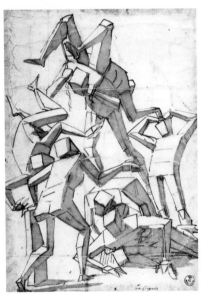

forms into clean structural statements, strengthening areas that otherwise might be weak and vague. When an artist comes to the model with a sensitive and well-trained eye, he can discern key moments and utilize them to reveal the hidden beauty of the model as well as convey his own emotions and opinions.

CUBED FORMS

The ability to conceptualize areas of the body as pure geometric forms is also a useful descriptive artistic tool. One of the first things an artist looks for when drawing the figure is the distribution of weight in the three main masses of the body: the rib cage, the pelvis, and the head. The way in which these three forms stack over one another determines the natural sense of movement within the pose. Rather than focusing on the myriad details that comprise the figure, the artist must consider these masses—and this requires thinking of the body in a sculptural way and in its broadest terms. Viewing the figure in this manner fosters an understanding that the surface forms and contours are inextricable from the skeleton that supports the anatomy. Many artists will roughly block in these imagined forms to serve as a template on which to build the particulars of the model they are drawing.

In addition to geometrically simplifying the large forms of the body, experienced artists often animate the figure by alternating rounded and squared forms, creating strength and variety within the image. Artists also create formal planes from parts of the body where the bone is close to the surface in other areas—such as the wrist, fingers, ankle, and neck—that are easily simplified into square and rectangular solids. Formalizing anatomy—whether large or small features—into geometric forms simplifies visual information and lends both accuracy and solidity to drawings.

Artists have to use their imaginations in tandem with their life drawing skills if they are drawing anything that cannot be actually set up. Rubens's *Study for the Fall of the Damned* on page 36 is a good example. Rather than try to draw dozens of obese people falling through space from life, he needed to improvise. Luca Cambiaso's *Group of Cubic Figures,* shown to the left, gives insight into how an artist can use the cubed forms technique. This sketch helped Cambiaso orient a large grouping of figures in action and was created in preparation for an ambitious painting.

Creating a preliminary sketch with cubed forms has a number of advantages. It can help orient an artist more easily to an imagined light source than complex naturalistic forms will. The structure provided by a conceptualization of the body as geometric solids often lends strength to the drawing as a whole. Of course, the body actually has no true straight lines nor any true cubed forms, but simplifying key shapes into planes will imply girth and mass, lending a feeling of solidity. This in turn helps the artist envision the three sides of a form necessary to create the illusion of the third dimension.

Top: The third dimension is exposed in this drawing by the indication of three planes of each cube. We see the top, side, and front planes of each of the following components—the head, rib cage, and pelvis of the rider and the hindquarters and upper legs of the horse. This helps to articulate the mass and volume in both figures. The underlying image is Peter Paul Rubens's copy after Leonardo da Vinci's *Battle of Anghiari.* An unadulterated version of this image is shown on page 83.

Above: Luca Cambiaso, *Group of Cubic Figures,* mid sixteenth century, pen and bister on paper, 13 3/8 x 9 7/16 inches, Uffizi, Florence, Italy

Photo Credit: Scala / Art Resource, NY

To conceptualize the volumes of the body, look for clues in the bony landmarks on the skeleton. These will help you identify the essential areas in your figure and position these three simplified cubed forms on your drawing. Many artists orient the rib cage first and then add the pelvis and head. However, the order that an artist chooses is a matter of personal preference and circumstance.

When rendering the simple form of the rib cage, orient the straight line suggested by the clavicle with the perpendicular line of the sternum. These lines will determine the top and front planes, formalizing the ovoid shape of the rib cage into a cubed form. One of the side planes of the cube will be visible, the other will be implied. Depending upon how your light source hits the figure, the visible side plane will likely contain the shadow line at some point where the front of the chest rounds out to the sides or where the oblique muscles wrap around the body.

The cubed form of the pelvis is articulated in a similar manner. The front of the top of the cube is determined by the bony protuberances of the hipbones (called the "anterior superior iliac spine"). The depth of the top of the cube is articulated by the line that connects the hipbones with the iliac crest. The two pelvic bones tip in relationship to each other; this tip gives us the overall attitude, or tilt, of the cube. The height of the cube runs from the hipbone down to the sacrum and ends at the gluteal fold (or the bottom).

Above: Geoff Laurence, *Study for the Offering*, 1998, charcoal on paper, 30 x 22 inches. Notice the articulation of the fingers into planes and cubed forms. This gives a structure and solidity to the hands.

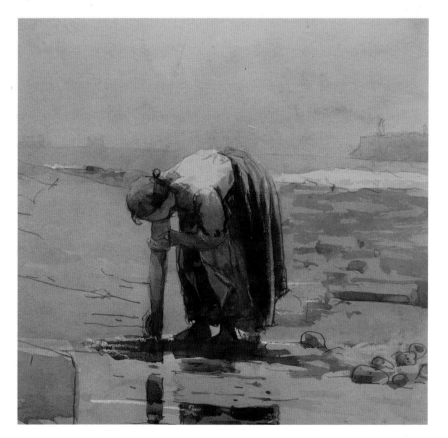

Above: These three cubed forms underlie the figure and give it its sense of solidity.

Left: Winslow Homer, *Starfish*, circa 1880s, ink wash, gouache, and pencil on paper, 7 3/4 x 8 inches, A.J. Kollar Fine Paintings, LLC, Seattle, Washington

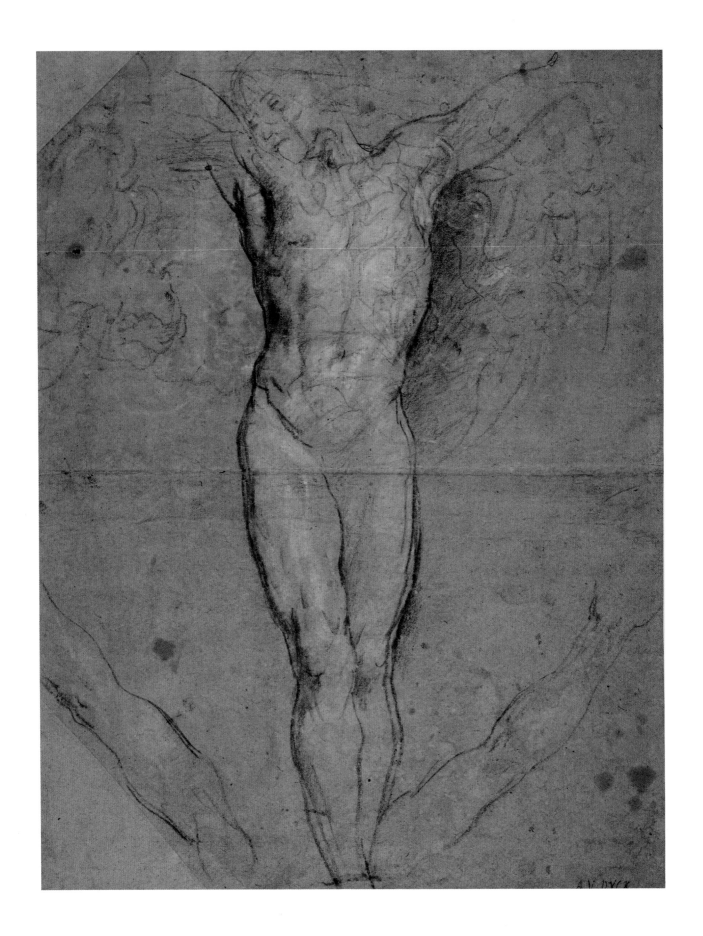

The cubed form of the head is easy to identify. The centerline that runs down the middle of the face defines the attitude of the head in relation to the horizontal lines that intersect the features. The chin forms the base and the top of the head forms the top of the front plane of the cube. The side plane is formed by the top of the skull and the temples on the top and the mandible (or jaw line) to the back of the skull on the bottom; the rounding of the cheekbone articulates the edges of this plane. Even with all the clues provided by creating cubed forms, it is not always easy or even possible to simplify the figure in this way. However, when these forms are apparent they give a strong and reliable starting point for orienting the figure in space.

A beautiful figure drawing is the culmination of many skills that manifest themselves simultaneously. Design provides the scaffolding for the figure and its placement in the rectangle. Line imbues the image with a thematic organization and movement. Value provides mood and organization of value as a pattern. And form provides depth and solidity. When all the elements are integrated masterfully none of the mechanics are revealed. The viewer looks at the drawing and senses the emotion and sentiments that are conveyed. In other words, the viewer sees what the artist felt. This communication, some might argue, is the goal of art.

Below: Anthony Van Dyck, *Dead Christ*, seventeenth century, black chalk, heightened with white chalk, on blue-gray paper, 10 7/8 x 15 7/16 inches, The Pierpont Morgan Library

Photo Credit: The Pierpont Morgan Library / Art Resource, NY

Opposite: Anthony Van Dyke, *Studies for a Painting of the Crucifixion*, circa 1627–1632, black chalk, heightened with white, on green-gray paper, 22 1/4 x 17 1/4 inches, The British Museum, bequeathed by Rev. Clayton Mordaunt Cracherode

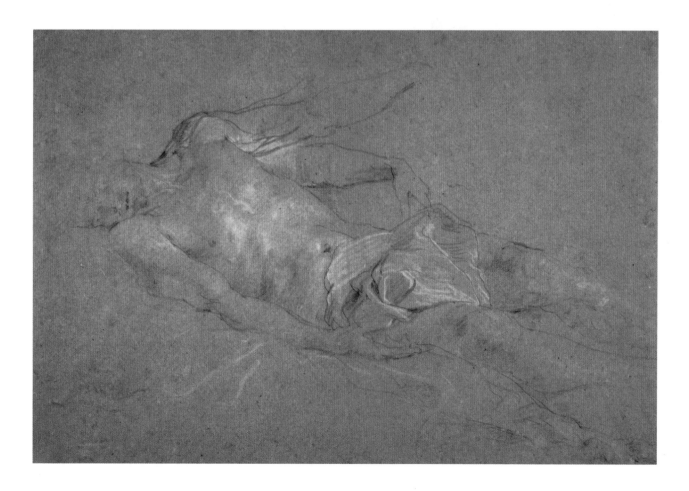

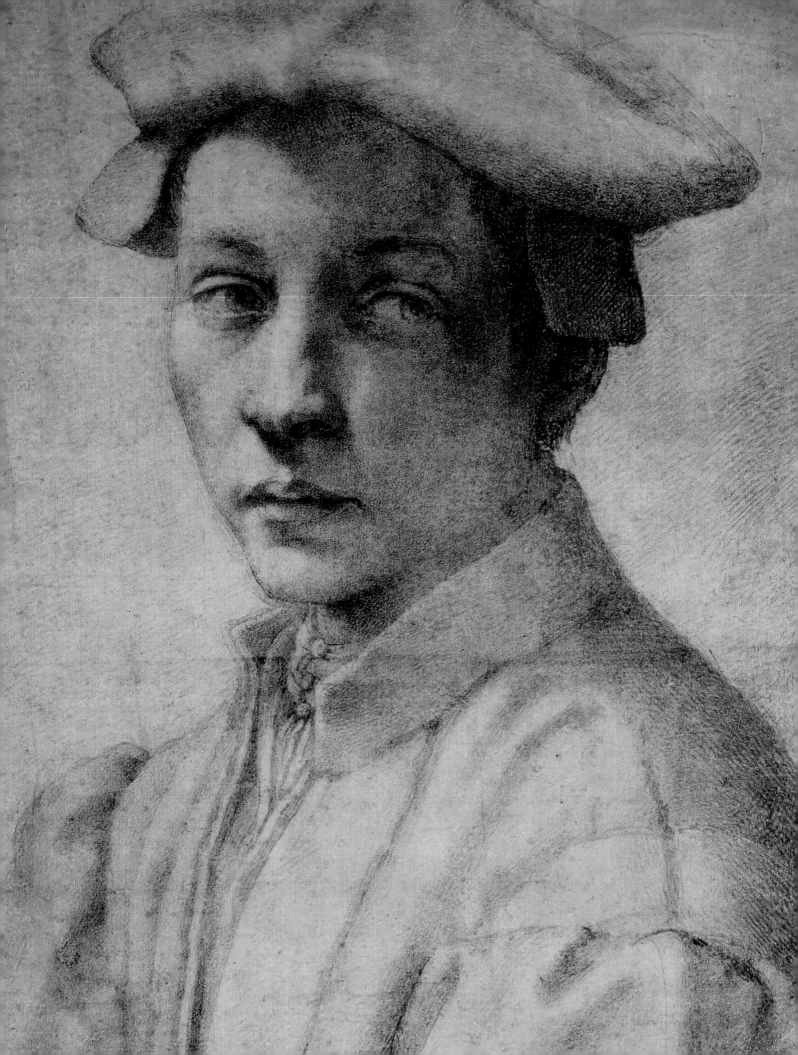

PORTRAIT DRAWING

Window to the Soul

"A writer has to say almost everything in order to make himself understood, but in painting it is as if some mysterious bridge were set up between the spirit of the persons in the picture and the beholder. The beholder sees figures, the external appearances of nature, but inwardly he meditates, the true thinking that is common to all men." — EUGÈNE DELACROIX (from *The Journal of Eugène Delacroix*)

The portrait is a uniquely intimate art form—and is distinct from other genres, such as allegorical, narrative, or history painting, which all utilize the human figure but in very different ways. In allegorical work the figure is not an individual, but rather stands for an abstract concept such as time, justice, peace, or love. In narrative and history painting specific individuals may be represented but their portrayal is intended to tell a story, convey a moral, or illustrate history—in other words to represent an idea greater than the subject. Portraiture, although it has been used for many purposes, is ultimately a celebration of a single human life. It presents an actual person just as he is in a particular place and time in history and makes that small story powerfully relevant to others living in vastly different settings and eras.

In the days before the camera, portrait drawing and painting were highly prized, as they were the only way people could record a likeness of their loved ones. If families were prosperous and fortunate, they would have a handful of images of themselves and those they cared about to pass down to posterity. Now the photograph has made documenting our lives inexpensive and, therefore, accessible to virtually everyone in our society. The technical breakthrough of the camera has signaled the end of portrait painting as a means of mere documentation, but is it the end of portraiture?

The answer is a resounding "no." The greatest portraits are not always the most accurate ones and certainly are not the most photographic. They are first and foremost works of art designed through a process of selection, emphasis, and subordination. The portrait is ultimately valued for its aesthetic merits and its insights into the psyche of the sitter, and it is appreciated and collected even by those who do (or did, as the case may be) not know the subject. When the painting

Opposite: Michelangelo, *Portrait of Andrea Quarates*, circa 1528, black chalk on paper, 16 1/8 x 11 1/2 inches, The British Museum

Photo Credit: Art Resource, NY

is finished it has a life of its own. A butcher painted by Rembrandt can become more famous and valuable than a king painted by an artist of lesser talent.

Portraits remain an intriguing subject to this day, in part because of our inherent fascination with the face itself—especially the individual features. Facial features are instrumental for identity and help us distinguish one person from the next. There is, in fact, so much variety among the facial features t᠁ ᠁ you will never see the same face twice. Beyond identification, however, facial features serve a number of crucial roles. They make intimate communication possible, both verbal and nonverbal. In addition, the features are the gateway for four of our five senses (sight, smell, taste, and hearing); as such, they provide us with much of the sensory information that we need for survival.

Masterpieces of portraiture are not only brilliant technical acheivements, they also reveal insight into the subject and celebrate the intellect. Where the figure drawing is in large part a representation of the body, the compelling portrait adds the dimension of the mind of the sitter to the image as well. The great artist draws an individual, yet in the subject's face we also see both a self-portrait of the artist and a likeness of ourselves. If we commissioned ten master artists to paint a portrait of a young woman, they would all be true and insightful representations, and yet each one would look vastly different.

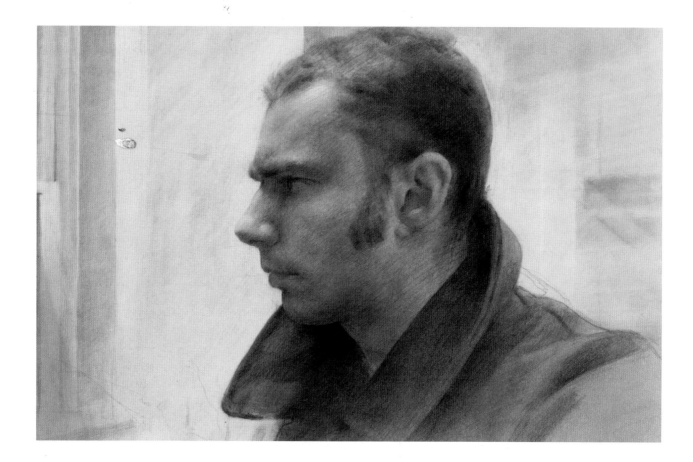

Every painting would express a different quality of the sitter based on the artist's empathy toward the model; she could be transformed into a "Rembrandt" or a "Renoir" while still remaining herself.

Portraiture allows us, as viewers, to connect with the sitter in a uniquely intimate way by eliminating some of the walls that exist in normal encounters. All human interaction is accompanied by personal boundaries that function as gates between intimacy and distance. These boundaries give individuals a feeling of security and govern behavior in interpersonal relationships. For example, as a society we tend to keep a certain distance from one another, even in crowds. If this personal space is transgressed, we become uncomfortable. These personal boundaries include staring at people we don't know.

Part of the power of the portrait is the absence of these walls. We are permitted to enter a space normally reserved for close friends. We can stare at this person. The master portrait captures not only a likeness but a state of mind and emotion, which we are privy to as viewers. When I look at one of my favorite portraits (Rembrandt's rendition of Herman Doomer) I see an unguarded moment of tenderness and sorrow conveyed through his eyes. Rembrandt has given me the opportunity to have an intimate encounter with a stranger from a vastly different place and time.

Above: Michael Grimaldi, *Self-portrait in Left Profile,* 2003, graphite on paper, 10 1/2 x 14 1/2 inches, courtesy of John Pence Gallery

Opposite: Kamille Corry, *Self-portrait* (detail), 2005, charcoal, pencil, and ink on paper, 18 x 19 inches

Portraiture in Art

Portraiture spans the history of western art—from the likeness of the dead on Egyptian coffins through to the expressionistic representations of our own times. We could not possibly relay the breadth of this vast tradition in such a short space. Therefore, I will touch upon the major themes that parallel the ages we have discussed in the other sections of the book.

Although portraiture existed in ancient Greece, it did not flower until Roman times, when it became intrinsically linked to the individuality of the sitter. Roman portraits functioned on both the public and private level. Portraits were used to commemorate politicians, military leaders, and emperors. In an era when few people could read, low-relief portraits, often in profile, were pressed into coins and disseminated throughout the empire. They conveyed ideas about the rulers, such as their military might or their likeness to the gods. Private portraits were also popular among the wealthy. This kind of portraiture flourished in part because ancient Roman culture embraced a form of ancestor worship, and went to great lengths to memorialize the dead. Some of the most realistic and spectacular ancient portraiture came from Faiyum in Egypt during the second century c.e., when that area of the world was part of

Right: D. Jeffrey Mims, *Self-portrait* (detail), 1999, charcoal and colored chalks on toned paper, 35 x 30 inches

Opposite: Michael Grimaldi, *Study for Gawaine*, 2003, graphite and charcoal on paper, 20 1/2 x 26 1/2 inches, private collection, courtesy of Arcadia Gallery

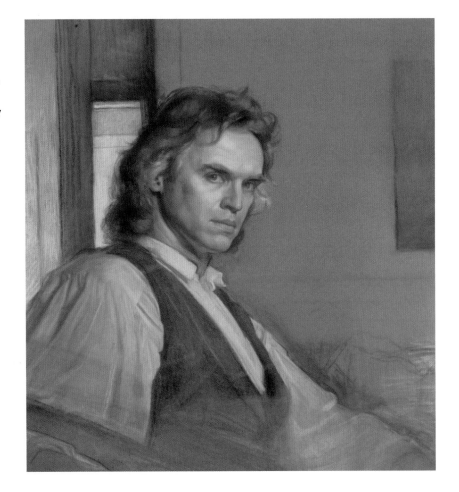

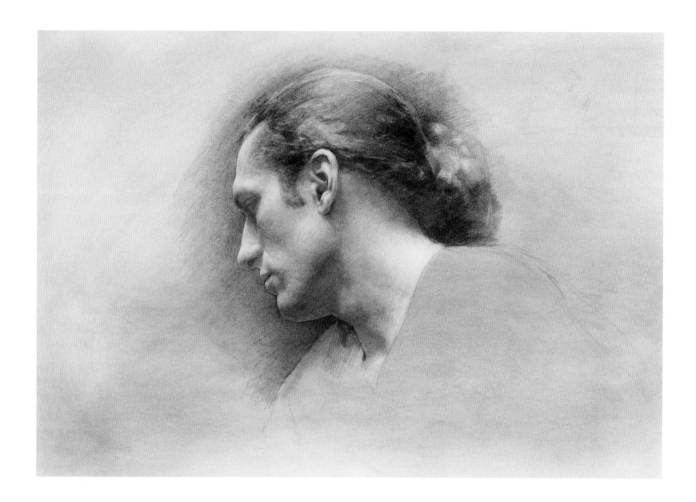

the Roman Empire. These portraits were painted in encaustic on wood or linen and then attached to the mummified bodies.

Although portraiture existed in the medieval period, it was generally associated with funeral customs or used to acknowledge donors of commissioned work. However, with the dawn of the Renaissance and the new emphasis on the individual, portraiture came back into prominence along with an interest in all things classical. An example from the High Renaissance in Italy is Raphael's portrait of Baldassare Castiglione from 1514. Castiglione was a count and a friend of both the artist and his patron Pope Leo X, and this painting is one of the most beautiful and realistic portraits of the time. The German Renaissance artist Hans Holbein the Younger is likewise celebrated for his portraits of members of the court of King Henry VIII. These sober portraits struck a careful balance, both displaying the formal rank and capturing the unique likeness of the individual.

The practice of self-portraiture also began in the Renaissance. Raphael, Leonardo da Vinci, and Albrecht Dürer all painted self-portraits during their careers. These works allowed them to experiment with new styles and techniques and

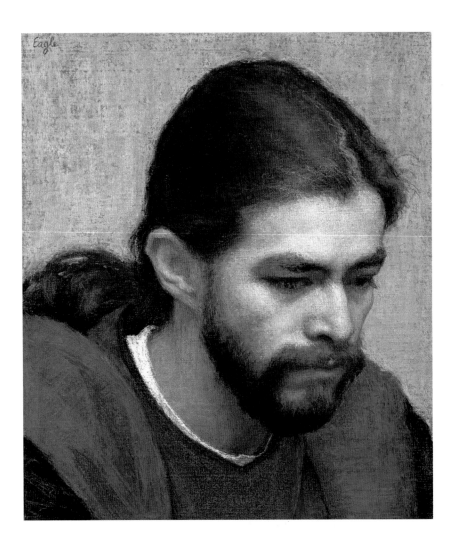

give us insight into the minds of these artists. The study of self-portraiture has continued through the centuries and remains popular to this day.

Portraiture continued to be an important genre of painting after the Renaissance, in large part due to the rise of the middle class and the effect that this had on patronage. Portraiture fully flowered in the Baroque era. The portraits created during this time are noted for their expressive qualities, capturing an internal world as well as an external one. There was a technical virtuosity, a grace, and a naturalism exemplified in the work of such artists as Diego Velázquez, Anthony Van Dyck, Peter Paul Rubens, Rembrandt, and Frans Hals, whose brilliant portraits helped define the era. Moving on to the eighteenth century we have contributions to the genre from such excellent portrait artists as Joshua Reynolds, Thomas Gainsborough, Elisabeth Vigée-Lebrun, and François Boucher. These artists celebrated the wealth and beauty of their clients, showing their high social status. Gainsborough's painting of the elegant Duchess of Beaufort comes to mind, with her pale skin, tall, powdered wig, and elongated, graceful gesture.

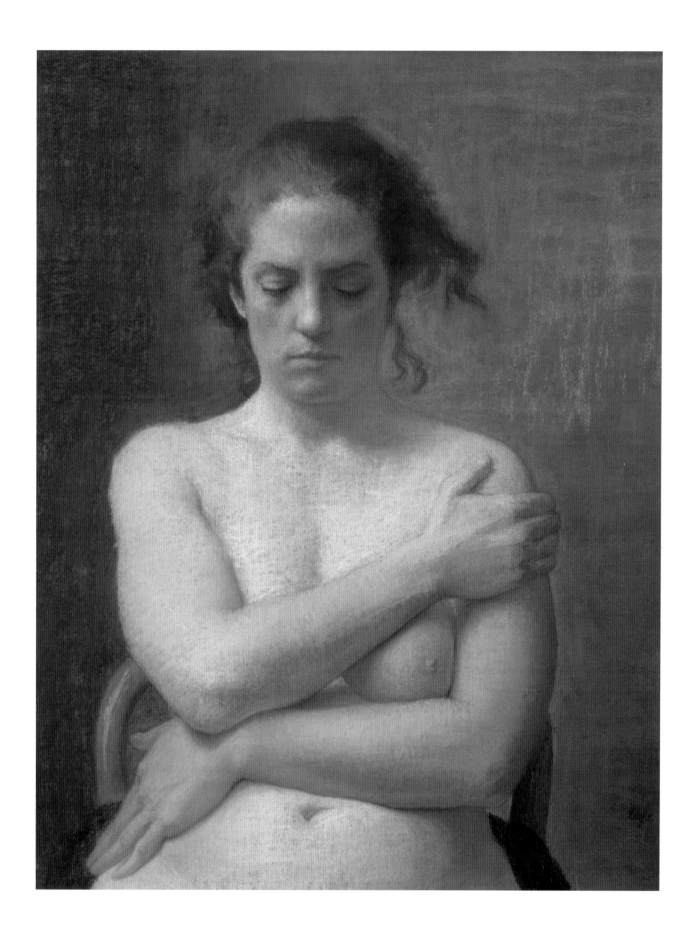

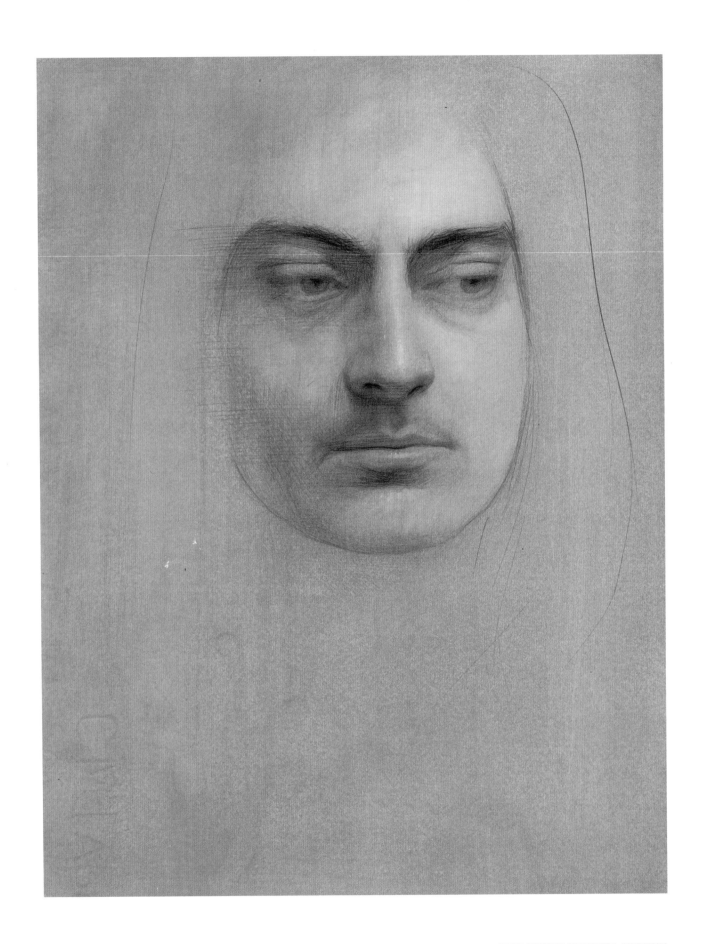

The nineteenth century was a period of great change, starting with the continuation of the neoclassical movement from the previous century and ending with the postimpressionists. Some of the contrasting views seen in the century are exemplified in the work of Jean-August-Dominique Ingres and Théodore Géricault. Ingres's *Napoleon I on His Imperial Throne* from 1806 exemplifies this style, with Napoleon presented as a Roman god in a powerful frontal view with his raised hand holding a royal scepter. By contrast, Romantic painters, whose influences included Eastern cultures, sought to portray movement, energy, and spontaneity in their painting. Géricault's *A Mad Woman* from 1822 is a formal portrait of an unconventional subject matter. With her shoddy dress, bloodshot eyes, and asymmetrical face, this portrait presents a member of the margins of society with much dignity and compassion. These two schools of thought gained momentum throughout the nineteenth century and continue to influence portraiture, including works produced in our own time.

Body and Mind

The body is in a unique position to communicate the thoughts and emotions of the mind. Only a small percentage of the content expressed during a conversation or exchange is transmitted by the words themselves. The bulk is conveyed by accompanying body language—the way a person tilts his head when he is talking, or hunches his shoulders when he is upset. If the relationships of the head, neck, and shoulders are correct in a portrait, the likeness often starts to emerge, even before any features are rendered.

Perhaps even more than the other parts of the body, the face is a highly sensitive instrument for communicating the thoughts and emotions of an individual. In contrast to other muscles, many muscles of the face attach directly to the skin and their purpose is to offer infinite and minute changes of expression. The master portrait artist uses his knowledge of these muscles to help describe and capture the complex range of emotion found in the face. As viewers, we are so good at reading and interpreting subtle expression shifts that we can differentiate between a counterfeit smile an authentic expression of joy. The range of expression reflected in the human face is unique in nature.

Nude portraits are not common. This is because it is difficult to convey a clear message when the body and mind compete for the viewer's attention. The body represents our sensuality and what we have in common with the rest of nature—the sexual drive, the need to eat and sleep, and other things physical. By contrast, the mind represents our identity and intellect, that which produces culture, friendship, love of beauty, love of God, and things that are appreciated for their own sake rather than their utility. We consider our minds and our faces more divine than earthly. Thus, if the body and the face vie with one another, it becomes difficult to know where to look—at breasts or at eyes.

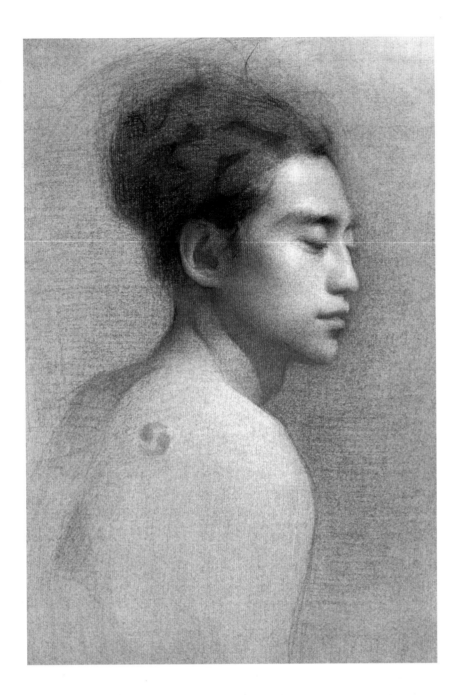

Obstacles to Observation

Familiarity with the face and our dependence on it as a communication tool
can block objectivity in drawing. As artists, our goal is to enter a naïve visual
state in order to see the world not as we think it is, but as it truly is. It takes a
lot of courage for someone to forget what he knows and observe what is really
there. It takes training to see the world as an artist.

Beginning artists often draw the equivalent of symbols for the eye, nose, and
mouth rather than the vague, obscured shapes that are found in life. The result

feels artificial. Every eyelash is in place yet in actuality the model's eyes seen by the artist are nothing more than a shadow shapes. Portraits drawn by students are also often marked by distortion. The features are too big for the face and are often conceptually drawn rather than carefully observed.

It is hard to gain objectivity when working from a model and it is even more difficult in portrait drawing. The facial features that are so helpful in aiding people to function in life can become the biggest obstacles to seeing the head with objective detachment. The eyes and mouth, which are so predominant physiologically, are actually of little importance when establishing a resemblance of an individual. Thus, the main difficulty that artists face when drawing a portrait is one of distance. In order to make a good work of art the artist often needs to separate himself from the sitter to try and see him objectively.

The artist should focus on what he can actually see instead of what he wants to see. It takes courage to squint at the model to subordinate the small forms of the head to the large planes. I have seen students using binoculars to stare into the places that they cannot see in order to find the eyes. The artist must trust that if he draws it the way he sees it, it will look convincing. When looking at a masterful portrait by Rembrandt, it is interesting to notice how broadly it is painted. He has given the impression of great detail without actually painting it.

Elements of Portrait Drawing

Daniel Parkhurst wrote, "Don't undertake the painting of a head without considering well that you are likely to have trouble, and that the trouble you will have is most likely to be of a kind that you don't expect. But, having begun, keep your heart and your grit, and do the best you can. Remember that you learn by mistakes, and failures are a part of every man's work, and of every painter's experience, and not only of your own."

It is hard not to laugh at Parkhurst's assumption of imminent failure. Every artist secretly anticipates this, yet very few discuss it. M. Bertin, a client of the great artist Jean-Auguste-Dominique Ingres, whose portrait now hangs in the Louvre, said, "Ingres used to weep and I spent my time consoling him." The reasons for potential failure have already been discussed, including the barriers to seeing objectively, the complexity of the subject, the margin for error, and people's familiarity with the subject. Nevertheless over the ages artists have found ways to approach the subject that stack the cards in their favor.

Aim for gradual accuracy over the course of the drawing instead of trying to get an exact likeness up front, which can have a stifling effect. Richard Lack said that it is easier to draw a head than a portrait, so he recommended that students try to create a good head study and be pleasantly surprised if it becomes something more. Having realistic expectations helps an artist put

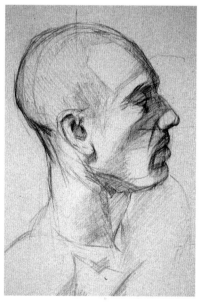

Top: Mark Kang-O'Higgins, *Skull Block In*, 2005, charcoal on paper, 24 x 18 inches. The skull imparts the structure of the head, providing its form.

Above: Mark Kang-O'Higgins, *Male Profile*, 2005, charcoal on paper, 18 x 24 inches. The bone of the skull is just below the surface of the skin and it is easy to see its influence on the shape of the head.

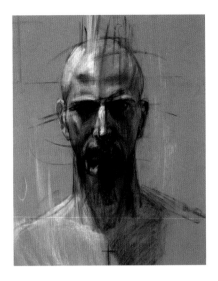

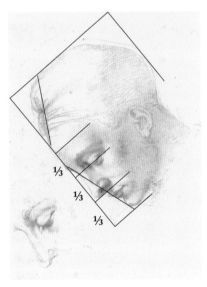

Top: Mark Kang-O'Higgins, *Genesis (Self-portrait)*, 2004, charcoal on paper, 24 x 18 inches

Above: The facial features can be positioned by measuring the face into thirds. The underlying image is Michelangelo's *Leda*. An unadulterated version of this image is shown on page XIII.

aside the immediate desire to focus on the physiological aspects of the sitter and trust that if everything else is in place that element will come unsought.

One method for getting started is to block in the gesture of the sitter by focusing on linear angle directions. To do this, first place a center line down the middle of the face to see which direction the head is tilting and determine its angle. Then add a horizontal line across the clavicle, which helps determine the angle of the shoulders. Finally, sketch the angles of the contour of the model, including the head, neck, shoulders, and rib cage. I often find that when these elements are in place, a likeness starts to emerge.

To locate the positioning of the features, place a few simple markers that will serve as guides. The center line of the face is an anchor for the other measurements. Find the halfway point along this line; on a level head this generally marks the position of the eyes. The major facial features can be easily found by checking measurements. For instance, from the chin to the bottom of the nose is generally one third. From the underside of the nose to the brow line and from the brow line to the hair line are also one third each.

This system is based on standard measurements and can help get the drawing started. However, each person is unique, so develop your image by aligning angles with no preconceptions, just look for the unexpected relationships found in the model. For instance, check the horizontal line that extends from the eyebrows to see where it intersects with the ears; make a vertical line from the eye to see where it hits the neck; and so on. (See the master copy of Leonardo da Vinci's *Study of a Head* on page 46 for inspiration.) These angles form a web of relationships, which start self-correcting each other and forming shapes.

In the next stages, find the shadow shapes and use these values to further correct the drawing. These continents of light and dark reveal the tonal structure and give verisimilitude to the drawing. When everything looks accurate, turn form in small areas to create a convincing tonal structure. As the artist renders these small shapes, he is actually also making an assessment of tiny relationships, including the direction and quality of the light. Ultimately, drawing the head is just like drawing anything else. The difference is that the relationships need to be finely tuned in order to be believable and accurate.

Despite the difficulties inherent in drawing a portrait, there is a great reward when it has been done well. When the technicalities have been mastered and the artist can freely transcribe what he is seeing, a new element often enters into the work. This indescribable quality conveys a spirit and an emotion that transcend the subject. The powerful wordless communication that is possible with great portraiture motivates many artists to keep working—and draws a steady stream of visitors to museums and galleries to view the masterpieces that they have made.

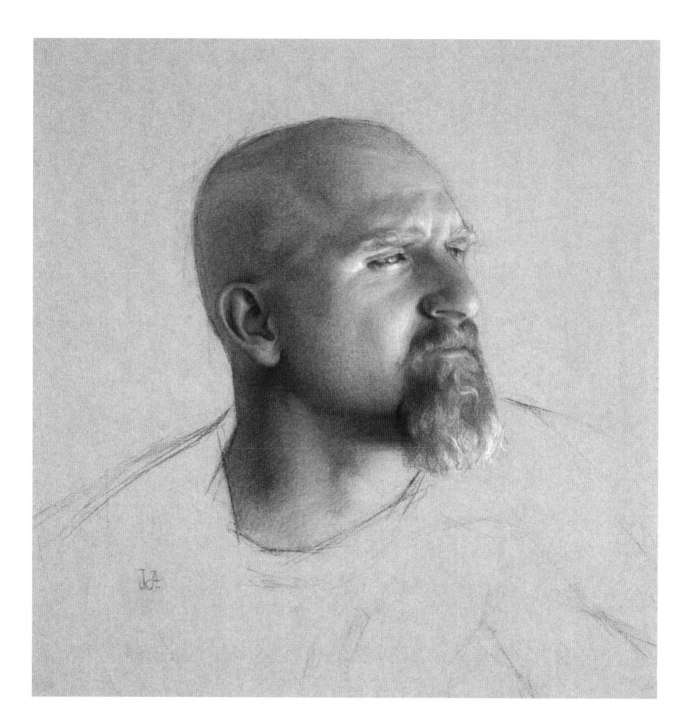

We live in a new era and have insights unique to our time, yet our fundamental human nature remains the same as it was in ancient times. The desire to make a contribution, to live a life of significance, and to create something that outlasts our time is intrinsic to humanity. The elements of drawing outlined in the book thus far form the foundation of great drawing throughout the ages. Understanding these principles will ensure that our contemporary art will not only speak to a new generation but will join the great art of the past and transcend the time in which it was made.

Juliette Aristides, *Forrester,* 2000, sepia pencil and charcoal on paper heightened with white pencil, 16 1/2 x 16 inches, private collection

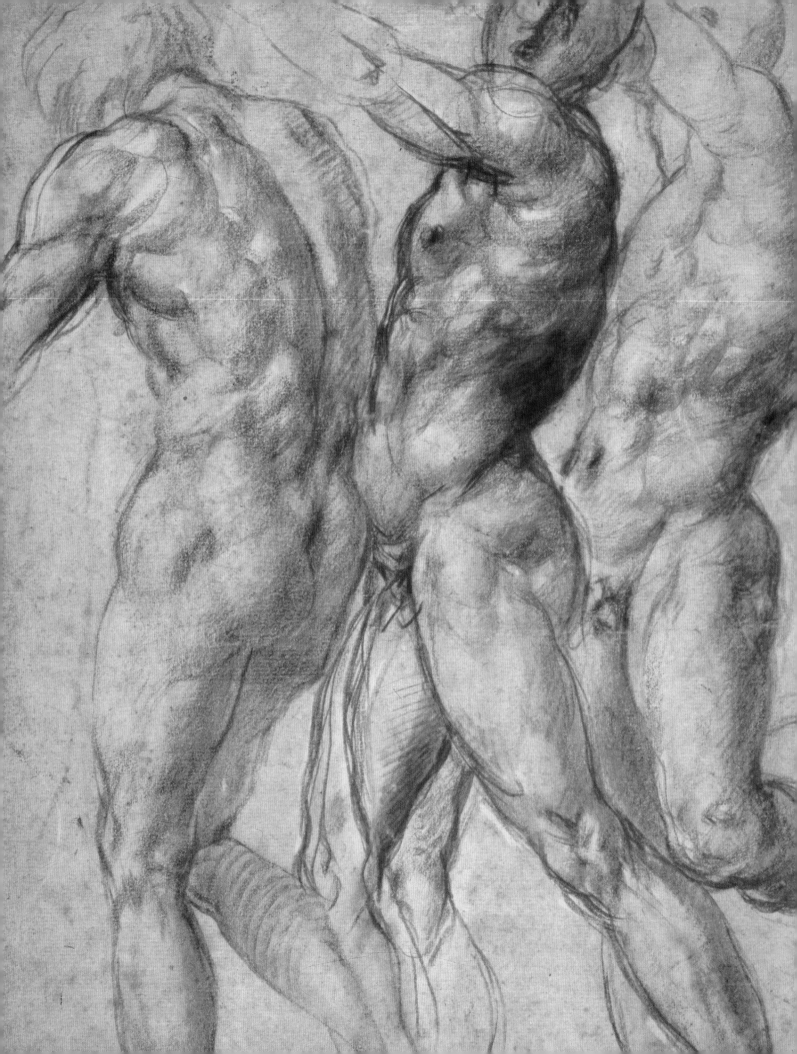

Putting Theory into Practice

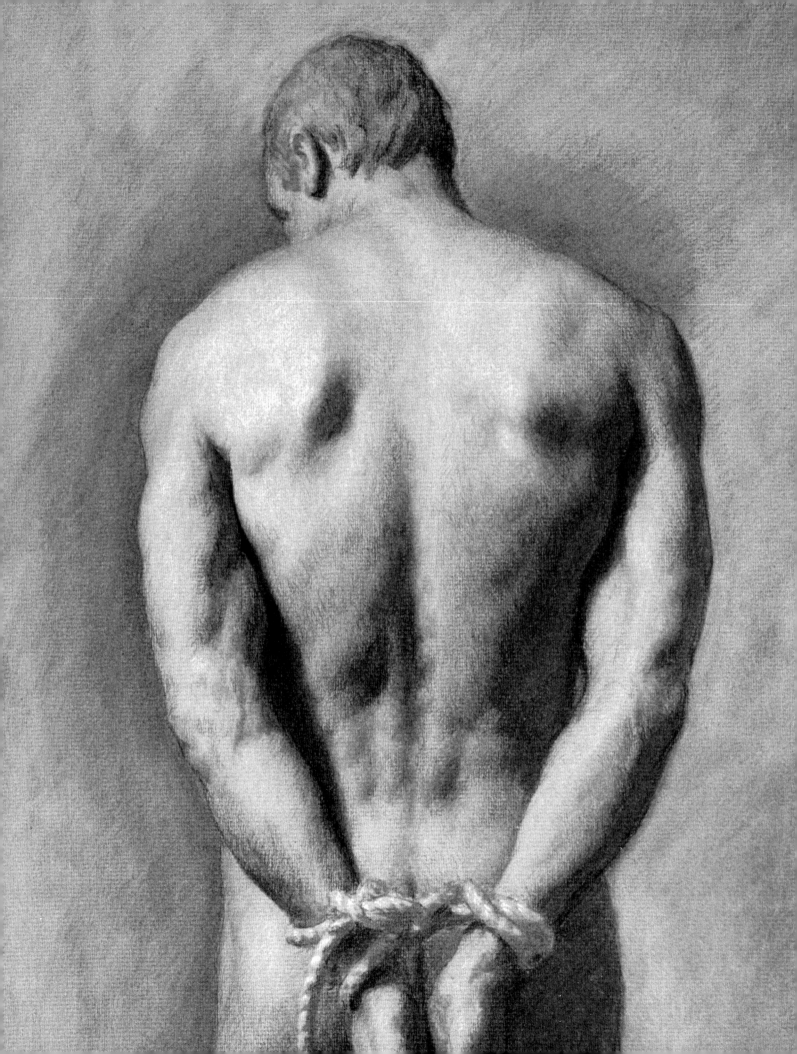

CHAPTER TEN

ATELIER DISCIPLINES

Finite Principles, Infinite Applications

"I would have those who begin to learn the art of painting do what I see practiced by teachers of writing. They first teach all the signs of the alphabet separately, and then how to put the syllables together, and then whole words. Our students should follow this method with painting." — LEON BATTISTA ALBERTI
(from *On Painting*)

Unlike a cake, which has a recipe that, if followed correctly, will produce a consistently good dessert, a drawing has too many variables to predict any one outcome. Depending on the purpose or nature of the subject matter of your drawing, many different approaches could be followed. Unfortunately, there is no quick trick that will enable the student to avoid traveling the long road necessary to become a well-trained artist. Classical training is a lifelong process of gaining experience through practice and application of sound principles. Drawing is an organic process that requires more than simple acquisition of a series of techniques. No one can learn to draw solely from a book; learning to draw takes years of practice under the guidance of a trained artist.

Mastering the art of drawing is also more than creating one good piece of work over the course of many months in a studio under the guidance of a teacher. That one good drawing is like a rare flower blooming in perfect hothouse conditions. Students must know why and how the techniques they have learned work in order to have a consistent level of production. A careful balance between knowledge and experience makes the student resilient enough to survive the transplant from the atelier into the more natural setting of his own studio outside of a school.

Often an understanding of the theory of art, how and why things work, can be gained through reading. A book such as this one can give information that serves as a general guide to aid the practices of an art student. A book can fill in the gaps in an artist's education and provide a road map for continued training. This basic road map can empower art students to confidently question and pursue their educational choices, ensuring that no part of their time is wasted on fruitless activities. A book can also provide some of the background theory and history that give a cohesive context for the often confusing and conflicting world of art.

Opposite: John De Martin, *Bound* (detail), 2004, black and white chalk on blue paper, 18 x 12 inches

Previous Spread: Jacopo Pontormo, *Study of Standing Male Nudes* (detail), early to mid sixteenth century, red chalk and traces of white chalk on paper, Musée des Beaux Arts, Lille, France

Photo Credit: Rénion des Musées Nationaux / Art Resource, NY

The assignments laid out in this chapter parallel the beginning course of study for an atelier student. Each lesson includes an explanation of the goal of the exercise, lists the supplies that will be needed, offers tips for setting it up, and outlines the stages for its completion. By trying the recommended projects at home, you will gain a more complete understanding of artistic principles than could be gained by reading alone. Through hands-on practice, the theory of art discussed in the text can be transformed into insight and you can begin to make this knowledge your own.

Purchasing Your Materials

The materials needed for drawing are quite simple and inexpensive. Basically, you need something to draw with and something to draw on. The materials listed below are recommended for the exercises in this chapter. In addition, it is helpful to have an easel and some kind of controlled lighting situation (such as a lamp or spotlight); however, a large board, a table, and a window (preferably north-facing) will suffice. Don't wait until you have the perfect materials to get started. Masterful drawing can be done with a ballpoint pen and a piece of paper at the kitchen table, if all else fails.

DRAWING MEDIA

Vine charcoal and graphite pencil are the two essential drawing media. Vine charcoal is recommended for large drawings or those requiring a wide value range because the medium can get very dark without effort and because it erases easily. However, it takes practice to learn to control charcoal. Some students prefer pencil because it is lighter and more easily controlled.

Vine charcoal is essentially sticks of charcoal made from burnt pieces of wood. It is a flexible medium that can build up a wide range of values, quickly mass in large areas of tone, be easily erased, and be sharpened for more delicate work. It comes in soft, medium, hard, and extra hard. You will want all four kinds until you find the ones that work best for you.

Graphite pencil is an acceptable alternate medium to vine charcoal, particularly when you want to do light, detailed work. Graphite pencils are available in a range of densities, from 10H to 8B. (H stands for hardness and B stands for blackness.) For these exercises, you only need the range between and including 2H and 2B. If you find you want to go darker, then add additional pencils.

White pencil is used when drawing on toned paper to build up highlight areas. Many different kinds of white pencils are available. Experiment to see what works best for the paper you have chosen.

PAPER

A number of different papers are used in the atelier. Each student determines what he needs based on preference and on what drawing medium will be used for a particular piece. All of the exercises—with the exception of drawing on toned paper and silverpoint drawing—are done on white paper.

Charcoal paper has a slight "tooth" to the surface and is designed to be used with charcoal, as completely smooth drawing paper will not hold the charcoal satisfactorily. Some good, inexpensive, easy-to-find charcoal papers are made by Strathmore Ingres, Fabriano Ingres, and Hahnemühle Ingres. Higher-grade charcoal paper, such as that made by the Ruscombe Paper Mill, is delicate to work on, but is also more expensive.

Smooth drawing paper works well when you're drawing with a graphite pencil. Some recommended brands are Arches Aquarelle, Strathmore, Stonehenge, and Bristol.

Newsprint is used to provide padding underneath the good paper when you're doing your drawing.

Tracing paper or acetate is a transparent or semitransparent paper used to overlay a drawing for analysis or to transfer a drawing.

Toned paper is available in a number of varieties, including rough and smooth surfaces. Often the more expensive, higher-quality papers easily respond to gentle gradations of tone created by the drawing media; however, they are very delicate and easily damaged by erasing. A more resilient paper is often more appropriate for the needs of the beginning artist. In this section, you only need toned paper for the alternative sphere drawing lesson.

OTHER MATERIALS

Many of the materials listed here are specifically for the silverpoint exercise. If you want to get started with a charcoal or graphite drawing right away, you only need a kneaded eraser, chamois, sandpaper, (pencil sharpener), small mirror, plumb line, and knitting needles or skewer.

Kneaded erasers are for erasing mistakes in small areas. You'll want at least one pliable gray eraser.

Chamois erases broad areas of tone. This soft cloth will last for a long time.

Sandpaper is used to sand the charcoal, graphite pencil, or silverpoint pencil into a sharp point. A 220-grit sandpaper works well for this purpose.

Pencil sharpener is used as alternative for sharpening graphite pencils.

Small mirror is helpful for viewing your drawing. Leonardo da Vinci mentioned this in his notebooks as a way to be able to see a drawing in a fresh light, as it is easier to see mistakes in the reflected image than in the actual drawing.

Plumb line is a thin, dark thread with a weight at the bottom. It creates a true vertical line, which can be used to compare vertical angles and for measuring purposes.

Narrow knitting needle or skewer can also be used for sighting angles and for measuring.

Cast is required for the cast drawing exercise. Casts can be bought in a statuary store, art store, or online at such places as www.statue.com, www.eleganza.com, www.giustgallery.com, and www.designtoscano.com.

Opposite: Sharpened sticks of vine charcoal. To sharpen your charcoal simply hold it flat against the sandpaper and rotate it so each side gets flat. Try not to put pressure on the point as you do this or the charcoal may snap in two. Save your charcoal shavings; this powder will be used for the reductive drawing.

Below: Drawing materials.

Photo Credits: Greg Nyssen

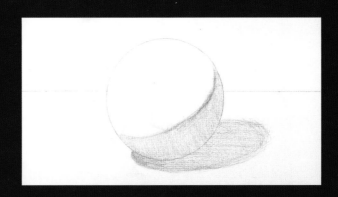

Stage One: Position the circle and horizon line in relation to your paper, and draw the shadow shape and cast shadow.

The goal of drawing the sphere is threefold. It offers an ideal forum in which to practice creating the illusion of form, study simple compositional relationships, and master a drawing medium. The sphere is a pure geometric object that reveals form very easily. Understanding how light hits such a simple shape becomes the basis for recognizing how light hits almost every other form. Most other drawing subjects, such as a portrait or figure, require the ability to turn form on a far more complex object. However, due to the simplicity and purity of the sphere, skills can be mastered methodically. Mistakes are revealed easily; the sphere hides nothing.

This sphere project will allow you to study a simple composition and the relationship between a foreground, background, and object in relation to a light source. It is a useful exercise to help think about spatial relationships, value patterns, and form drawing. The last challenge posed by this lesson is to master a drawing medium—either charcoal or graphite. This is a great practice exercise to help you become familiar with and gain confidence in employing a particular drawing medium.

Gathering Your Materials

In preparation for creating your sphere drawing, assemble the following materials:

- White ball (or any colored ball painted white)
- Vine charcoal or graphite pencils
- Charcoal paper or smooth drawing paper, depending on which medium you have chosen
- Sandpaper or pencil sharpener
- Kneaded eraser
- Chamois
- Newsprint

Setting Up Your Drawing

Illuminate the sphere so that it is has form-revealing lighting, with two thirds of the sphere in the light and one third in shadow. Make sure that you can see a flat horizon line (where the background, such as a wall, meets the ground plane, such as a table). The horizon line should be at eye level and should be straight. If you are looking down at the sphere or if the horizon line is tilted, the sphere in your drawing will look as if it is rolling off the table. You can use an easel or set up a board to rest against a table. Always pad your paper with newsprint.

Drawing the Sphere

While doing this exercise, there are just a few things to keep in mind. It is important to keep your charcoal well sharpened. It is easier to tone in your shadow shape value and ground plane value before moving on to rendering the sphere itself. This will give you a context for judging the accuracy of your values within the sphere. It is advisable to have a light ground plane or to render the tabletop as being lighter than the background. This will reinforce the idea that the ground plane is being hit by the same light source as the sphere.

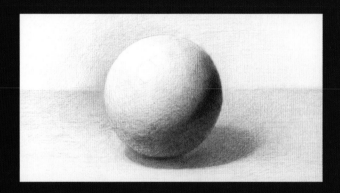

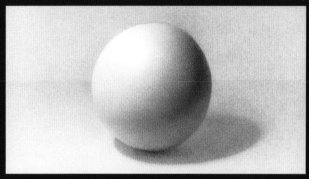

Stage Two: Develop the circle into a sphere by placing halftones along the core shadow line of the sphere and additional tones adjacent to the sphere.

Stage Three: Fully resolve the halftones on the sphere and add depth and space to the background.

STAGE ONE: BLOCKING IN THE SHAPE

First, create a simple line drawing of a circle; it is fine to use a compass or stencil. Although this drawing contains only one object, it is still important to think about its compositional aspects. Consider where the sphere will be located in the rectangle shape of your picture, how high the horizon line will be in the background, and at what place the horizon line will intersect the sphere. Determine how much space you want above or below, and on the left and right, of the sphere as well as the direction from which you want your light source to come. After you have established your circle, draw a simple crescent to indicate the shape of the shadow on the sphere. Lightly tone down the shadow shape with your drawing medium to show the direction of the light.

STAGE TWO: CAPTURING LIGHT AND SHADOW

The sphere is not an isolated entity; it exists in an atmosphere of air and light. Now consider how the sphere relates to its environment by establishing the value of the background and the ground plane as well as the shape the shadow casts onto the ground plane. You will notice that the outline of the sphere is not easily seen all the way around; there are moments where it merges or dissolves into the background tone. This is called "losing an edge" or "passage." These small areas of lost form have an important role in the drawing, as they link the object to the surrounding environment. This stage of the drawing provides a tonal map of the overall relationships.

STAGE THREE: FOCUSING ON FORM DRAWING

The halftone area of the drawing is responsible for the feeling of form or volume in a work of art. Because the sphere is a continuous round surface, careful gradations of tone are necessary to convey the illusion of bulging form. At this stage, it is important to focus on turning the form between the core shadow line and the highlight. (See the value sphere on page 65.) Try *not* to render the form as concentric circles, as this would just reemphasize the shape of the core shadow. Rather, turn the form by focusing on the values perpendicular to the shadow line, working from the core shadow up to the highlight. This motion reinforces the girth of the object.

When you have completed these gradations, make sure all the areas look complete. Then assess the success of the drawing as a whole. I recommend making a list of things that can be improved during the final pass (such as darkening the core shadow, identifying points in the sphere where you want to lose the edge, or adjusting the shape of the sphere) and, one by one, working through the list until the drawing feels complete.

Above: Yumiko Dorsey, *Sphere Drawing*, 2005, charcoal on white paper, 6 x 9 1/4 inches, courtesy of the Aristides Classical Atelier

MASTER COPY DRAWING

Stage One: Using straight lines, block in the angle directions and map out the abstract patterns and relationships.

The goal of this lesson is to study the great drawings of master artists and create a drawing in the spirit of a single masterwork. By imitating the accomplishments of artists who came before you, you will surpass your current skill level and gain particular insights into the master artist's working method and use of materials. This lesson often provides surprising solutions to problems and enlarges a student's artistic vocabulary. By careful and detailed study of a brilliant drawing, you can find inspiration, enjoy camaraderie, and learn to push the boundaries of what you believe is possible. Through the process of analyzing, deconstructing, and rebuilding a masterwork, you will gain experiential knowledge of the working methods of the master that cannot be found any other way. It also provides an excellent process through which to master your selected drawing medium.

Gathering Your Materials

In preparation for creating your master copy drawing, assemble the following materials. Feel free to experiment with different drawing media, depending on the image that you are copying. For instance, if the original uses pen and ink, use that instead of charcoal or pencil.

- Vine charcoal or graphite pencils
- Charcoal paper or smooth drawing paper, depending on which medium you have chosen
- Sandpaper or pencil sharpener
- Kneaded eraser
- Chamois
- Newsprint
- Tracing paper
- Plumb line
- Small mirror

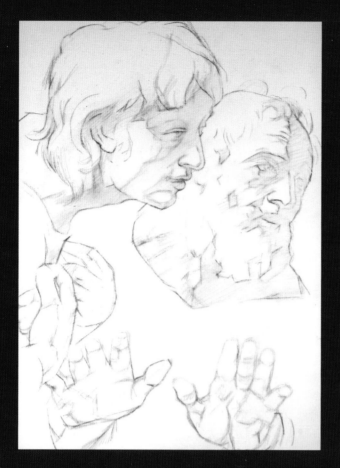

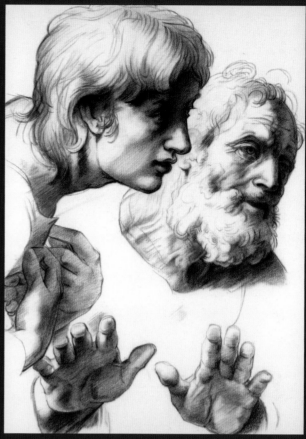

Stage Two: Determine the placement of the biggest shapes and add a light tone on some of the shadow shapes.

Stage Three: Push the full range of values and turn the form to give the illusion of light, shade, and volume.

Selecting Your Master Drawing

In addition to gathering your basic drawing materials, you need to select an image to use for this lesson. It can be taken from a book, printed from an online source, or drawn in a museum from the original. One approach to choosing your drawing is to immerse yourself in the work of one particular artist or period of time. This could lead to creating a number of master copies of that particular artist's work. Another approach to choosing a masterwork could involve focusing on technique. Approaching the lesson in this way allows you to get a handle on the limitations and freedoms of a particular drawing technique. Yet another approach is to look to master drawings as a means of problem solving. This can be a very useful way to gain artistic tools.

Setting Up Your Drawing

For this lesson, we will be copying the masterwork line for line. This will provide you with a detailed examination of the master artist's technique, and at the completion of the lesson you will have a facsimile of the original work. Attach the master drawing on one side of your drawing board. Place your paper next to and directly aligned with it. Plan to work the same size as the piece you are copying; this will allow you to compare your measurements to the original drawing to ensure correct proportion and will help train your eye to see and reproduce exactly the same shape.

Above: Joshua Langstaff, copy after Raphael's *Cartoon for the Heads and Hands of the Two Apostles in the Transfiguration*, 2006, graphite pencil on paper, 9 x 12 1/2 inches, courtesy of the Aristides Classical Atelier

Executing Your Master Copy Drawing

Before beginning your drawing, it is a good idea to analyze the masterwork. One way to do this is to place a piece of tracing paper on top of the original and sketch it. This provides the opportunity to try different theories without spending a lot of time actually producing a drawing. Analyze the piece by looking for its structure. Ask such questions as: Is there a repetition of certain governing lines? Is there a dominant arabesque? Are there cubed forms underlying the structure that give the drawing its power?

STAGE ONE: BLOCKING IN THE SHAPE

Begin by marking the top and the bottom parameters of the drawing on your paper so as to establish a sense of scale. Then place a dominant vertical line to anchor the drawing. Lightly sketch the overall proportions of the piece and place any key directional lines that give a sense of the gesture. Proceed naturally with your drawing, just as though you were drawing from life. Work from large shapes to small shapes. Continuously check the original piece to ensure that the proportions of your drawing are the same.

STAGE TWO: CAPTURING LIGHT AND SHADOW

Increase the accuracy of your drawing by zeroing in on smaller areas. Before adding any line, check what is above it, below it, and diagonal from it by using a plumb line to compare across from one drawing to another. By following this process of comparison you are sure to self-correct and catch any inaccuracies that could occur in the drawing process. Gradually the lines that you place will lose their abstract quality and begin to describe shapes and enclosures. Once you get a likeness, you should determine core shadow shapes and any key areas of structure. Depending on the drawing, you might want to lightly hatch or tone the shadow shape areas. This will give you another way to improve the accuracy of the piece. Often it is easier to correct the small forms on a toned area than in line.

STAGE THREE: FOCUSING ON FORM DRAWING

This is the fun part of the drawing. Once you have determined the general proportions of the drawing and placed the overall shapes, it should already look a lot like the masterwork. Now is the time to zero in on your line work or tonal relationships. Focus on the weight and the character of the lines. Try to create fluid lines that are executed with confidence, even if they are not perfect. An unencumbered, self-assured line that is wrong will be more pleasing to look at than a painfully accurate line that has been erased sixteen times. Turn form on smaller areas, paying close attention to all the areas of subtle halftones, hatched volumes, and the undulation of lost and found edges. Match the areas of value as closely as possible, making your dark areas as dark or light as those found in the original.

DOING A MORE INTERPRETIVE STUDY

After you complete your line-for-line drawing of the masterwork, you may want to do another drawing of the same image, using a more personal and interpretive approach. Doing a freer interpretation of the masterwork can provide a more general sense of the drawing as well as be a source of inspiration. When taking this approach to copying a master drawing, you can use any medium you want.

For example, you can do a drawing of a painting or use pen and ink to copy a drawing done in pencil. You can also work in any size, making a small drawing larger than it is, or shrinking down a larger work.

Opposite: Rembrandt van Rijn, *Abraham's Sacrifice*, 1655, etching and drypoint on paper, 6 1/8 x 5 1/8 inches, A.J. Kollar Fine Paintings, LLC, Seattle, Washington

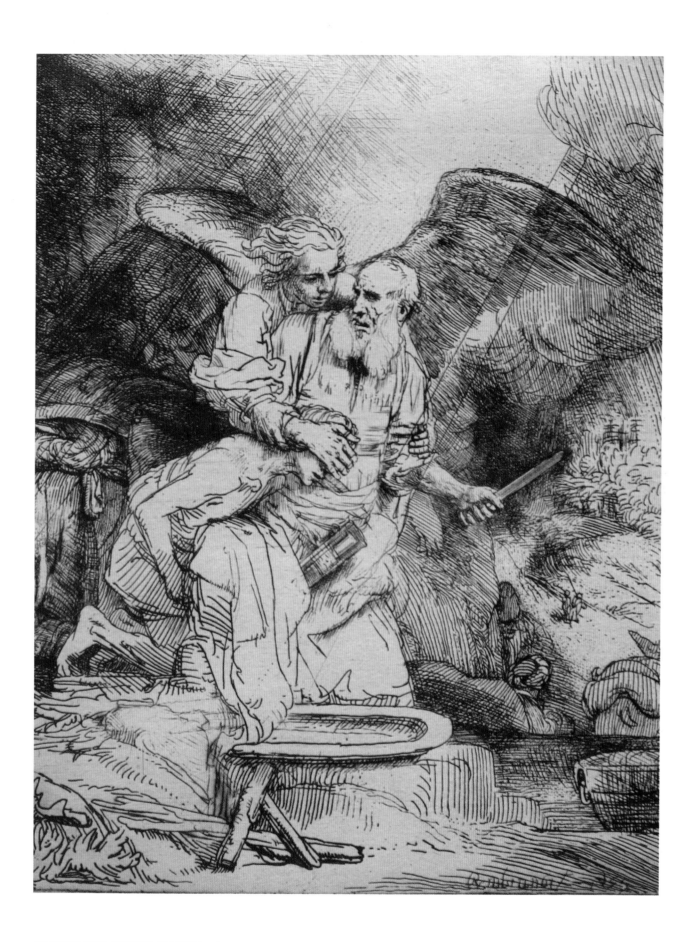

CAST DRAWING

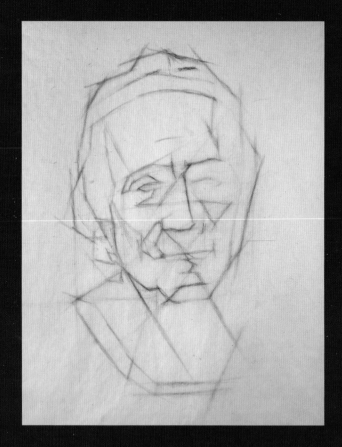

Stage One: Using simplified lines, determine the placement and overall gesture of the cast.

As discussed in chapter seven, there are several benefits to drawing from casts. Cast drawing is useful for gaining experience with observation and design, as it can help develop a systematic way of approaching drawing. It also builds confidence with a particular drawing medium, such as graphite or charcoal. Lastly, it helps cultivate an aesthetic as you learn to transform life into art by studying the work of a master sculptor.

Gathering Your Materials

In preparation for creating your cast drawing, assemble the following materials:

- Cast
- Vine charcoal or graphite pencil
- Charcoal paper or smooth drawing paper, depending on which medium you have chosen

- Sandpaper or pencil sharpener
- Kneaded eraser
- Chamois
- Newsprint
- Plumb line
- Narrow knitting needle or skewer
- Small mirror

Setting Up Your Drawing

Select the view of your cast that you find most pleasing and position your easel so that you can comfortably render this view. Make sure to place your easel far enough from the sculpture so that you can see the entire object without having to move your head. The suggested rule of thumb mentioned in Leonardo da Vinci's notebooks is for the artist to distance himself from the object he is drawing by three times the height of the object. Your easel should be

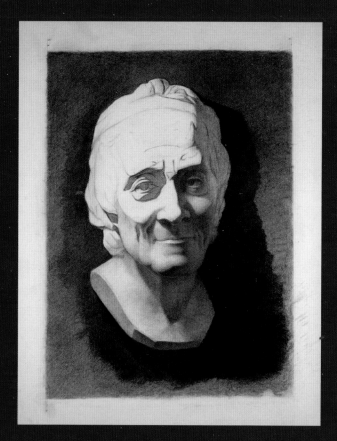

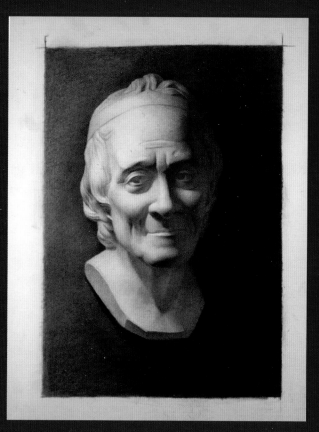

Stage Two: Add tone to the shadow shapes of your cast as well as the background, defining these areas in relation to the light areas.

Stage Three: Focusing on how the halftones turn from dark to light, turn form in one small area at a time.

upright, as close to 90 degrees in relation to the floor as you can manage. Your charcoal or smooth drawing paper should be well padded with newsprint and flush with the edge of the drawing board. Use a single source of light that reveals the form of the subject, with roughly two thirds of the cast in the light and one third in shadow.

Drawing Your Cast

Rather than trying to produce a highly finished work the first time you attempt a cast drawing, it is helpful to consider this lesson as a series of mini exercises that culminate in the creation of a more finished drawing. Begin by doing one three-hour drawing. Then start a fresh drawing the next day. By doing many relatively quick drawings, you will gain accuracy, speed, and confidence. Keep rotating the cast to get a fresh view, or draw different casts until you have gained confidence. Once you're comfortable with

the process, you can begin a more finished cast drawing. As you're working, always keep a small mirror handy and look at the drawing in the mirror periodically.

STAGE ONE: BLOCKING IN THE SHAPE

The first decision to be made in any drawing is how large the image will be in relation to the size of the paper. Determine the parameters of your drawing by first making a line on the top and a line on the bottom of your paper and then dropping a vertical line between them on which you will later anchor the cast. Measure and mark the halfway point on the vertical line and determine the height-to-width relationship of the cast. Then mark the

Above: Joshua Langstaff, cast drawing of Jean-Antoine Houdon's *Portrait Bust of Voltaire*, 2005, charcoal on paper, 14 3/4 x 10 1/2 inches, courtesy of the Aristides Classical Atelier

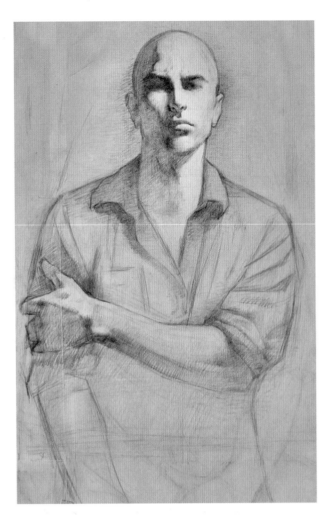

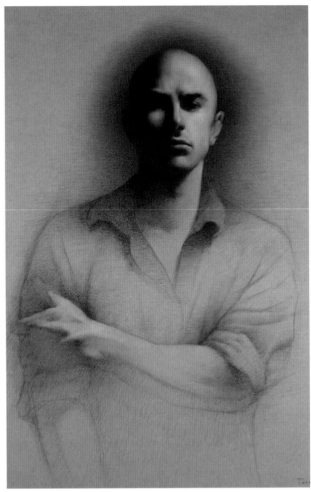

left and right edges. This process gives you an accurately proportioned armature, or framework, on which to build your drawing. It is important to take your time at the beginning of the drawing, as your first marks are key to ensuring the drawing's future success.

Next you need to block in the image. (See chapter three for more on this process.) During the block in stage, your goal is to simplify the cast into a concise, accurate gesture that can be built on with confidence. The more you are able to simplify a complex image into a few unified lines, the stronger the image will be. Avoid focusing on the contour, or outline, of the cast, which is somewhat arbitrary information indicating mainly where the figure happens to hit the background. Rather, work from the inside of the form to the outside the form.

While you're establishing the major line directions found in the cast, you will start to notice repeating angles and dominant diagonals as well as how these elements relate to one another. Observe how the lines are organized, using your plumb line to determine what forms stack over one another and how their widths and heights relate. I suggest using only straight-line relationships to establish proportions, because straight lines are easier to measure and relate than curves. The block in should be lightly drawn, with the maximum freedom of line work so that the drawing stays flexible and easy to work on. It is important to be willing to make changes and correct your marks.

STAGE TWO: CAPTURING LIGHT AND SHADOW

Once you have made your drawing as accurate as possible using just line, advance the image by blocking in the

shadow shapes. Organizing the lines into shapes will enable you to compare the shapes rather than just the line directions. Doing these sorts of comparisons often helps increase the overall accuracy of the work. While looking at your cast, squint your eyes. This will allow you to observe only large areas of value, which will help you separate the drawing into light and dark shapes. The main thing to focus on at this stage of the drawing is the major division between light and shadow, called the core shadow (which is explained in detail in chapter three). It is helpful to imagine the shadow shapes as a landmass on a map, with the "coastline" or border of the shadow shape as an irregular, yet very specific, contour. Draw them in by focusing on the angle changes in the dark line of the core shadow.

Once you have delineated the shadow shapes, apply an even wash of tone to fill them out. Keep it generally light until you are confident that it is accurately placed. This tone makes the shapes easier to see and also more immediately like the cast that you are observing. Once you finish this process, you will have established enough information in the drawing to determine how accurate it is compared to the actual cast and will be ready to make a round of smaller drawing corrections. To assess the accuracy of your piece, look at the relationship of shapes rather than just line. Notice any small discrepancies that can be adjusted. The drawing process is one of making cumulative corrections, all of which gradually bring the drawing in line with your intentions. Each stage is helpful for revealing adjustments that need to be made.

STAGE THREE: FOCUSING ON FORM DRAWING

The beginning stages of the drawing are geared to capturing universal characteristics or general truths of the object. In this last stage your attention is turned toward the particulars—those idiosyncratic attributes that make your object unique. This requires focusing on small areas of form and treating every aspect of the cast with your utmost attention. For many students, this is the first time they have very closely observed anything. It can be a profound experience when a thing that at first seems too slight to notice gradually reveals itself. Some refer to this epiphany as though scales had fallen from their eyes, an almost mystical experience where something seems to appear suddenly.

The simple, flat areas you established in the previous stage ensure that your drawing will have breadth and power, but they cannot give it volume. This is the role of the halftones; they alone are responsible for giving your work girth, weight, and form. During the form drawing stage you turn your full attention to the complexities of the halftones. To this end, artists generally pick one small area at a time on which to focus. This microcosmic attention is useful for rendering small idiosyncrasies in the surface of the form. It is easiest to start by matching the dark tone of the core shadow and gradually getting lighter toward the local (or general) tone of the object.

Working in this manner is akin to placing small value step scales perpendicular to the direction of the shadow line. You work perpendicular to the shadow line because that is the direction from which the light is shining. Also, this perpendicular shading describes another aspect of the object. For example, if you are drawing a cylinder and the shadow runs the full height of the form, the long, narrow characteristic is already being emphasized. What is not being convincingly shown is the circular girth of the object. By rendering rings of tone that are perpendicular to the length of the shadow, we show the eye that the object is both long and round.

When you apply a single-minded focus on turning form one area at a time, each area is guaranteed to get your best effort. As you finish one area, move to the next. Finishing the drawing requires first attending to all the areas that remain unresolved. Theoretically, the drawing can be finished with one pass. However, you often need to go back and pay additional attention to areas of the drawing that feel less successful.

Opposite Left: Tenaya Sims, *Self-portrait,* shown during the block in stage

Opposite Right: Tenaya Sims, *Self-portrait,* 2006, charcoal on paper, 18 x 24 inches, courtesy of the Aristides Classical Atelier

LESSON FOUR

REDUCTIVE FIGURE DRAWING

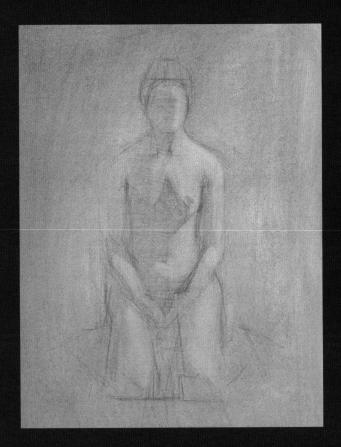

Stage One: Using light charcoal marks, determine the overall size of the figure on the page and its proportion.

A reductive drawing is one in which the artist begins with a toned ground, or a surface covered entirely with tone, and erases out the lights rather than drawing in the darks. It is called "reductive drawing" because it is a process of reducing rather than adding value. Reductive drawing is an atmospheric, mass-oriented way to draw—meaning it is more dependent on tone than on line. Normally, when working with dark lines on a white paper you capture the reverse of what you actually see. In life, the shadows of the object join with the background and the light parts of the form stand out. However, in drawing, the light parts of the subject fade into the light paper and the shadows jump out. Consequently, the reductive drawing process—which involves working on a darker paper and pulling out the lights—mirrors the way that our eyes see in any situation where the subject is lighter than the background and hence needs less translation.

Gathering Your Materials

In preparation for creating your reductive figure drawing, assemble the following materials:

· Vine charcoal
· Charcoal paper, either white or off-white
· Sandpaper
· Kneaded eraser
· Chamois
· Newsprint
· Plumb line
· Narrow knitting needle or skewer
· Small mirror

Setting Up Your Drawing

Set up the model as you would a cast, giving careful consideration to the placement of your easel and to the light

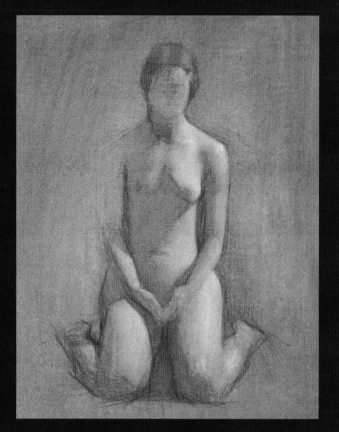

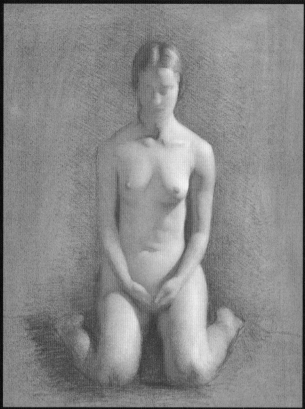

Stage Two: Locate the shadow shapes and then use a chamois to strengthen these shapes by pulling out the light areas.

Stage Three: Strengthen the lights by pulling them with a kneaded eraser, allowing the white from the original paper color to become the highlight.

source. The easel should be far enough away from the model so that you have some distance, roughly three times the height of what you are drawing (unless you are working sight size; see pages 44–50). It is useful when getting started to observe the two-thirds light/one-third shadow rule when adjusting the light and create simple flow of light over the figure. Any lighting situation that has a background darker than the subject you are drawing would be a good candidate for the reductive figure technique.

Preparing the Paper

As mentioned at the beginning of this chapter, I save up the charcoal dust that I gather when sharpening sticks of vine charcoal. This extra dust can be stored in an empty film cartridge or another small container. If you don't have any dust on hand, you can create dust by sharpening more charcoal.

To prepare the paper, pour a pile of dust onto the center of your paper. Then, using a chamois or tissue, rub the dust over the surface so that it is evenly distributed. It is important to use a chamois or tissue rather than your finger so that the paper is treated gently and remains receptive to more charcoal. Do not rub the tone too deeply into the paper because you will want be able to easily pull back to the white of the paper later. The distribution of tone does not have to be perfectly even. In fact, sometimes an uneven surface adds to the overall character and beauty of the drawing. The goal in preparing the paper is to create a middle tone that will function as either the shadows or the halftones in the drawing. You will be adding more charcoal to create the extreme dark areas and pulling out tone to create the light areas.

Above: Juliette Aristides, *Pipi Kneeling*, 2005, red chalk on paper, 18 x 14 inches

The reductive drawing technique more closely resembles painting than line drawing. As when starting a painting, your first concern is establishing masses of value onto which you apply the smaller forms found in life. This proves to be an easy, flexible, and forgiving method of quickly creating an atmospheric drawing.

Drawing Your Subject

When the tone is just laid on the paper, often it is just resting on the surface and is easily removed. You have to be careful initially not to pull away too much tone. It is advisable to lightly map out the placement of your shadow shapes before you start pulling out the lights. To pull out the lights, first wipe away with a tissue (a chamois will pull away too much), then pull out the brighter lights with a kneaded eraser. If you accidentally erase away too much value or if you find you need more halftone, you can work more charcoal powder back into the surface.

STAGE ONE: BLOCKING IN THE SHAPE

When starting a figure drawing it is useful to determine the gravity line (which is also called a "weight line"). In this case that would be the positioning of the head over the knees. Mark the top of the head and the bottom of the feet (if you are doing a standing figure) along a vertical line on your paper. This will ensure that the figure stays on the page locked into a certain size. For reference, you should also mark the halfway point. This simple proportional notation can help you keep your figure drawings more accurate.

Now start to block in the key areas of your figure. Determine the angle of the clavicle, or collarbone, which is easy to see on the surface of the model and is referred to as a bony landmark. The angle of the clavicle provides vital clues to the tip and tilt of the rib cage. The rib cage can be blocked in as an egg shape, or as a series of directional angles. Next, formalize the pelvis and head, making sure that they are aligned in a believable manner. In addition to identifying these anatomical features, at this stage it is important to place in significant angles and repeat them as often as possible. This repetition ensures that the lines used are important ones that impact the gesture of the whole figure. If you are drawing an angle in the neck, look where the line intersects the foot and the head. This

limits the angle direction, creating unity, and keeps your composition dynamic and fluid. (For more on blocking in the essential shapes of the figure, see chapter eight.)

After you have established the gesture, or positioning, of the figure, check the accuracy of the drawing by measuring. Using a narrow knitting needle or skewer, check the vertical alignments, such as how the side of the neck aligns over the leg. Measuring (as discussed in chapter three) is simply the comparison of one part of the drawing to another. Through measuring you can combine intuition with the truth observed in nature and ensure an accurate foundation on which to build the details of the drawing.

STAGE TWO: CAPTURING LIGHT AND SHADOW

As with any drawing, this next stage moves from line and focuses on shape. It is easier to see the likeness in your drawing and compare it with the subject when using light and dark shapes. This process also helps improve the accuracy of your drawing. As you locate and shade in the shadow shapes, the drawing will take on a lifelike quality. The key element in the shadow shape is the core shadow, that dividing line between the light and shadow. Much descriptive information about the forms on the body is found in this area. Offset the simplification or flatness of the shadow by observing well the small nuances of the core shadow area.

STAGE THREE: FOCUSING ON FORM DRAWING

The last stage of the figure drawing is to render form. The block in provided a strong foundation by ensuring that you considered each part of the drawing in relation to every other part. Nothing has been seen in isolation and each part relates to the whole. Now you can turn your attention to small forms without worrying that the drawing will lose balance. As discussed in detail in chapter five, the area responsible for volume is the halftones. Start rendering the halftone areas, focusing on one area of the drawing at a time. Turn from dark to light, looking for nuances where one area will flow into another or where forms are clearly delineated from one another. After you have rendered each area of the drawing, you might once again reassess the success of the whole drawing against the original. This is the time to evaluate hard and soft edges, or areas that need to be emphasized or subordinated.

USING ALTERNATIVE MEDIA

I recommend doing your first reductive drawing in charcoal. It is flexible, applies effortlessly, and erases easily. Charcoal can also most easily approximate the wide value range found in life, getting darker than most drawing media. However, after you are comfortable doing this exercise in charcoal, you can experiment with different drawing media such as graphite pencil, conté crayon (which is what I used for the examples shown on pages 134–135), or pastel pencil.

A graphite reductive drawing starts off lighter than a charcoal drawing and requires smooth drawing paper. Use carbon dust to apply a smoky midtone on the surface of the paper. It doesn't erase as easily as charcoal, so it is a less sensitive surface to work on.

Use graphite pencils to build up the dark areas on top of this surface. This method can get a beautiful range of tones and a feeling of soft atmosphere.

Pastel pencils and conté crayons both come in a wide range of colors. Both can be sanded with sandpaper or shaved with a knife into powder and the colored powder can then be used to tint your paper. Conté crayon is harder to erase than charcoal, but offers a larger range of colors to work with. You can use one color or combine more than one color to create your own tone.

Above: Sharpened sticks of vine charcoal.

Photo Credit: Greg Nyssen

LESSON FIVE
PORTRAIT DRAWING

Stage One: Capture the simple dynamic of the lines of the model and set the overall proportion and likeness.

The goal of portrait drawing is to create an accurate and compelling likeness of the sitter and to study expression. Portrait drawing poses particular challenges for the artist, as we all have such intimate familiarity with the subject matter. There is almost no room for error. Each deviation from the model results in a change in the appearance of the portrait. The necessity for accuracy is greater with portraiture than with any other subject.

Gathering Your Materials
In preparation for creating your portrait drawing, assemble the following materials:
- Vine charcoal or graphite pencil

- Charcoal paper or smooth drawing paper, depending on which medium you have chosen
- Sandpaper or pencil sharpener
- Kneaded eraser
- Chamois
- Newsprint
- Plumb line
- Narrow knitting needle or skewer
- Small mirror

Setting Up Your Drawing
Set up the model as you would a cast, giving careful consideration to the placement of your easel and to the light

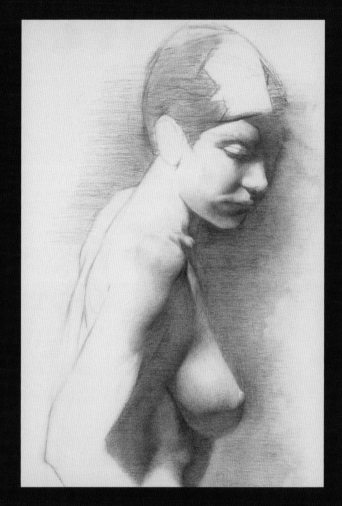

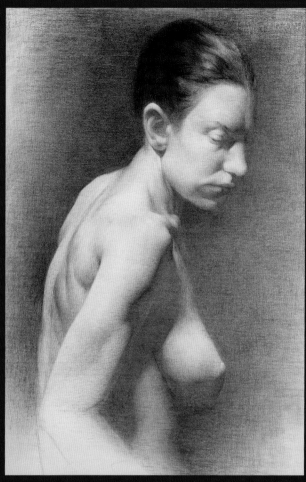

Stage Two: Position the shadow shapes and indicate the background in a few places to create a context for the head.

Stage Three: Preserve the big shapes of light, but now carefully turn the form between the light shapes and the shadow areas.

source. The easel should be far enough away from the model so that you have some distance, roughly three times the height of what you are drawing (unless you are working sight size; see pages 44–50). When lighting the model, try to have the light source reveal the form of the face. Avoid half light, half shadow, which will make the face feel flat. Also notice the shadows that are being cast onto the face. Try to avoid unpleasant shadows, such as the nose causing a moustache-like shadow on the upper lip.

Drawing Your Portrait

It is important to take some time to study the model before drawing the portrait. Many students start immedi-

ately without determining the dynamics of the pose or uncovering what it is that they find most interesting about the model. Nature will present you with a series of facts; it is up to you not only to faithfully record what you see but also to emphasize the most significant facts, create a focal point for the work, and produce a compelling image. This focal point could be a beautiful sweep of curves, a value transition, an expression, a contour line, a twist of two forms juxtaposed against one another, or a dynamic angle change. A series of factors can affect you in an

Above: Holly Hudson, *Sarah*, 2005, vine charcoal on paper, 14 x 23 3/4 inches, courtesy of the Aristides Classical Atelier

emotional way. The success of a great drawing is its ability to communicate not only the truth of the pose but this emotional connection. In other words, the drawing should affect the viewer the way the model affected the artist.

STAGE ONE: BLOCKING IN THE SHAPE

Keep in mind that drawing the head is just like drawing any other subject. Creating an objective mindset will enable you to start the drawing more confidently. Often it is useful to squint and to start with the broadest possible shapes.

The block in of a portrait starts the same as in any other drawing. The overall gesture is established using a series of simplified angles. It is important that the eyes, nose, and mouth are parallel to one another; if they are misaligned, the angles of the face will appear strangely distorted. To avoid that mistake, place a centerline that runs between the eyes to the center of the chin. The angles of the features should be placed perpendicular to the centerline. This will ensure that the two sides of the face are evenly aligned. The structure of the neck and shoulder girdle are also important to making the pose believable. Additionally, make sure to leave enough room for the skull in the back of the head, and for the space between the ear and the face. These points are easy to miss yet are essential for the success of the drawing. It is important to carefully measure the relationships among the features during this time.

STAGE TWO: CAPTURING LIGHT AND SHADOW

When the block in is accurate and the armature of the head feels solid, it is time to add value. The goal at this stage is to place a unified shadow shape on the drawing and to assess the overall likeness of the image. Pay careful attention to the core shadow and to the unique shapes that are formed between the division of the shadow and the light. After you have determined these shapes, place a simplified "flat" value over all the shadows. Having a simply massed-in shadow shape and a clear shape for the lights will give you new information with which to assess the drawing. Consider the accuracy of the likeness to the model something that is attained gradually rather than all at once. If you find that the likeness is strong at the end of this process, then you can move on to turning form. If not, go back and make corrections in the drawing.

STAGE THREE: FOCUSING ON FORM DRAWING

Now move from rendering general shapes to specific ones until the drawing is finished. During this stage you should focus on creating a likeness by carefully observing the smallest shapes. Look for small areas of ambiguity—how one swelling merges into another. Putting aside preconceived notions about what things should look like and becoming aware of small, surprising washes of tone will make the drawing more complex. By focusing on value and turning the form from dark to light, you will help make the cheekbone rise and the eyes rest in their sockets. As you are working on these smaller shapes you will find ways to improve the accuracy of the drawing.

Top: Drawing materials.

Above: Toned paper

Photo Credit: Greg Nyssen

Opposite: Paul Baudry, *Study for the Torture of a Vestal*, late nineteenth century, charcoal on paper, 32 3/16 X 26 3/8, Musée des Beaux-Arts, Lille, France

Photo Credit: Réunion des Musées Nationaux / Art Resource, NY

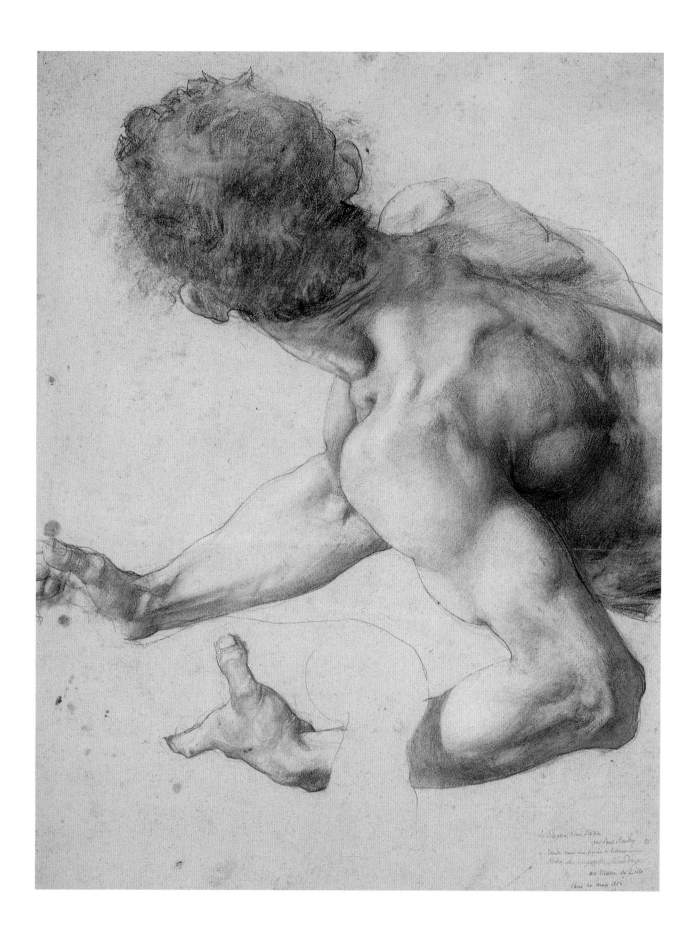

APPENDIX

There are ateliers all across the country. A complete, up-to-date list can be found on the Art Renewal Web site at *www.artrenewal.org*. The following schools contributed art to this publication:

Angel Academy of Art, Florence
Via Fiesolana 34r
Florence 50122, Italy
Director: Michael John Angel
Tel/Fax: 011-39-055-2466737
www.angelartschool.com
info.angel@angelartschool.com

Aristides Classical Atelier
Gage Academy of Art
1501 Tenth Avenue East
Seattle, WA 98102
Instructor: Juliette Aristides
Tel: 206-526-2787
Fax: 206-526-5153
www.GageAcademy.org
www.AristidesArts.com
info@gageacademy.org

Corry Studio of Figurative Art
Salt Lake City, UT
Director: Kamille Corry
Tel: 801-485-4309
kamillecorry@mac.com

Mims Studios
11 Camellia Way
Southern Pines, NC 28387
Director: D. Jeffrey Mims
www.mimsstudios.com
administrator@mimsstudios.com

BIBLIOGRAPHY

Alberti, Leon Battista. *On Painting.*
London: Penguin Classics, 1972.

Ames-Lewis, Francis. *Drawing in Early Renaissance Italy.* New Haven, CT: Yale University Press, 1981.

Arnheim, Rudolf. *Art and Visual Perception: A Psychology of the Creative Eye.* Berkeley: University of California Press, 1954.

Boime, Albert. *The Academy and French Painting in the Nineteenth Century.* London: Phaidon Publishers, 1971.

Bouleau, Charles. *The Painter's Secret Geometry.*
New York: Hacker Art Books, 1980.

Cennini, Cennino d'Andrea. *The Craftsman's Handbook.* Translated by Daniel V. Thompson, Jr.
New York: Dover Publications, 1954.

Clark, Kenneth. *The Nude: A Study in Ideal Form.*
Garden City, NY: Doubleday Anchor Books, 1956.

Couture, Thomas. *Art Methods.* Translated by
S.E. Steuart. New York: G.P. Putnam's Sons, 1879.

Doczi, Gyorgy. *The Power of Limits.*
Boston, MA: Shambhala Publications, 1981.

Elam, Kimberly. *Geometry of Design.*
New York: Princeton Architectural Press, 2001.

Ghyka, Matila. *The Geometry of Art and Life.*
New York: Dover Publications, 1977.

Hambidge, Jay. *The Elements of Dynamic Symmetry.*
New York: Dover Publications, 1967.

Haverkamp-Begemann, Egbert. *Creative Copies: Interpretative Drawings from Michelangelo to Picasso.*
London: Philip Wilson Publishers, 1988.

Lawlor, Robert. *Sacred Geometry.*
London: Thames and Hudson, 1989.

L'Hote, André. *Treatise on Figure Painting.*
London: A. Zwemmer, 1953.

Parkhurst, Daniel Burleigh. *The Painter in Oil.*
Norwood, MA: Berwick & Smith, 1898.

Pearce, Cyril. *Composition: An Analysis of the Principles of Pictorial Design.* London: B.T. Batsford Publishers, 1927.

Schneider, Michael S. *A Beginner's Guide to Constructing the Universe.* New York: HarperCollins, 1994.

Speed, Harold. *The Practice and Science of Drawing.*
New York: Dover Publications, 1972.

Weinberg, H. Barbara. *The Lure of Paris: Nineteenth-Century American Painters and Their French Teachers.*
New York: Abbeville Press Publishers, 1991.

INDEX